WARNING

INTEGRATED INMATE
SENSING SYSTEM

ACCESS REQUIREMENTS

- REVIEW INMATE SCHEDULE
- SECURE DOOR UNLOCK WITH SUPER
- INFORM YARD WATCH
- NO WEAPONS BEYOND THIS POINT

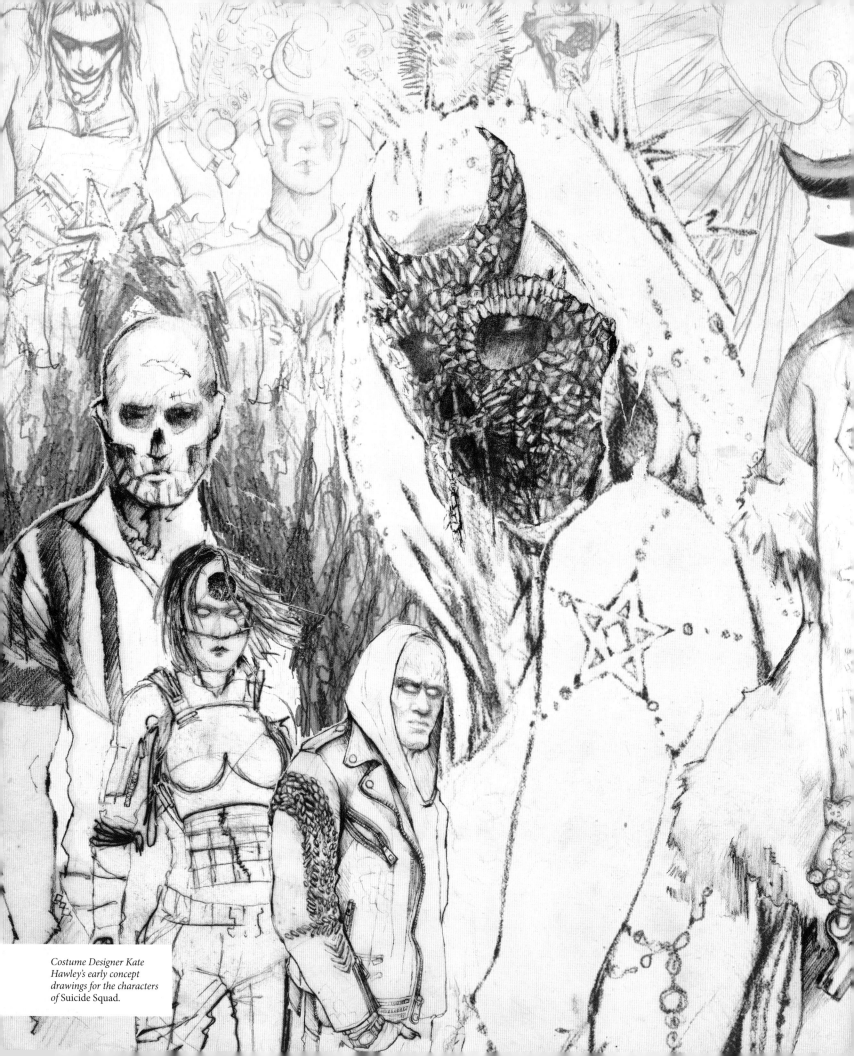

Costume Designer Kate Hawley's early concept drawings for the characters of Suicide Squad.

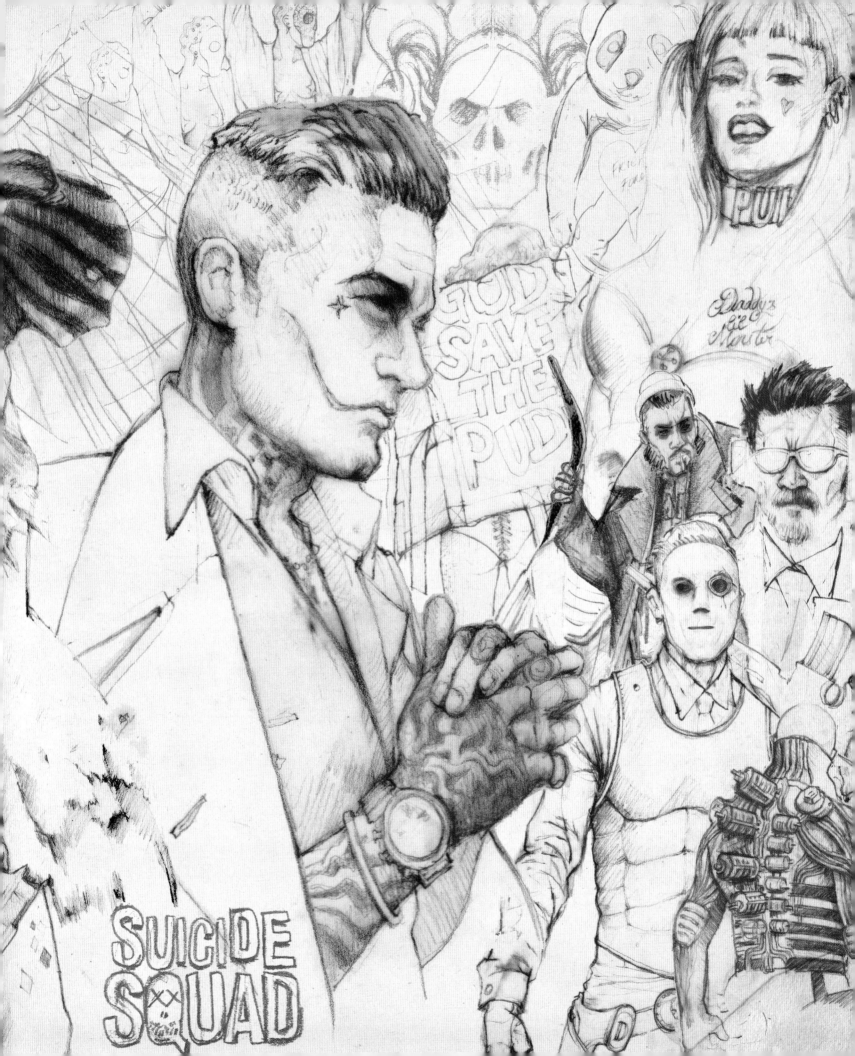

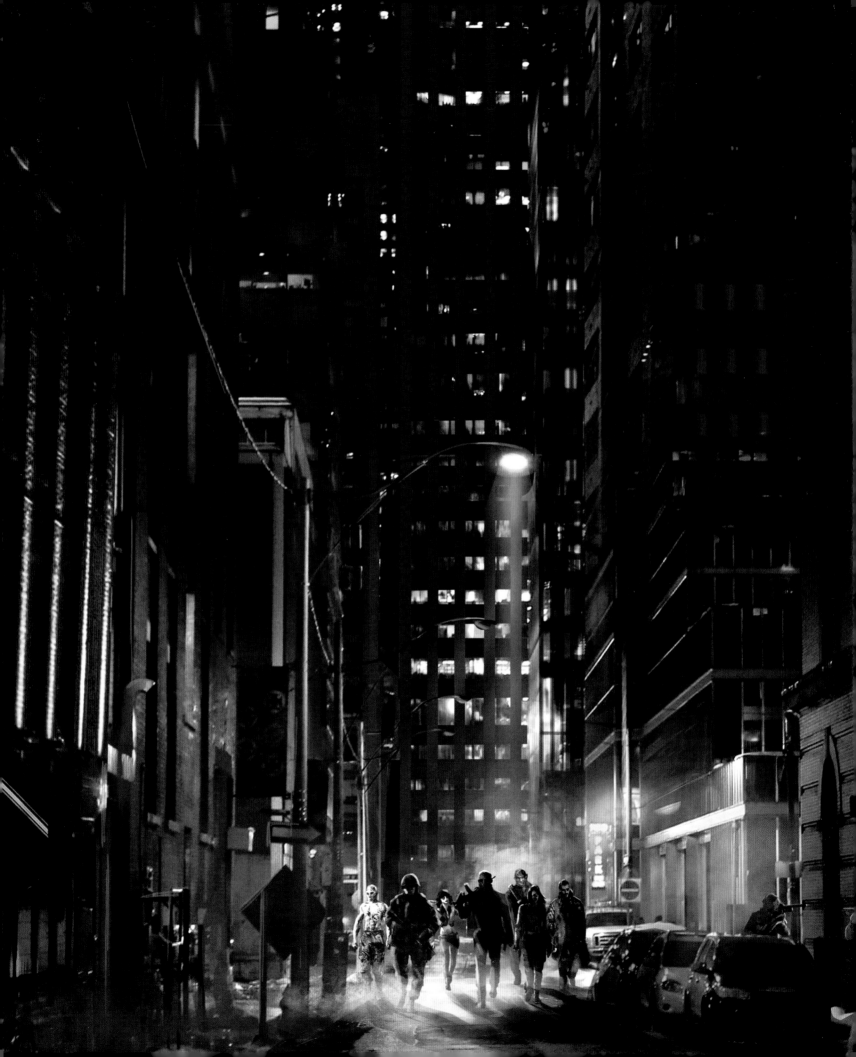

SUICIDE SQUAD

BEHIND THE SCENES WITH THE WORST HEROES EVER

PREFACE BY DAVID AYER
FOREWORD BY GEOFF JOHNS
TEXT BY SIGNE BERGSTROM

HARPER DESIGN
An Imprint of HarperCollins Publishers

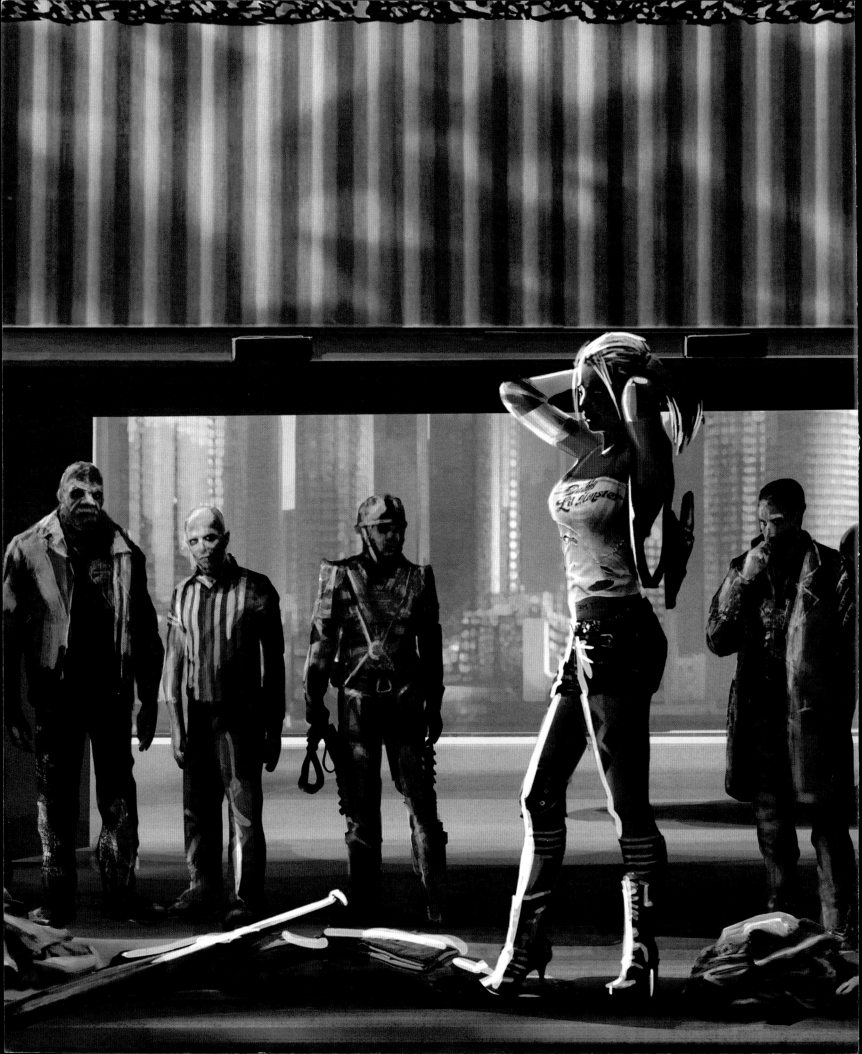

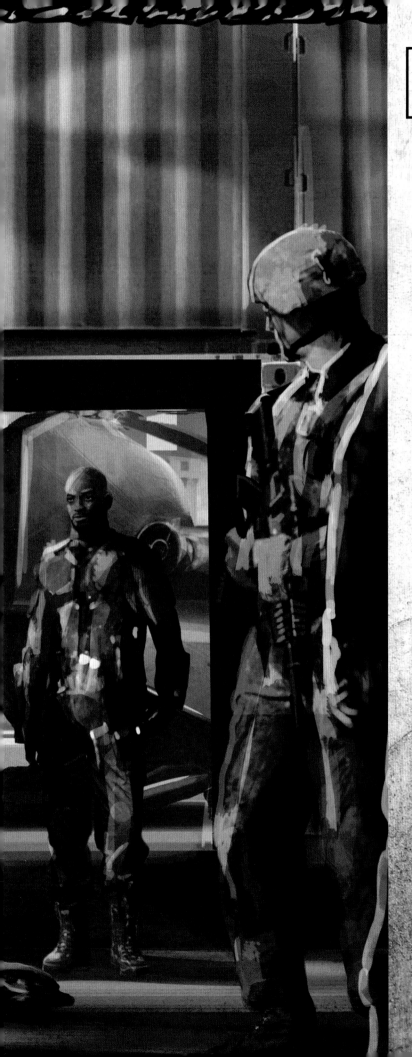

CONTENTS

PREFACE *by* David Ayer • 8

FOREWORD *by* Geoff Johns • 9

THE PRODUCERS' DIARY *by* Charles Roven, Richard Suckle, *and* Andy Horwitz • 10

INTRODUCTION: Worst. Heroes. Ever. • 12

ASSEMBLING THE SUICIDE SQUAD: The Worst of the Worst • 17

VIOLA DAVIS *as* Amanda Waller • 21

WILL SMITH *as* Floyd Lawton/Deadshot • 24

MARGOT ROBBIE *as* Dr. Harleen F. Quinzel/Harley Quinn • 32

JAY HERNANDEZ *as* Chato Santana/Diablo • 41

ADEWALE AKINNUOYE-AGBAJE *as* Waylon Jones/Croc • 49

JAI COURTNEY *as* George Harkness/Boomerang • 55

ADAM BEACH *as* Christopher Weiss/Slipknot • 61

KAREN FUKUHARA *as* Tatsu Yamashiro/Katana • 67

JOEL KINNAMAN *as* Colonel Rick Flag • 76

MEN ON A MISSION • 80

SMASH AND GRAB: Stuntwork & Physical Training • 82

PRISONERS OF CRIME: Welcome to Belle Reve • 89

THE GUARDS • 92

THE CELLS • 94

MIDWAY CITY • 99

THE FEDERAL BUILDING • 106

DOUBLE TROUBLE: Supernatural Siblings • 111

CARA DELEVINGNE *as* June Moone/Enchantress • 115

SKULL CAVE • 122

INCUBUS • 126

THE EYES OF THE ADVERSARY • 131

ENCHANTRESS'S MACHINE • 134

BATTLE ROYALE • 138

ALL INKED UP: The Suicide Squad Tattoo Parlor • 143

THE JOKE'S ON YOU: Becoming the Joker • 151

JARED LETO *as* the Joker • 152

ARKHAM ASYLUM • 158

THE JOKER'S GANG • 166

CAST & CREW FAREWELL • 172

ACKNOWLEDGMENTS • 173

BRAVO TO THE WHOLE SKWAD • 174

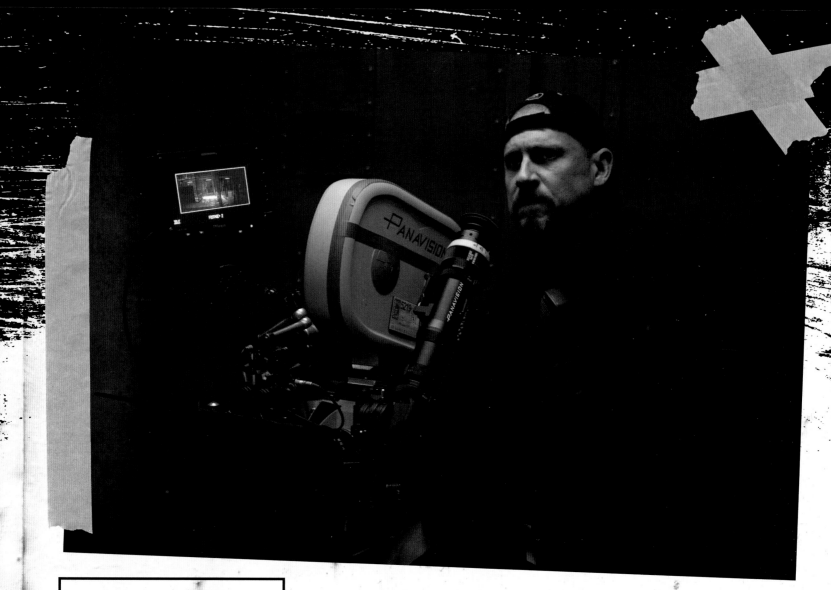

PREFACE

I REMEMBER AS A KID reading comic books at the library for hours and hours. Sometimes I would pause to study the pages, the black lines, the hand shading, the colors. Such simple elements combining to create an illusion. An illusion of other worlds, fantastic lives, heroes and villains engaged in battles that spanned worlds. Good guys doing good things. And then there was *Suicide Squad*. They weren't so good. And they lived in a murky world of government intrigue. Covert operations. Black ops. They did bad things, but had a lot of fun doing them. All occurring within the crucible of the Cold War; us versus them, save the free world at any cost. The Squad was the perfect counter to all of the square-jawed heroes doing the right thing.

Now how do you turn a comic book into a movie? In a lot of ways the process is similar. You sketch it out first. Rough pencil sketches become elaborate key frame illustrations, which yield set designs, then shop plans. Then construction crews swing hammers and paintbrushes and a world rises before your eyes. Film is a unique medium, it is the potluck dinner of artistic mediums in many ways. Almost everything has to be created, not just sets built, but wardrobe designed and then sewn. Graphics and signage created for buildings. Labels for bottles. Menus for restaurants. No detail is too small.

A film is the result of thousands upon thousands of decisions, of choices, both large and small. It takes many, many amazing creative people coming together for a single purpose. In the beginning, the road ahead is murky. Just collages of images taped to poster boards. Constellations of drawings, paintings, photos, sketches slowly become a unified vision seen through the lens of a camera. It is a massive effort that starts with a drawn line and ends with a feature film. Come walk the road with me.

—DAVID AYER, writer/director, April 18, 2016

SUICIDE SQUAD

FOREWORD

SOMETIMES IT'S MORE FUN to root for the bad guys.

The Suicide Squad first appeared in *The Brave and the Bold #25* (1959) by Robert Kanigher and Ross Andru. Back then the Squad was introduced as a military team led by Colonel Rick Flag, but it wasn't until *Legends #3* (1987) that writer John Ostrander reintroduced and reconceived the Suicide Squad as a "Dirty Dozen-like" team of super-villains: criminals recruited by government powerhouse Amanda Waller to go on covert missions in exchange for reduced sentences. And the team lived up to its name. On the very first mission, one of its members died. Another betrayed the team. That was the kind of unpredictability you couldn't find in any other comic book title on the stands, and it would become a staple to the subsequent *Suicide Squad* series that John launched, and wrote, for several years afterward.

As a concept, the Suicide Squad was unique in the world of Super Heroes, focusing on the super-villains instead. But more important it was John's deft pen and passion that elevated it from a "cool" concept to a cornerstone within the DC Comics Universe. The reason for that, and it is something that was one of the primary influences on me as a comic book writer, was that John took super-villains that had been around for decades–from Deadshot to Captain Boomerang to Enchantress–and made them more three-dimensional, more complex, and more sophisticated than I think anyone thought imaginable. It always comes down to characters. And because John was taking what some

foolishly considered B-list or unsalvageable villains he could take them to places where Super Heroes couldn't go.

The assassin Deadshot was ordered to stop Rick Flag from killing a corrupt senator by any means necessary–and so Deadshot killed the senator himself.

On one of the first missions out, Captain Boomerang had the chance to save one of his teammates, but because they'd pissed him off earlier Boomerang let them die.

There was redemption among villains. One was a coward who attempted to become a hero and died for it. Another found religion and sacrificed himself. Others sabotaged missions in progress.

And the missions were as personal as they were political. Superpower terrorists, wars over metahumans as weapons, corruption within our own government–there was no subject matter that the Squad shied away from. The metaphors for our world and the grayness within it was reflected through every mission the Squad undertook and within the characters themselves.

Over the years, the Squad grew. Countless villains were recruited. Some became mainstays to the team alongside Deadshot and Captain Boomerang, like Harley Quinn.

Which brings us up to the present day.

Today the Suicide Squad is finally headed to the big screen. And the entire world is going to learn why it's fun to root for the bad guys.

—GEOFF JOHNS, April 13, 2016

THE PRODUCERS' DIARY

ATLAS ENTERTAINMENT'S INVOLVEMENT in the current DC Universe of films began with 2013's *Man of Steel*, leading to this year's *Batman v Superman: Dawn of Justice*, and now *Suicide Squad*.

We first met David Ayer in the summer of 2014 as he was finishing his film *Fury* when the journey began. David was very clear: he wanted to make a character-driven film with a simple plot, offering him the opportunity to dig deep into these characters and explore the multiple members of this motley crew, warts and all. This not only excited the producers but equally Warner Bros., where David had already displayed his abilities as a screenwriter when he brought to life one of the most memorable morally ambiguous bad guys ever to appear on the big screen: *Training Day*'s Detective Alonzo Harris, for which Denzel Washington won the Academy Award for Best Actor.

David dove right in and picked his squad: Deadshot, Colonel Rick Flag, Killer Croc, Captain Boomerang, El Diablo, Katana, Enchantress, Slipknot, and the one and only Harley Quinn. And, of course, if you have Harley Quinn, then the clown prince himself, the Joker, won't be too far behind. And a *Suicide Squad* movie wouldn't be complete without Amanda Waller casting her all-encompassing shadow over all of them.

By the fall, not only was a script delivered, but also a cast assembled. Prep was full on, and fall became winter, and winter became spring. It was finally go time. Principal photography commenced on April 13, 2015, in Toronto.

The pages that follow beautifully bring you on the ride the three of us experienced with the hundreds of dedicated and superbly talented collaborators to bring *Suicide Squad* to life.

We hope you enjoy it as much as we did.

So get ready for the bad guys! And maybe they'll even do some good.

—CHARLES ROVEN, RICHARD SUCKLE,
and ANDY HORWITZ, April 2016

OPPOSITE: *Producers Charles Roven* (TOP), *Richard Suckle* (RIGHT), *and Andy Horwitz* (LEFT).

BELOW: *First promotional photograph of the fully assembled Squad.*

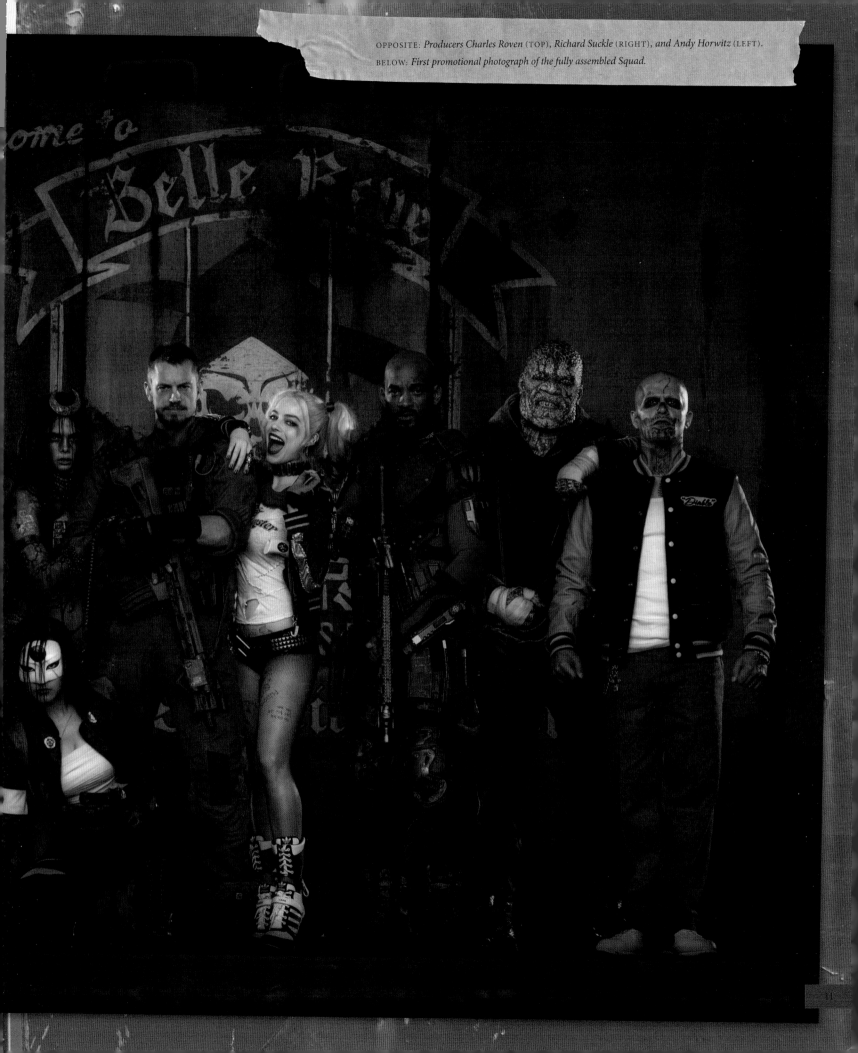

INTRODUCTION
WORST. HEROES. EVER.

"The Suicide Squad characters, both as individuals and as part of the squad, have a legacy that goes back many generations. So it's rewarding for us to be able to take these characters and bring them to the big screen."

—Charles Roven, *producer*

W<small>E ALL LOVE</small> B<small>ATMAN</small>, Superman, and Wonder Woman but where's the fun in being good all the time? Sometimes it's good to be a little bad. Cue Task Force X, better known as the Suicide Squad.

Comprised of DC's most notorious super-villains, the Suicide Squad is the worst of the worst—depraved lunatics, misfits, and criminal masterminds. Because every high-risk operation they embark on spells disaster, the team is expendable. With built-in deniability for their actions, government agent Amanda Waller hand-picks the Squad members from the bowels of Belle Reve Penitentiary, a prison so foul it makes a Supermax look like kiddie stuff. When timid scientist June Moone unintentionally unleashes the Enchantress, a super-natural evil entity dead-set on bringing humanity to its knees, Waller gives the Suicide Squad its first deadly mission: Save the world at any cost.

To ensure no one walks off the job, Waller embeds an explosive device in the head of each super-villain. How's that for mind control? Extreme situations require drastic measures . . . and the Suicide Squad is nothing if not extreme. Forget the good guys—they're off . . . doing whatever it is those regular ol' heroes do.

This time around, it's bad versus evil.

"As a producer, it's exciting to be part of making something that is building out a world that I'm a big fan of. It's a producer's dream really to be a part of and to work on a property and characters that are beloved by so many people."

—Richard Suckle, *producer*

THE ORIGIN OF *SUICIDE SQUAD*

F<small>ANS OF THE</small> DC U<small>NIVERSE</small> have long been acquainted with the Suicide Squad. The Squad made its first appearance in DC's 1959 comic book *The Brave and the Bold #25*, created by writer Robert Kanigher and artist Ross Andru. This early incarnation of the team laid much of the comic's foundation. In 1987, comic book writer John Ostrander took the helm and revamped the series, updating and finessing the Suicide Squad characters into the super-villains we know and love today. Ostrander made some big changes, introducing audiences to the scariest mastermind of the bunch—ruthless government agent Amanda Waller—while modernizing aspects of other characters. (Deadshot's 1950s-style top hat and monocle, for example, were replaced with body armor and wrist magnums.) In bringing the Suicide Squad to life on the big screen, Writer/Director David Ayer wanted first and foremost to honor the comic's legacy while giving it a platform within the cinematic context of the DC Universe. To successfully pull off this balancing act, Ayer wanted to retain some elements of the comic—fan-favorite costumes and weapons—but also be fearless enough to take risks and shape these characters for the big screen.

Jared Leto's portrayal of the Joker, for example, is a modern reinterpretation of the classic character audiences have known for years. Created over seventy-five years ago, the Joker doubtless didn't have full-body tattoos in the 1940s. Today, though? "This is the Joker with an iPhone," Ayer says.

Like Ostrander before him, Ayer made character adjustments and additions to the Suicide Squad oeuvre. Ayer adapted some of the characters' backstories too, and grounded them in today's sense of realism. Croc, for example, isn't half-man, half-crocodile per se. Instead, he suffers a rare skin disorder that renders him crocodile-like in appearance. Actor Adewale Akinnuoye-Agbaje

> ## "There's a tremendous amount of wish fulfillment with these characters. There's a lot of people who wish they could do the kinds of things these characters do. They're fun to watch, they're entertaining, and you have no clue what they're gonna do next at any moment."
>
> —Andy Horwitz, *co-producer*

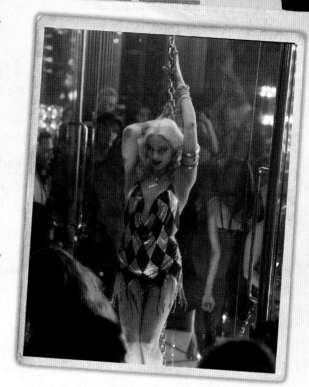

integrated this information within his performance so audiences can see the humanity of the man beneath the beast rather than the other way around. Ayer encouraged the cast to fully understand and explore the psychological underpinnings of their character's flaws . . . and to have fun with them, too. The result? On screen, the Suicide Squad is a group of fully realized individuals, complete with personality quirks and compelling backstories. They're human—granted, flawed, dysfunctional, and wicked to the core—but human nonetheless. To be sure, the cinematic world of *Suicide Squad* is darker and edgier than its comic book counterpart. Even its sense of humor has been ratcheted up and feels wickedly wrong; one-liners are delivered with the fierceness of machine-gun fire. But times of darkness demand darkness in kind. Sometimes you need a villain to catch a villain.

Co-producer Andy Horwitz knew they scored big when Ostrander gave the film his blessing. The cast and crew had been working on the film for two years when Ostrander visited the set. The pressure for his approval was intense. Horwitz says, "We had to take a step back and realize, oh my God, this is the guy that created this whole thing . . . it was very nerve-wracking." After seeing the various costumes, props, and set design and meeting key actors Will Smith, Joel Kinnaman, and Margot Robbie, Ostrander reported being speechless for the first time in his life. "I don't think the smile left his face from the time he walked into the studio until he left in his car," Horwitz says.

THE PRODUCTION

EVERY SQUAD needs a leader. For cast and crew alike, that person is Writer/Director David Ayer. Like Waller wrangling up her leads, Ayer corralled his crew and assembled Hollywood's top echelon of actors and he did so without having a script in hand. Ayer's body of work—*Fury*, *Sabotage*, and *End of Watch*, among others—spoke for itself. So did his enthusiasm and passion for the project. When Jared Leto was considering signing on to the film, he visited Ayer at his home. He says, "We sat outside . . . and we talked. And it was clear to me that he wanted to make something really special. And that's incredibly compelling, you know? To be part of something where the motivation is to do something different, to do something that hopefully we'll all be proud of. . . . He had a lot of passion and decisiveness . . . and he certainly had a vision." Margot Robbie reported a similar encounter, saying, "All there

> ## "The best moments for me on set are the times between takes when I get to hang out with the actors. It's wonderful to listen to them and be part of this traveling circus we've created."
>
> —David Ayer, *writer/director*

was, was David's name. David Ayer will be writing and directing. And I was like, 'I'd kill to work with David Ayer.' So I jumped on Skype and had a twenty-minute conversation with him where he vaguely explained a loose concept t me. And I was like, 'Yeah, I'm in.'" During this initial stage of production, Ayer asked his cast and crew for one thing: trust. Without it, *Suicide Squad* never would have realized its full potential. "One of the wonderful things about David Ayer's writing is that he can certainly hit the dramatics," says Producer Charles Roven, "but he also gives these characters great personality, and that great personality results in many of them having fabulous wit."

In the realm of big-budget feature films, Ayer's rehearsal process is notoriously rigorous, and his directorial approach is actor-centric. It takes a certain kind of person to sign up for three to six months of intense physical training and rehearsal *before* the ninety-four-day shoot begins. Days are long—frequently fourteen to fifteen hours and for several of the actors, a large percentage of that time is spent in hair and makeup. As Ayer says, "It's a marathon." And not just for the cast. Costume Designer Kate Hawley and her team began their work long before the actors arrived on set. During the early stages of the film's conception, she and Ayer spoke at length about his creative vision. She recalls, "One of the earliest conversations I had with David he said, 'I don't want them in super-villain, Super Hero suits.' . . . No men in tights. . . . He uses this phrase a lot: chasing the real. . . . He was very interested in how we find that particular person in our world and then heighten the experience and distill the elements, the iconography of the comic book characters into our reality." Hawley and her team began working up costume illustrations, with Ayer's input, long before committing a single stitch to fabric. The Production, Art, and Special Effects Departments were faced, early on, with the daunting task of figuring out how to render the characters' supernatural powers— and the collateral damage of several large-scale battle scenes—in the most realistic way possible. The Makeup Department began fitting and adjusting prosthetics for Akinnuoye-Agbaje's transformation into Croc months in advance. All told, hundreds of individuals leant their talent and skill to *Suicide Squad*. From all accounts, it was

a transformative creative experience, with cast and crew bonding to become a tight-knit team. Ayer ran the production with military-like precision, focus, and intention. No surprise there. Having served in the U.S. Navy, Ayer's military training easily transferred into the directorial skills necessary for commandeering a film set populated with several hundred people, divided into so many smaller units. Co-Producer Andy Horwitz may have said it best: "I mean, the movie is called *Suicide Squad*, and I think you're going to need a director, a leader that's going to make them a squad. And I think David's methodology about how he gets the actors to act like family, his rehearsal processes, I think he was the perfect guy to bring a cast of characters that come from very different backgrounds, and to bring all these characters and make them a family is a talent that's unique to David's skill set."

If only Waller could say the same about herself. In the film, the Suicide Squad comes together in spite of Waller's conniving ways, and their flaws—extreme stubbornness, trigger-happy fingers, and biting (literally) wit—become their greatest sources of strength. Their triumph over evil proves that even bad guys can have good days.

LOOKING FORWARD

WHAT'S HAPPENING NOW with the DC Universe is incredible," says Ayer, "because it's finally breaking open the way it should. *Suicide Squad* is just part of a larger fabric and a big surprise for the fans is gonna be how interconnected these movies are. There's gonna be surprises in this film that ripple in others so people are going to need to pay attention when they watch this one. There are a lot of hidden Easter eggs."

Suicide Squad is a revealing, behind-the-scenes look at the creative vision that brought the Suicide Squad to stunning cinematic life. With interviews from the cast and crew, and removable extras, these pages chronicle every detail of the film—from conception to final production.

Welcome to Belle Reve.

> "The best thing about the Suicide Squad is none of them are good guys. And they're all messed up. And they have so many flaws and so many problems and issues and it, weirdly enough, makes them relatable. And in some cases, really likable."
>
> —Margot Robbie, *Harley Quinn*

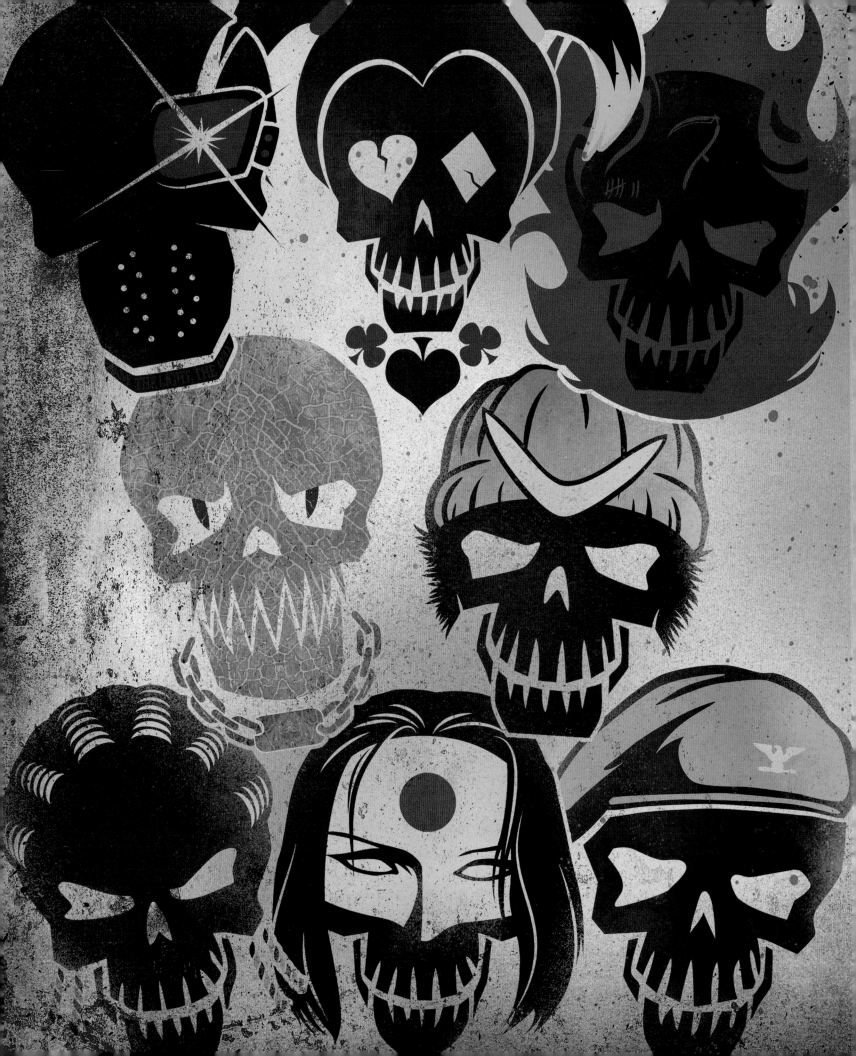

ASSEMBLING THE SUICIDE SQUAD

THE WORST OF THE WORST

I N THE SEEDY UNDERBELLY of Belle Reve Penitentiary lives a tribe of people, criminals so corrupt that their allegiance belongs to no one. One woman, Amanda Waller, understands what no one else does: When harnessed and controlled, these hardcore thugs have the potential to rival any threat. Best of all? They're disposable. Waller assembles a task force of the world's most dangerous masterminds and locks them up inside Belle Reve, a prison so formidable it makes a maximum-security facility look like an amusement park.

> ## "The first time I saw the cast of the Suicide Squad together, it gave me the chills."
>
> —David Ayer, *writer/director*

When the fate of humanity is threatened, Waller calls on her stable of badass super-villains to take out the enemy. Before calling for arms, however, she embeds a self-destructing bomb in each of the criminals' heads, effectively turning their job into a suicide mission should they stray from its course. The Suicide Squad is born.

THE ROSTER

DEADSHOT
Floyd Lawton is the world's best assassin. He's also a dedicated dad and harbors a soft spot for his daughter, Zoe.

HARLEY QUINN
Inside the walls of Arkham Asylum, Dr. Harleen Quinzel fell for her patient, the inscrutable Mr. J, and turned into Harley Quinn, his baseball

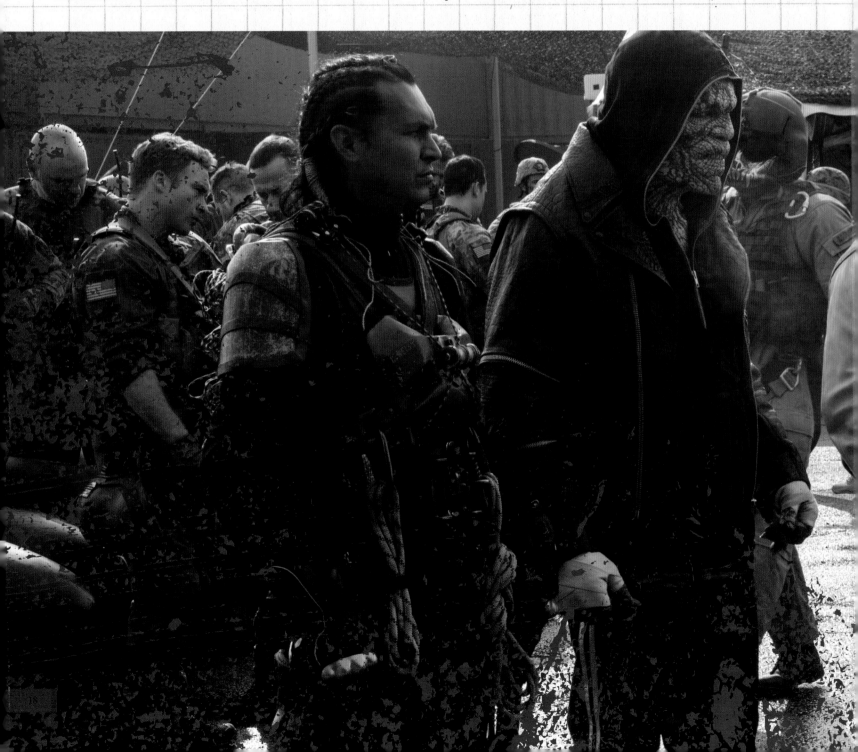

bat-wielding girlfriend. While best known for her wisecracking attitude, her gunplay gets attention too.

DIABLO

Diablo's a gangster through and through, and has the tats to prove it. Diablo unleashes his power with the fury of fire.

CROC

Croc relies on his reptilian-like instincts for survival. Get too close to him and you're lunch.

BOOMERANG

An experienced jewel thief and an expert at hand-to-hand knife combat, Boomerang loves catching his enemies off-guard.

SLIPKNOT

A master at the ropes, Slipknot is a hired assassin/thief who wants

nothing more than to exercise his incredible skills and make some money in the process.

KATANA

Katana's weapon of choice is a one-of-a-kind samurai sword called the Soultaker so named because it supposedly extracts the soul of whomever it kills.

COLONEL RICK FLAG

Colonel Rick Flag is a top-tier military operator charged by Amanda Waller to lead the Suicide Squad mission.

Will this unlikely band of criminals join together to fight for the common good? Or will the Suicide Squad implode, inflicting as much collateral damage as possible? Waller is confident she can control the deranged group of baddies, because, as she says, "getting people to act against their own self-interests is what I do for a living."

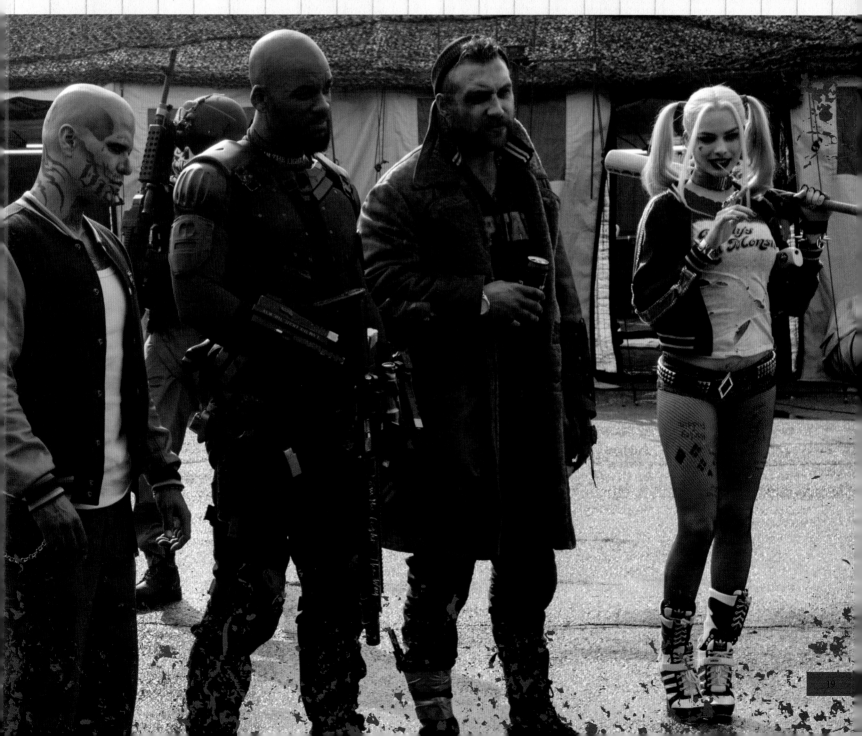

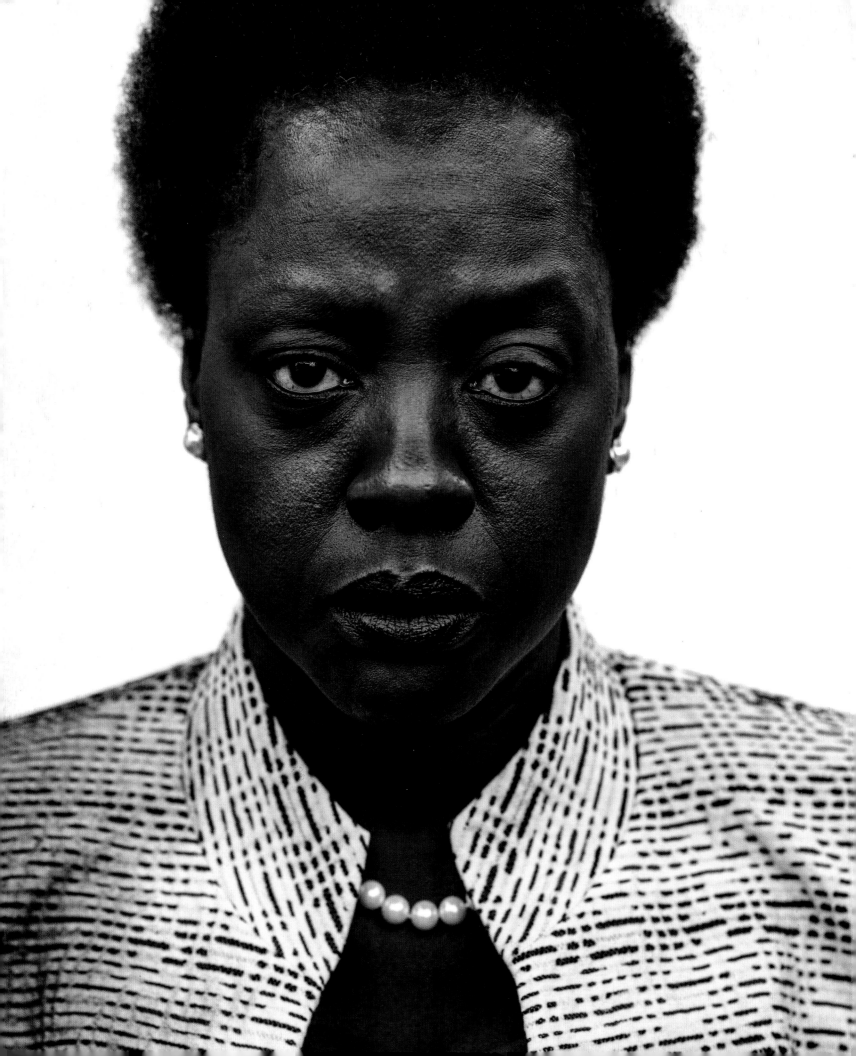

Amanda Waller's weaponry is her intel—top-secret case files, memos, transcripts, dossiers, et cetera. To create the most realistic-looking documents possible, ███████████████████████████████████ Prop Master Dan Sissons and his creative team examined photographs of top-secret docs found in the White House Situation Room. The team was then able to graphically re-create material that genuinely looks like something that would be referenced and used in the real world.

Davis says, "I was drawn to the complexity of Amanda Waller, her sense of authority, and the fact that she was in charge of the whole Suicide Squad. I have to say: I like being the bad ass." ████████████████████████████ While her game plan is straightforward, its execution is riddled with so much risk that it borders on being impossible. Not one to let a good challenge slide, in the end Waller elevates the game herself and shows the Suicide Squad what a good boss is made of—grit, wit, and, in this case, plenty of ammunition. "She's the best person to corral these villains and make them do the things she needs them to do," says Producer Charles Roven. ██████████████████████████████████████ ██

When Enchantress takes over June Moone, Waller senses an opportunity and uses Moone the way an expert chess player moves a pawn across the board. What to Moone is a predicament to Waller is a tactical advantage, one that Waller is convinced will give her the upper hand in her fight to save humankind.

Will Smith

DEADSHOT

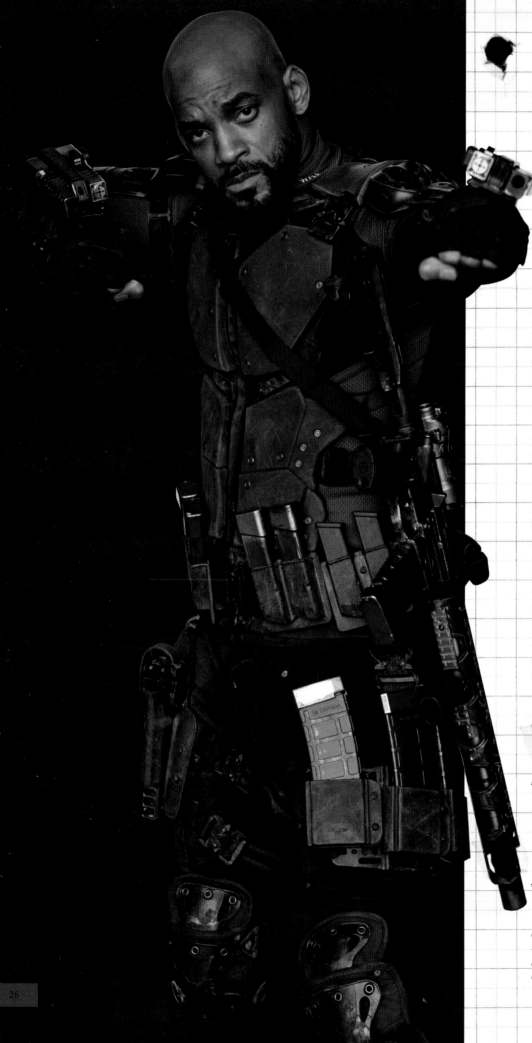

A S A CONTRACT KILLER, Deadshot is unmotivated by vengeance, passion, or even anger. Instead, he lives by a simple code: Do the job you're hired for at any cost—even when it comes at substantial risk to himself. He's the perfect recruit for Amanda Waller's Suicide Squad: a trained assassin who trusts no one and openly nurses a death wish. When Will Smith signed on to portray Deadshot, he found himself grappling with the very character traits that make Deadshot who he is. He explains, "I could not get my head around the idea of killing people for money."

It wasn't until Smith read *The Anatomy of Motive* by Mark Olshaker and legendary FBI profiler John Douglas that he began to unwrap Deadshot's emotional underpinnings. Smith says, "The question wasn't 'Why did he do it?' but 'Why does it feel good?'"

For Smith, character investigation comes first, the story second. "There was a huge amount of character prep for this movie," he says. "You know, we all got in a room together and we worked, probably for about a month. We would do scenes once in a while but it was really about diving in and understanding . . . the low self-esteem of these characters and how their low self-esteem drove them into the lives they've created for themselves." Smith's character analysis brought him full circle to Deadshot's childhood as Floyd Lawton. Lawton was born to a wealthy but ultimately tragic family. "Deadshot has a fantastic emotional side because of familial dynamics," says Producer Richard Suckle. He continues, "The Squad is a dysfunctional family that he attempts to make functional."

"I grew a lot as an actor playing Deadshot."

—Will Smith

OPPOSITE (FAR RIGHT): *Costume Designer Kate Hawley's illustration of Deadshot.*

OPPOSITE (TOP AND BOTTOM): *Hawley's early concept drawings of Deadshot's costumes.*

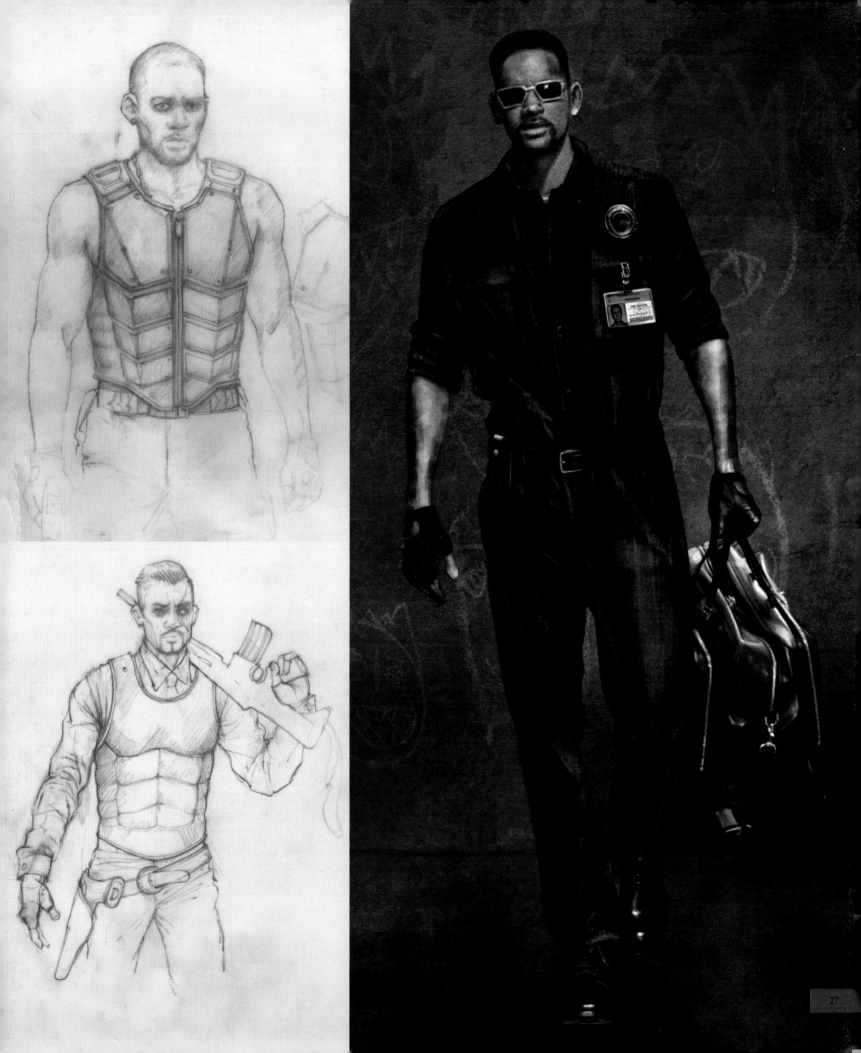

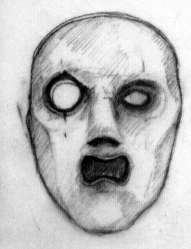

COSTUME DESIGNER Kate Hawley and Writer/Director David Ayer faithfully adapted Deadshot's costume from the comic book world albeit with a few twists. Hawley kept Deadshot's signature red color scheme in tact as well as his wrist-mounted firearms. When Deadshot was first created, he fancied a monocle, top hat, and tuxedo but that dapper look quickly evolved into a more badass version complete with bulletproof body gear and a metallic-looking contoured headpiece.

For the flashback to Deadshot's life in Gotham City, the coat Deadshot wears belonged to his father. It's a nice touch that audiences may never know—until now—but one that underscores Deadshot's dedication to his family.

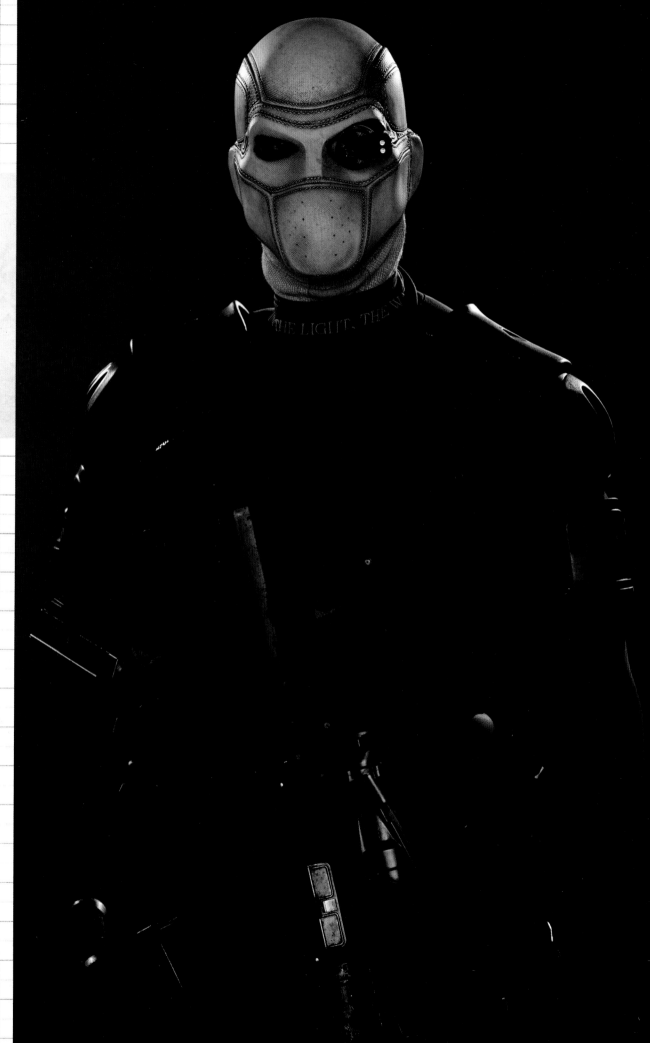

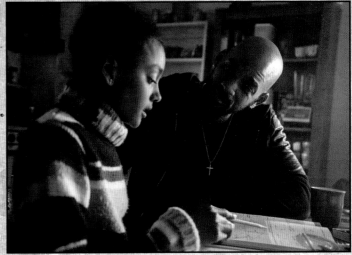

A FATHER'S LOVE

DEADSHOT'S REDEEMING QUALITY—his love for his daughter, Zoe, and his desire to do right by her—is also his Achilles' heel and makes him a compellingly flawed character. Being the leader of a gang of killers, crazies, and a man-eating crocodile means Deadshot isn't a perfect angel himself. But he can see the benefit of helping humankind. For her part, Zoe's sole power is the love she has for her father and that just might be enough for Deadshot to want save the world.

> ### "I know you do bad things. . . . I still love you."
>
> – Zoe

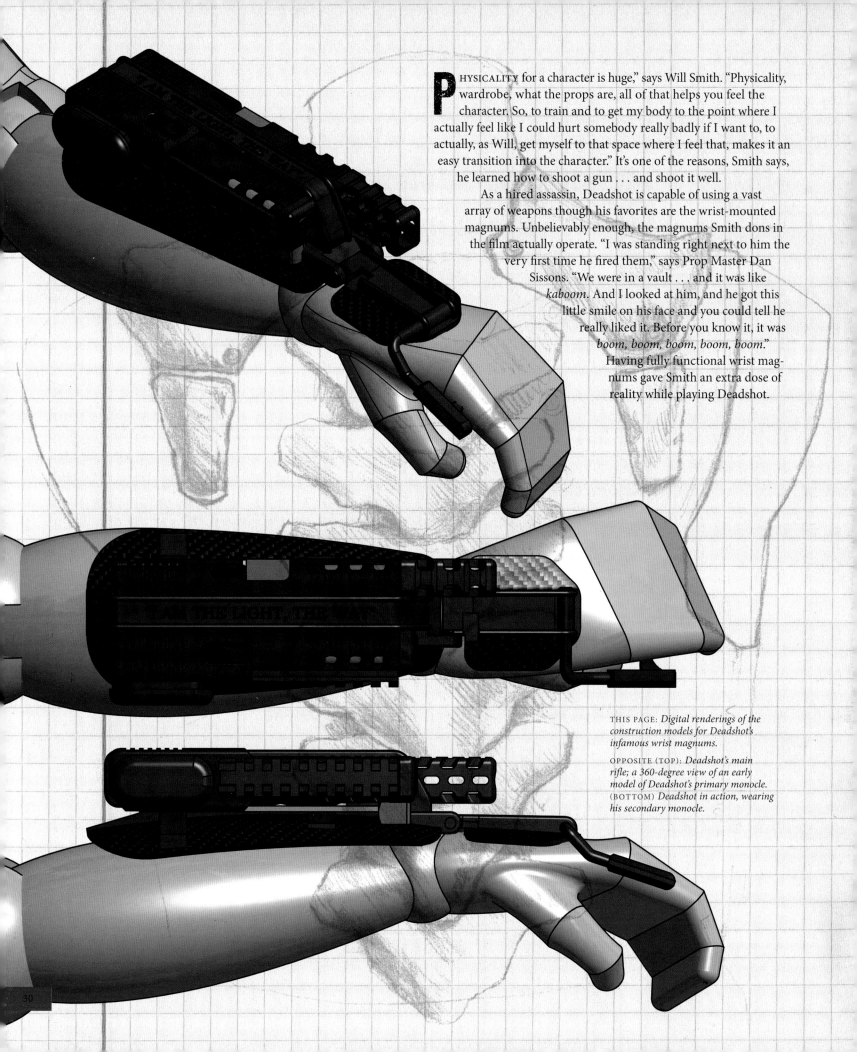

PHYSICALITY for a character is huge," says Will Smith. "Physicality, wardrobe, what the props are, all of that helps you feel the character. So, to train and to get my body to the point where I actually feel like I could hurt somebody really badly if I want to, to actually, as Will, get myself to that space where I feel that, makes it an easy transition into the character." It's one of the reasons, Smith says, he learned how to shoot a gun . . . and shoot it well.

As a hired assassin, Deadshot is capable of using a vast array of weapons though his favorites are the wrist-mounted magnums. Unbelievably enough, the magnums Smith dons in the film actually operate. "I was standing right next to him the very first time he fired them," says Prop Master Dan Sissons. "We were in a vault . . . and it was like *kaboom*. And I looked at him, and he got this little smile on his face and you could tell he really liked it. Before you know it, it was *boom, boom, boom, boom, boom.*" Having fully functional wrist magnums gave Smith an extra dose of reality while playing Deadshot.

THIS PAGE: *Digital renderings of the construction models for Deadshot's infamous wrist magnums.*

OPPOSITE (TOP): *Deadshot's main rifle; a 360-degree view of an early model of Deadshot's primary monocle.* (BOTTOM) *Deadshot in action, wearing his secondary monocle.*

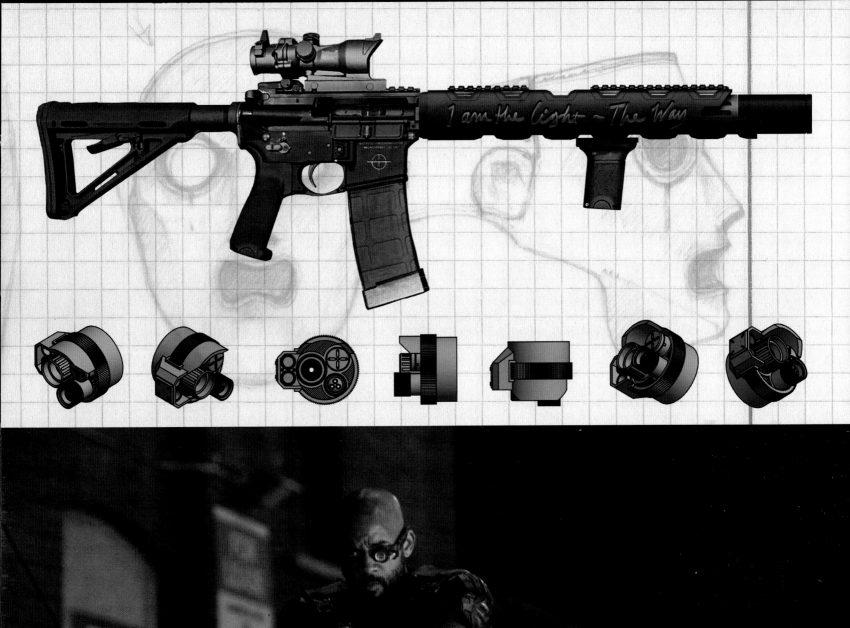

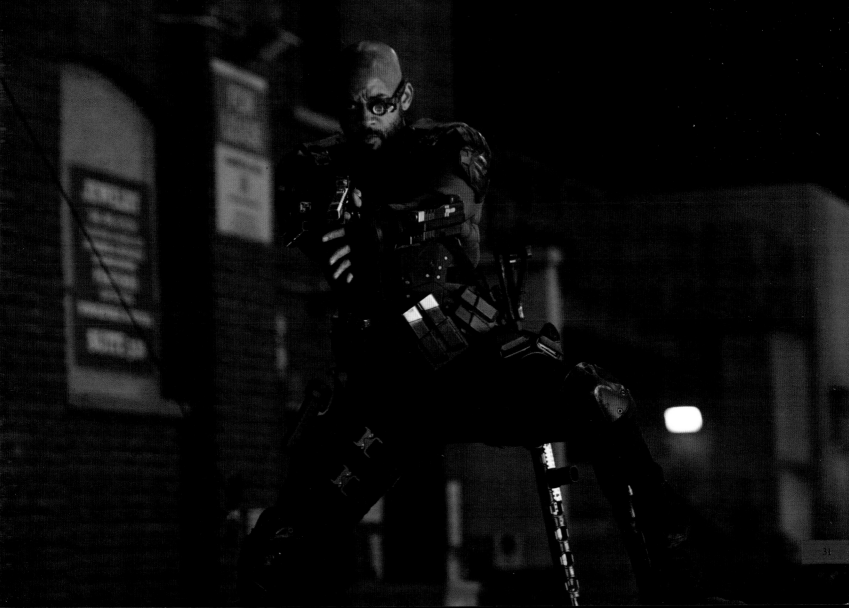

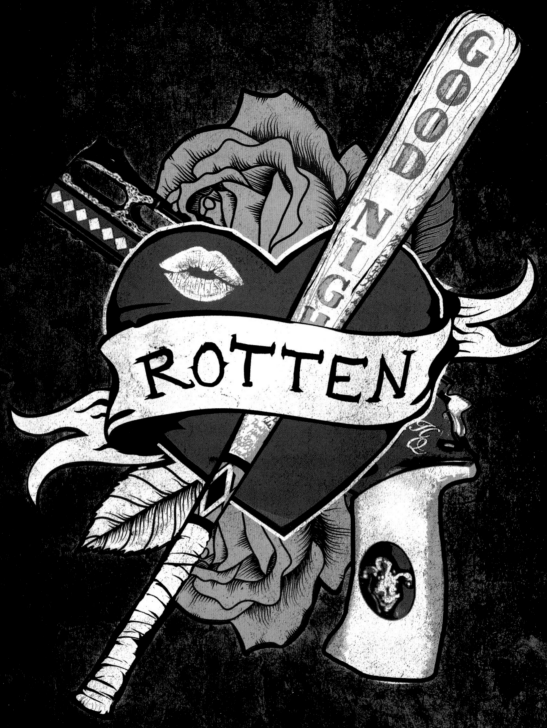

Margot Robbie

HarleyQuinn

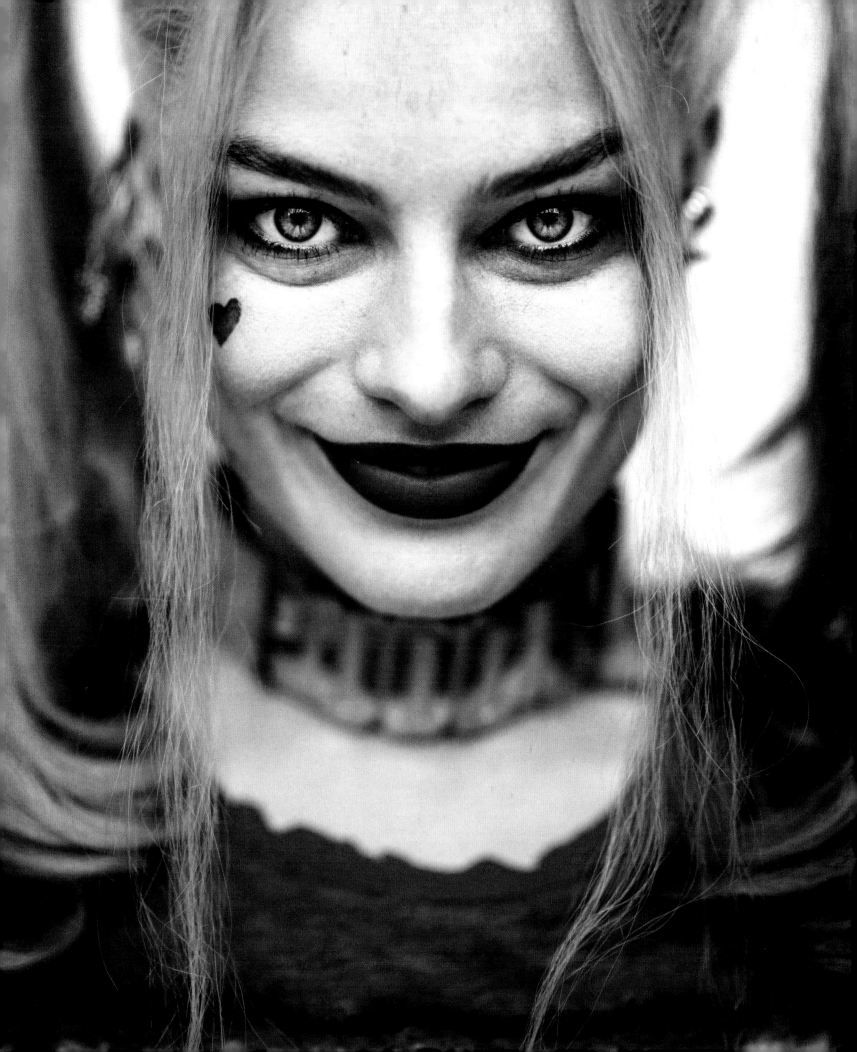

GOOD NIGHT

TROUBLEMAKER, PSYCHOTIC, and sexy as hell: Harley Quinn makes being bad look like good crazy fun. Harley Quinn's a woman few would dare cross. The fact that she's the Joker's girlfriend makes her all the more lethal . . . and insane. Harley Quinn was originally envisioned as a bit player in the feuding world of Batman and the Joker. Her quirky, unpredictable manner and unforgettable jester-inspired outfits endeared her to legions of fans, and she was quickly initiated into the canon of DC Comics as one of its most popular characters.

Australian actress Margot Robbie wasn't familiar with the Joker's mischievous sidekick. "I didn't read comic books growing up," she explains. When she was approached for the film, there was no script, no cast, and no crew, and yet Robbie leapt into the project with zero trepidation. Robbie's outrageously mad and unflinching portrayal of Harley Quinn reflects the actress's own sense of fearlessness. In order to truly understand the villain behind the bubblegum pink and berry blue pigtails, Robbie did her homework and started reading *Suicide Squad* comic books. "About three comics in," she says, "I was obsessed with her—as everyone is. . . . People really like how flawed she is."

Those flaws, however, revealed deeper fissures within Harley Quinn's psychological makeup, and Robbie genuinely struggled to figure out the relationship between Harley and Mr. J. How could such a strong, wickedly funny, and all-around badass of a woman fall to pieces over the Joker. "Once I started thinking of her relationship with the Joker as a compulsion or an addiction, I had a world of empathy for her," Robbie says.

Though mental preparation took up a significant chunk of time during the six months of pre-production, Robbie also trained like an elite athlete. Personal training every day. Gymnastics, jiujitsu, and shooting practice at the gun range every other day. She says, "I was already exhausted by the job before we started shooting." Stunt double Ingrid Kleining had previously worked with Robbie on *Tarzan* so the two women were already in sync with each other. Robbie, however, did the majority of her own stunts, including an action-packed underwater scene.

Robbie was the last cast member to wrap on the film. When filming ended, Robbie admits that she was saddened to leave. She says, "The Squad was something else. The Squad on-screen was really cool. The Squad off-screen, I've never seen anything like it."

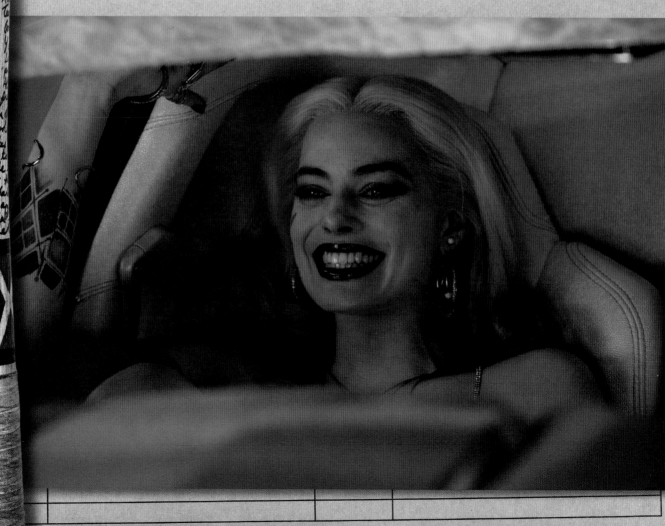

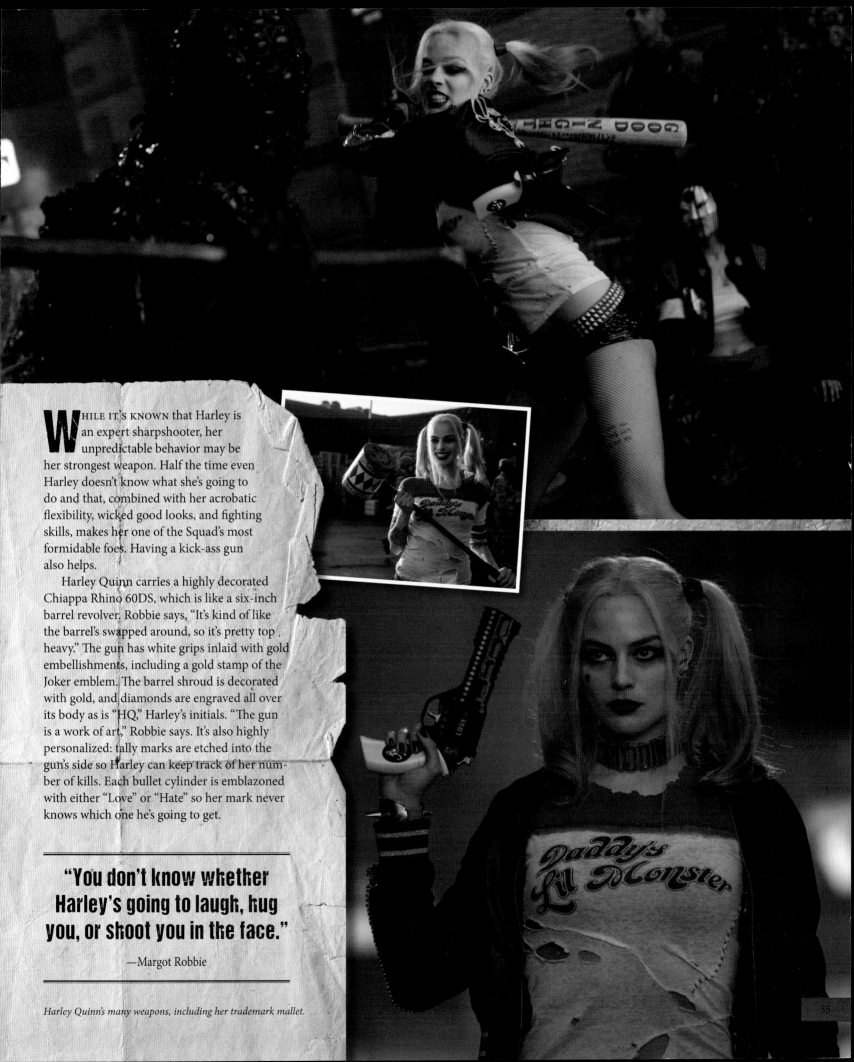

W HILE IT'S KNOWN that Harley is an expert sharpshooter, her unpredictable behavior may be her strongest weapon. Half the time even Harley doesn't know what she's going to do and that, combined with her acrobatic flexibility, wicked good looks, and fighting skills, makes her one of the Squad's most formidable foes. Having a kick-ass gun also helps.

Harley Quinn carries a highly decorated Chiappa Rhino 60DS, which is like a six-inch barrel revolver. Robbie says, "It's kind of like the barrel's swapped around, so it's pretty top heavy." The gun has white grips inlaid with gold embellishments, including a gold stamp of the Joker emblem. The barrel shroud is decorated with gold, and diamonds are engraved all over its body as is "HQ," Harley's initials. "The gun is a work of art," Robbie says. It's also highly personalized: tally marks are etched into the gun's side so Harley can keep track of her number of kills. Each bullet cylinder is emblazoned with either "Love" or "Hate" so her mark never knows which one he's going to get.

"You don't know whether Harley's going to laugh, hug you, or shoot you in the face."

—Margot Robbie

Harley Quinn's many weapons, including her trademark mallet.

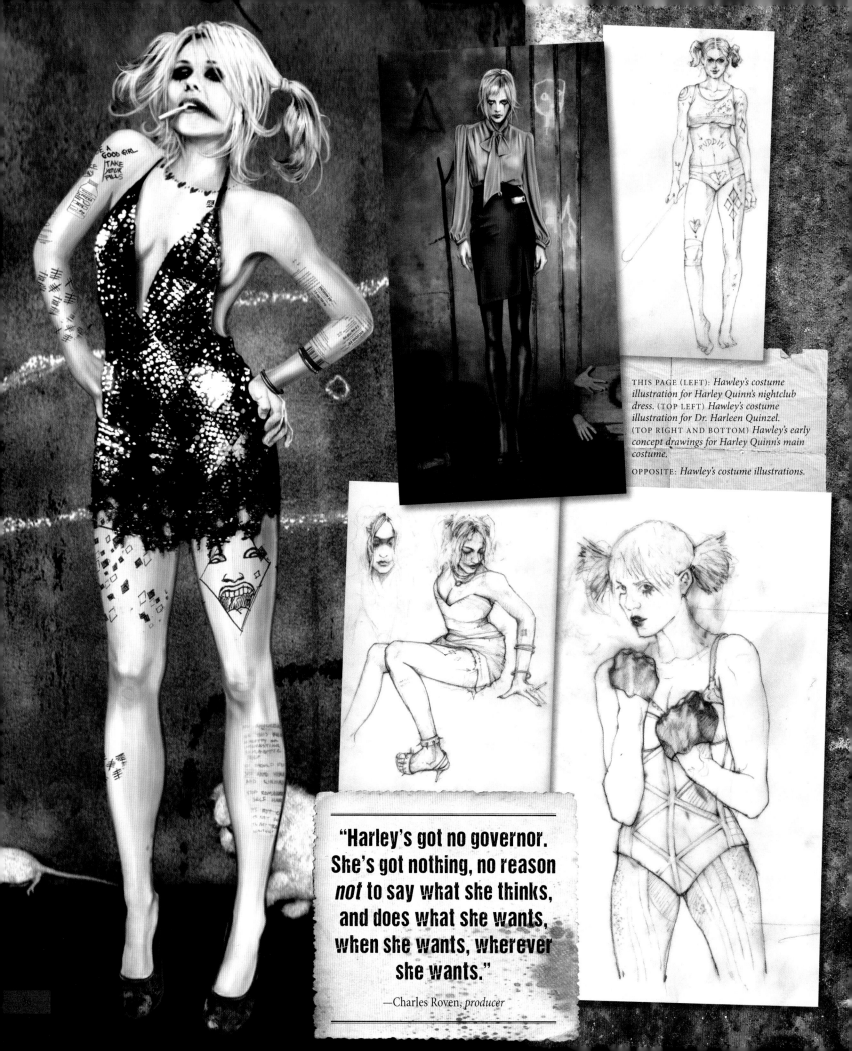

THIS PAGE (LEFT): *Hawley's costume illustration for Harley Quinn's nightclub dress.* (TOP LEFT) *Hawley's costume illustration for Dr. Harleen Quinzel.* (TOP RIGHT AND BOTTOM) *Hawley's early concept drawings for Harley Quinn's main costume.*

OPPOSITE: *Hawley's costume illustrations.*

"Harley's got no governor. She's got nothing, no reason *not* to say what she thinks, and does what she wants, when she wants, wherever she wants."

—Charles Roven, *producer*

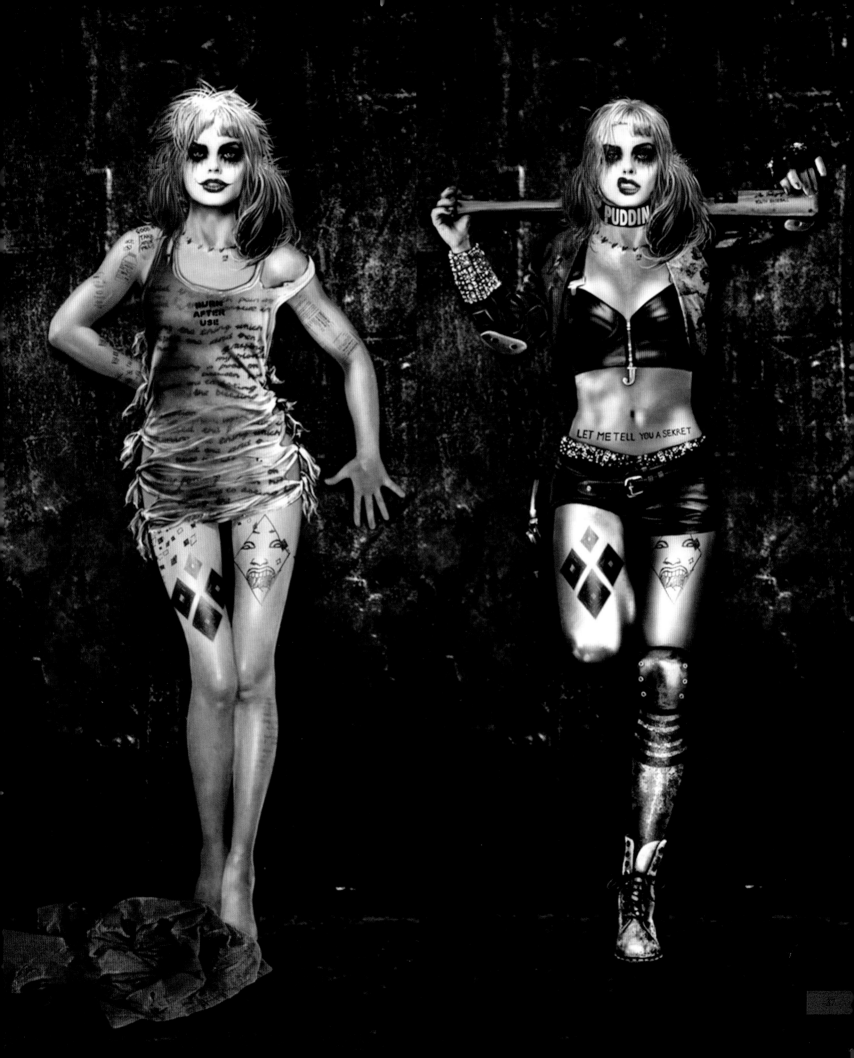

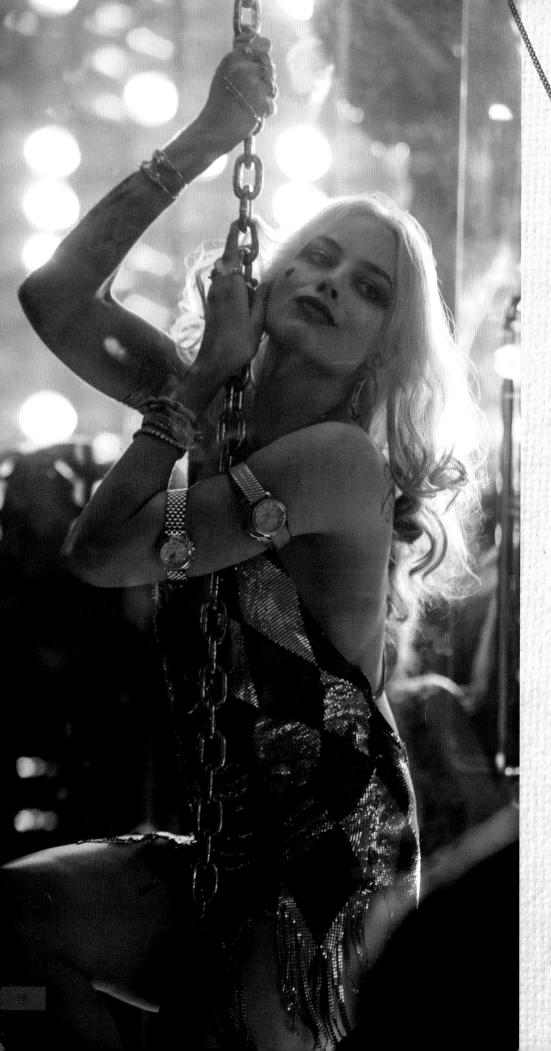

IN THE COMIC BOOKS, Harley Quinn started out decked out in red and black, a jester's hat perched on her head. Complete with gold bling, pink-and-blue hair, short shorts, tattoos, and high-heeled sneakers, Ayer's Harley is a more modern version. She wears a satin jacket, the back of which reads "Property of the Joker." With the word "Rotten" tattooed across her face, Harley's appearance is anything but sweet.

Makeup and hair was a daily three-hour process. First Robbie's body was painted white from head to toe. "Then there were twenty tattoos to put on," she says. And cuts and bruises depending on the daily sequence of filming. Harley's face makeup isn't perfectly applied—her eyeliner is smudged; the lipstick looks hastily applied—and that's because Harley's character herself isn't perfect. Her tattoos are mainly displayed on one side of her body because Harley's not a well-balanced person, and Makeup and Hair Designer Alessandro Bertolazzi wanted the physical manifestation of her character to accurately portray her out-of-whack mental and emotional state. Robbie says that the time spent on physically transforming her into Harley was the best way for her to get into character. Once she looked like Harley, she felt like Harley too.

> "I walked on set and saw everyone, and realized I wasn't the only crazy character. Everyone was nuts. Everyone looked so wicked, just insane and cool and dirty and grungy. I was, like, this is the Squad!"
>
> —Margot Robbie

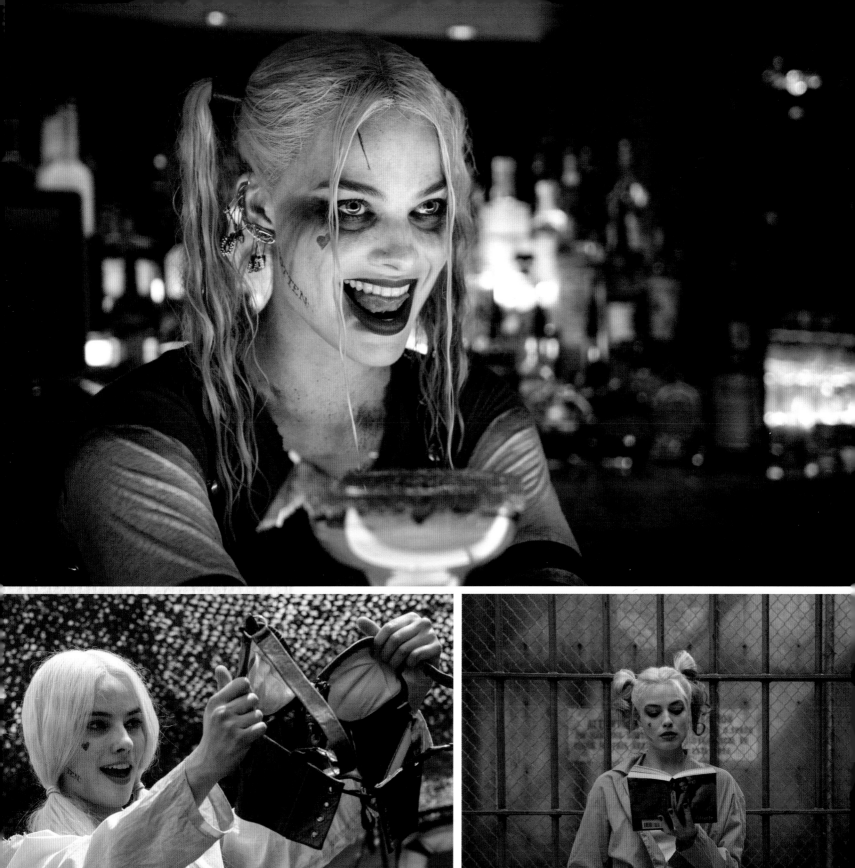
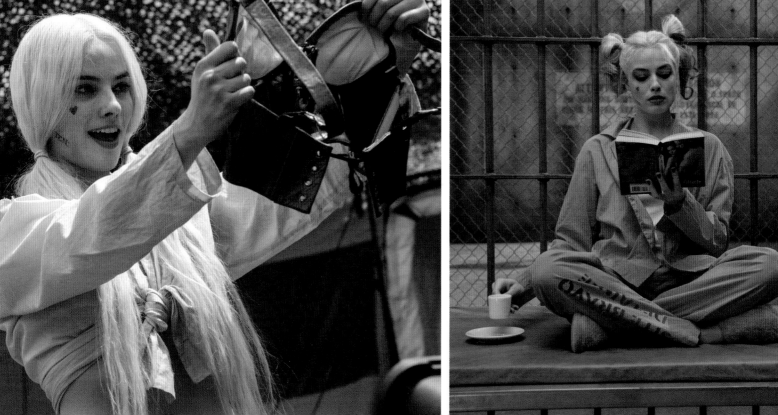

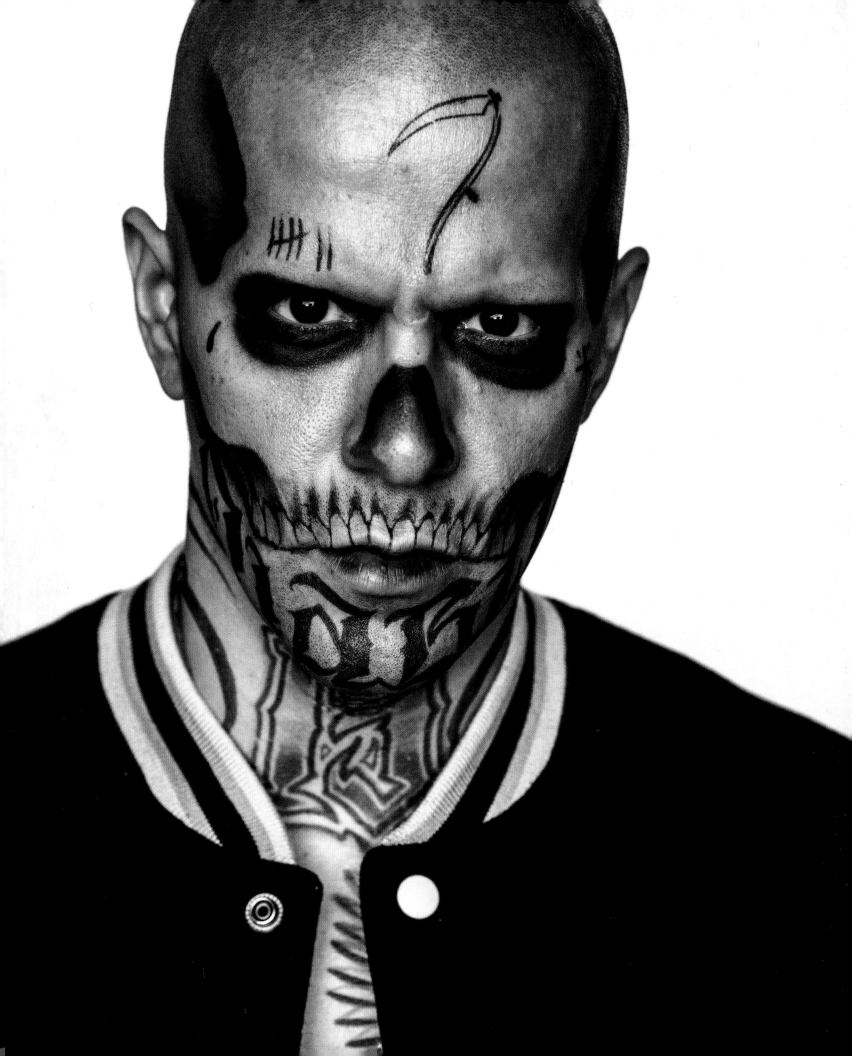

Jay Hernandez

DIABLO

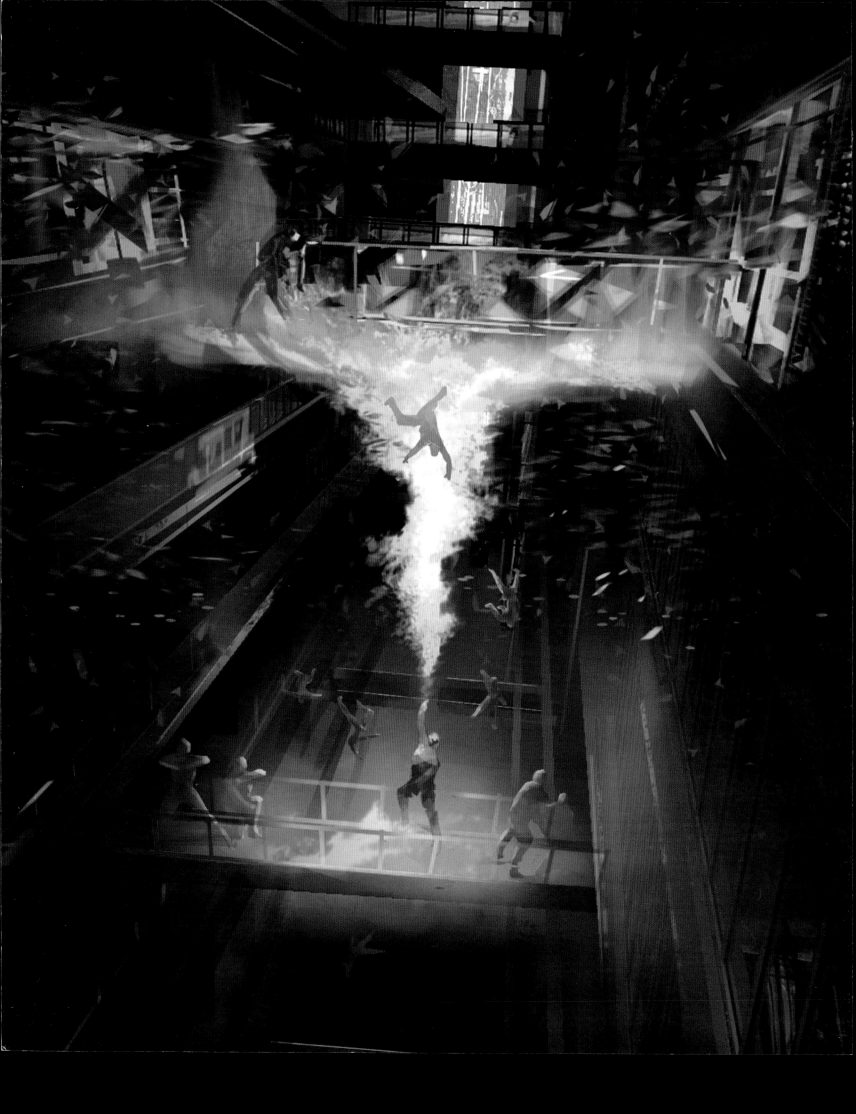

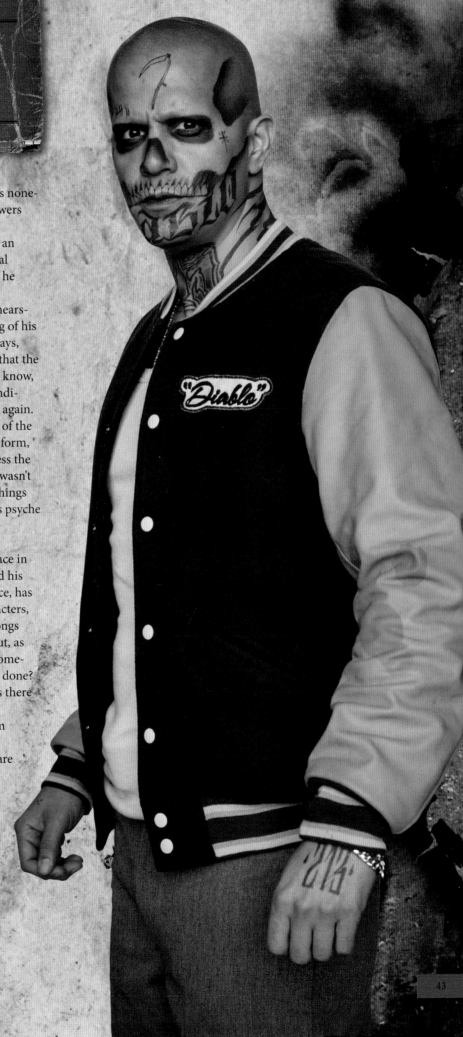

A S A RELATIVELY NEW CHARACTER to DC Comics, Diablo has none-theless become an instant fan favorite. With pyrokinetic powers that border on the supernatural, Diablo is a larger-than-life tough-looking gangster. When unleashed, his power is an intense fireball explosion of rage. Much of the character's internal struggle is about Diablo coming to terms with his power so that he controls it and not the other way around.

Jay Hernandez spent the month before shooting in heavy rehears-als, exploring and mining each scene for a deeper understanding of his character. "When something was thrown at you on the set," he says, "you'd essentially be prepared for anything." Hernandez admits that the rehearsal period felt like boot camp. He elaborates, saying, "You know, the process of boot camp is to mentally, psychologically break indi-viduals down to their base components and then build them up again. And that was a bit of what Ayer's process was like." While much of the rehearsal period was spent getting the actors into peak physical form, another part was getting them to mentally and emotionally access the humanity of their individual characters. In Hernandez's case, it wasn't enough to don the costume, hide behind the tattoos, and light things on fire. Ayer wanted Hernandez to have a firm grasp on Diablo's psyche too, and that meant the actor was forced to shine a light on some dark and scary places.

When the audience first encounters Diablo, he's in a dark place in his life. Unable to control his rage, his superpower has destroyed his family. He's essentially given up on himself and, as a consequence, has backed away from crime and aggression. Unlike the other characters, Diablo has no desire to fight. On the contrary, he thinks he belongs in a cage, somewhere his power—his evil—can be contained. But, as Hernandez explains, "there's a greater narrative at play. When some-body makes a misstep along their journey through life, are they done? Should they be locked up and thrown away and forgotten? Or is there room for redemption?" It's only when Diablo comes to see the Squad as his new family that he understands it's possible for him to redirect his energy and do good with his power.

Prison tattoos rage across Diablo's body like wildfire. Some are small and homemade while others fill the width of his muscu-lar back. Despite their variety, one thing's for certain: they forecast the fact that Diablo is a man who shouldn't be crossed. "At first," Hernandez says, "I only had a few tattoos, and then they started to grow and then they got bigger." And pretty soon, they covered the actor's entire body. To complete the look, Hernandez shaved his head and his eyebrows. In full costume and makeup, the actor admits, he was terrifying looking. "Out of makeup," he says, "I looked strange. In makeup, I looked scary."

OPPOSITE: *Early concept art of the battle in the Federal Building.*

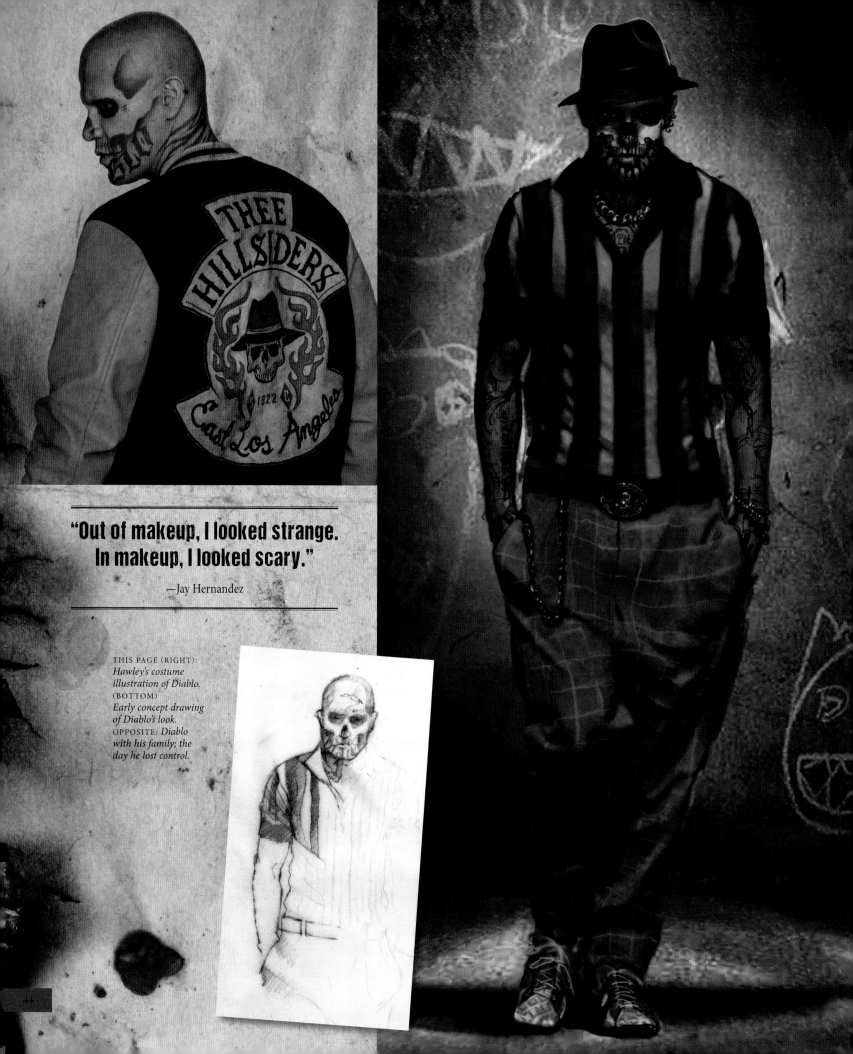

"Out of makeup, I looked strange.
In makeup, I looked scary."

—Jay Hernandez

THIS PAGE (RIGHT):
*Hawley's costume
illustration of Diablo.*
(BOTTOM)
*Early concept drawing
of Diablo's look.*
OPPOSITE: *Diablo
with his family; the
day he lost control.*

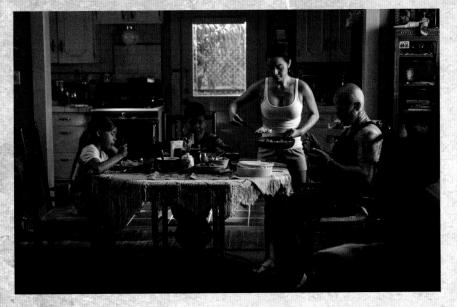

FIRE'S FURY

IABLO HAS NEVER BEEN ABLE to forgive himself for unwittingly killing his family with his pyrokinetic power. When he reveals his heinous and regrettable crime to his fellow Squad members, his confession marks a turning point for the character. Writer/Director David Ayer says, "He did something horrible but it changed him for the better. . . . He's on a path of healing and peace."

Diablo's new path of understanding and acceptance helps bring him into the fold with the rest of the gang, and he commits himself fully to their mission. If he can't have total redemption, the least he can do is put his powers to good use.

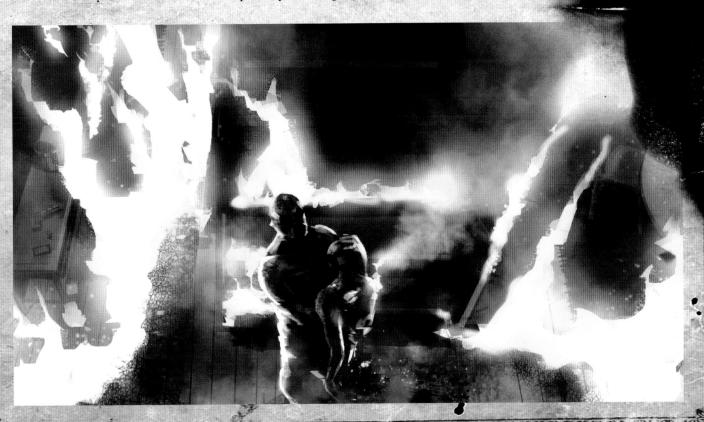

45

For the bulk of the film, Hernandez was forced to stand in the shadows while the other actors swirled around him, perfecting their stunts and aim. Hernandez sought an uneasy balance between restraint and explosive action. Watch closely: because his character is so reserved, he's building all the time—a slow burn. When Hernandez finally lets loose and shows the audience what he's capable of, it's literally a jaw-dropping fireball, the strength of which threatens the enemy to the core.

During pre-production, Hernandez honed his Shaolin Kempo Karate skills and trained with the rest of the cast for several hours each day. Being a karate master is one thing. A pyrokinetic fire-starting gangster is another. Luckily, the special effects crew made it seem as easy as lighting

> ## "I'm a man, not a weapon."
> —Diablo

a match. The team employed several techniques to make Diablo's fire look as natural as possible. "Sometimes there would literally be an LED light—a point of reference—for me to focus on," Hernandez says. Visual effects would then be layered in afterward. A massive explosion near the end of the film required approximately fifty stuntmen and a flame-thrower that shot fire thirty feet into the air.

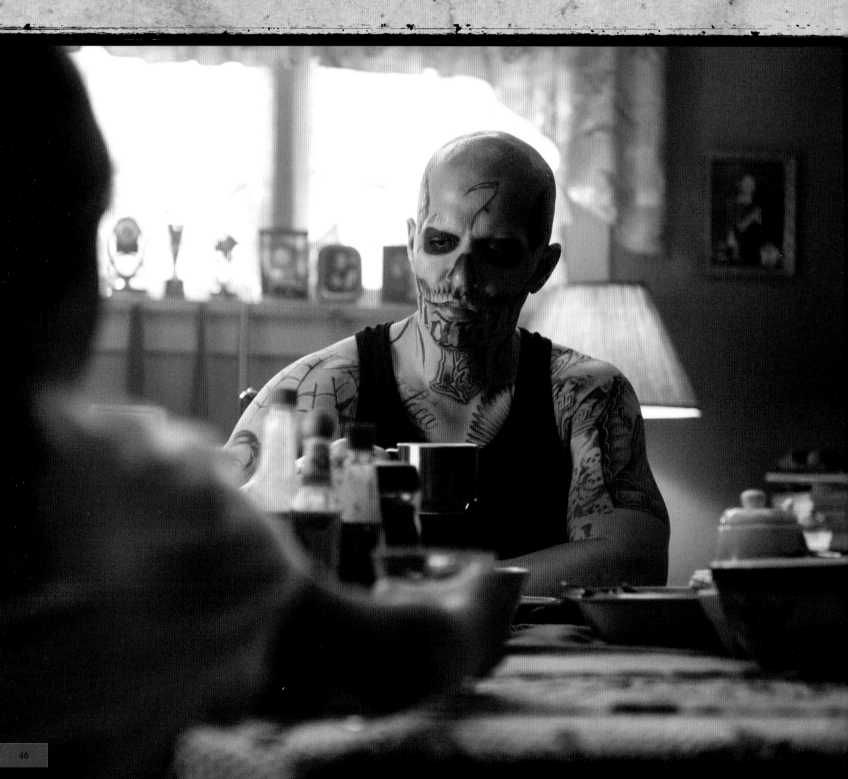

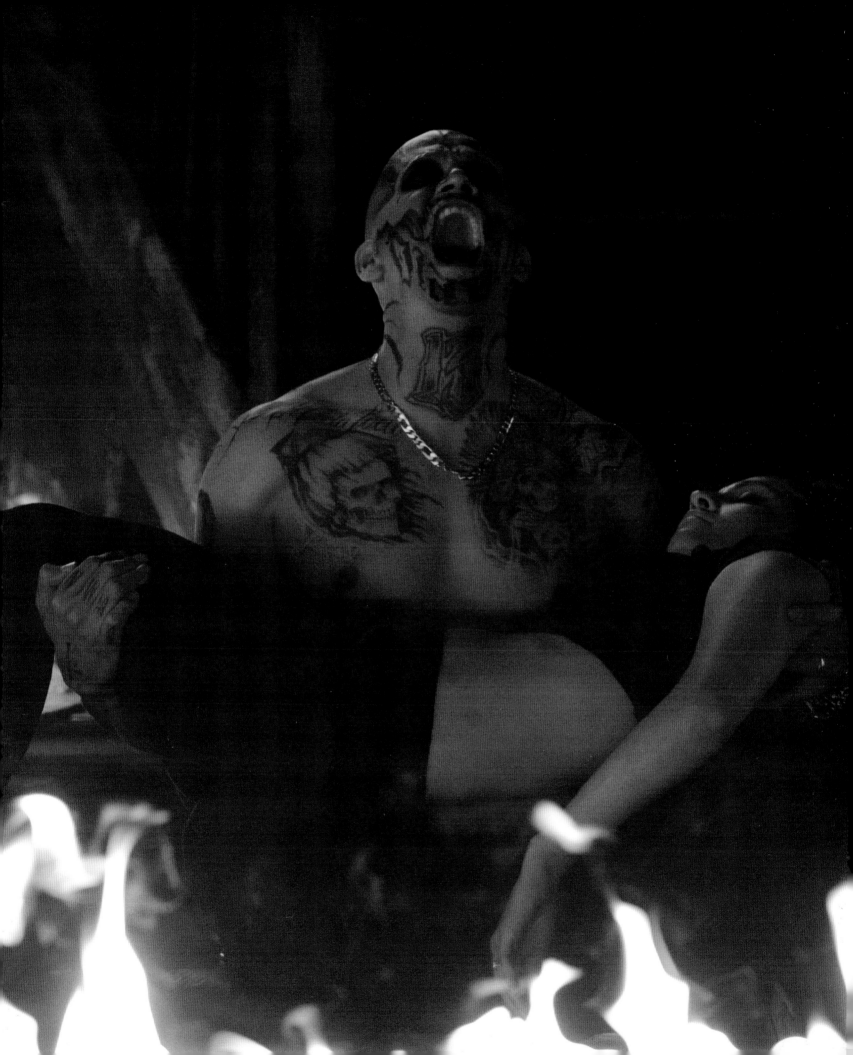

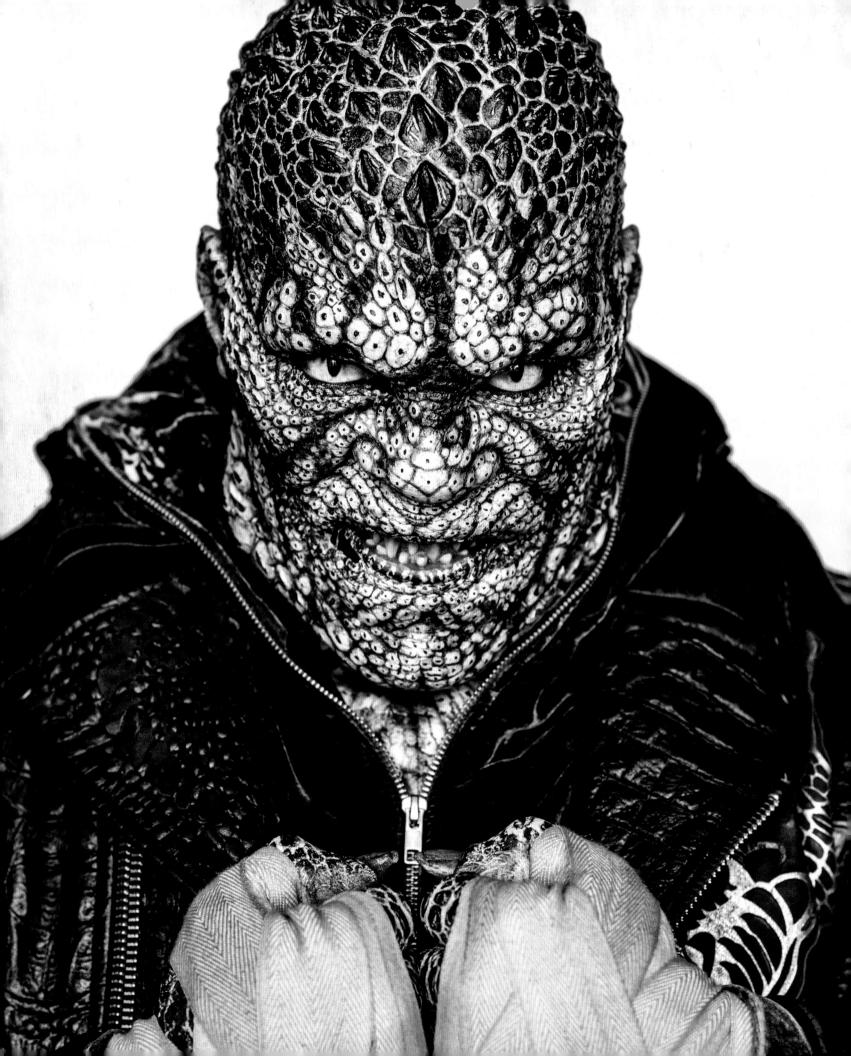

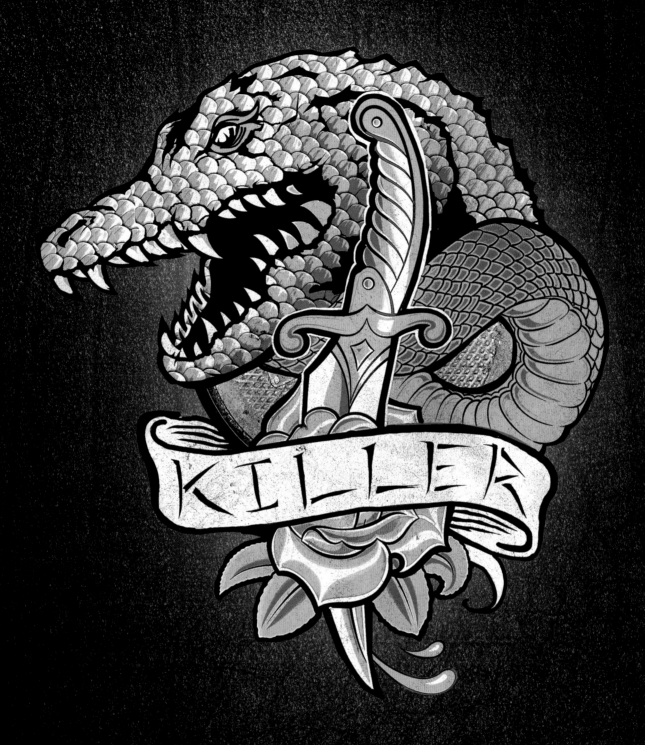

Adewale Akinnuoye-Agbaje

BORN WITH A FORM OF ATAVISM that gave him reptilian traits and raised by an abusive aunt who tried to rub the scales from his body, Waylon Jones/Croc didn't have an easy childhood. As a teenager, his deformity forced Jones into a life of crime as a recluse. It's only when a neighbor confronts him saying, "You can either run from this or you can embrace it" that Jones understands what he has to do to survive. "He starts to own the scales," says actor Adewale Akinnuoye-Agbaje. Croc has carnal urges along with superhuman strength, agility, and stamina. Quickly rising to the top of the criminal underworld, he becomes one of Batman's most formidable foes.

While there have been many iterations of Croc, *Suicide Squad* marks the first big-screen appearance of the carnivorous criminal. To prepare for the role, Akinnuoye-Agbaje withstood a rigorous six-week rehearsal schedule complete with grueling workout and fight training sessions: one hour each morning was spent weight lifting followed by an hour of fight training with the stunt crew and fight choreographer, and then heavy treadmill running. Akinnuoye-Agbaje says that the intensity was "more akin to working in theater. . . . Everyone spurred each other on until we collapsed together; that rigorous training schedule is what bonded the group together as a squad." It also helped the actor prepare for principal photography. When it came time to film, however, Akinnuoye-Agbaje stayed away from his castmates as much as possible until he arrived on set. That sense of wariness and distance, Akinnuoye-Agbaje says, "created an eeriness about him [Croc] because you didn't know if he would bite your arm off at any moment."

For David Ayer, Croc is one of the film's most fascinating characters. He says, "He's very frightening, terrifying. A big guy. But . . . there's a tenderness to him. He's surprisingly empathetic." Equally at home holding court as one of Gotham City's preeminent criminal kingpins or performing in a traveling circus show—as he did for years before assuming his nefarious identity—Croc is used to working on his own and outside convention. At heart, Croc is a solitary-minded creature who relies on his instincts for survival and rarely takes the time to plan or rationalize his actions. Despite these character traits, the role itself required just the opposite: tons of preparation, planning, and teamwork. Akinnuoye-Agbaje acknowledges that he had an amazing group of people supporting him. "It was one of those gigs where you had to be very prepared going in. And the more preparation I did, the smoother the journey became," he said.

> ## "He's a gentle giant who happens to eat people."
>
> —David Ayer, *writer/director*

THIS PAGE: *Film still of Croc preparing for battle.*

OPPOSITE: *Hawley's early concept drawing of Croc.*

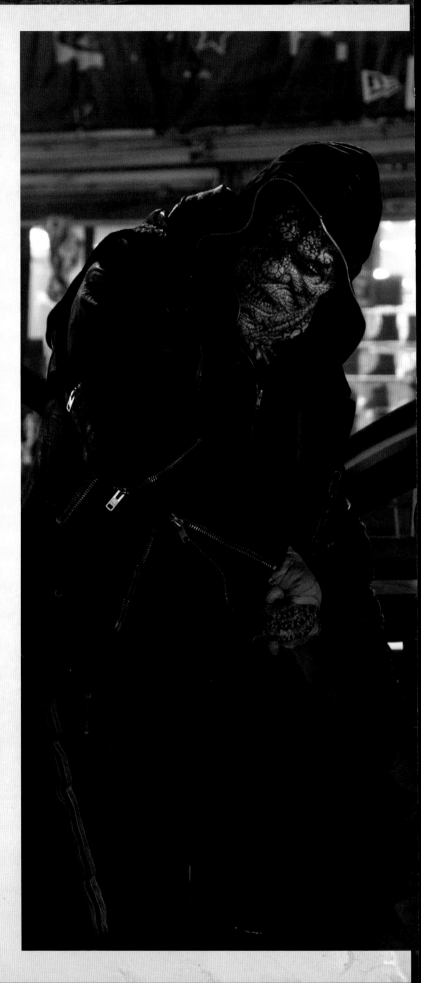

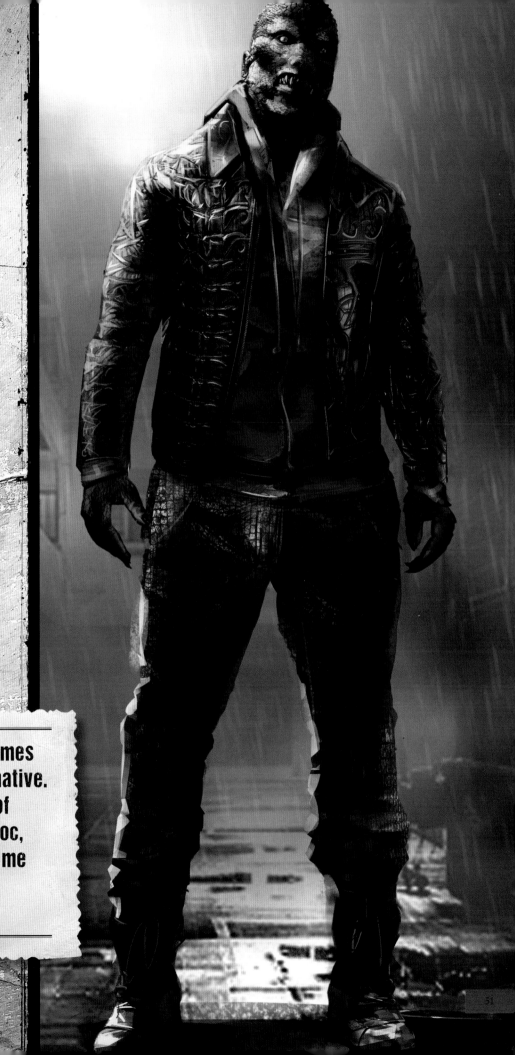

ORIGINALLY DRAWN as a powerfully built man covered in green scales, Croc's appearance has varied throughout the years. In recent years, he's assumed a more bestial comic book look, complete with elongated snout and tail. Writer/Director David Ayer had a fairly precise idea of what he wanted Croc to look like, but his appearance evolved as the cast and crew moved closer to principal photography. Above all else, Ayer sought to root the *Suicide Squad* in reality. So rather than having Croc appear as a crocodile-turned-human, his features and coloring appear to have the quality of being a skin affliction. The makeup team worked with Akinnuoye-Agbaje's own skin tone and incorporated browns, beiges, and tonal greens. This organic approach helped Akinnuoye-Agbaje internalize the character: the audience can see that Croc is human but that a creature lurks beneath.

During the rehearsal period, Akinnuoye-Agbaje performed and trained without the aid of the character prosthetics that would later help define the physical traits of Croc. Akinnuoye-Agbaje trained for three hours daily under two inches of foam, tons of makeup, prosthetics, and while wearing a forty-pound jacket. Makeup application alone took five hours. A days' worth of shooting is a minimum of thirteen hours and required Akinnuoye-Agbaje to function at peak physical fitness around the clock. The prosthetics team created one-of-a-kind cooling suits that Akinnuoye-Agbaje wore under some of the prosthetics. These suits helped regulate the actor's body temperature: if he began to overheat, the suits shot ice-cold water all over his body.

> "The day we put on our costumes was amazing. It was transformative. When they put that layer of skin on Adewale as Killer Croc, you're like, that guy will eat me for real, you know?"
>
> —Adam Beach, *Slipknot*

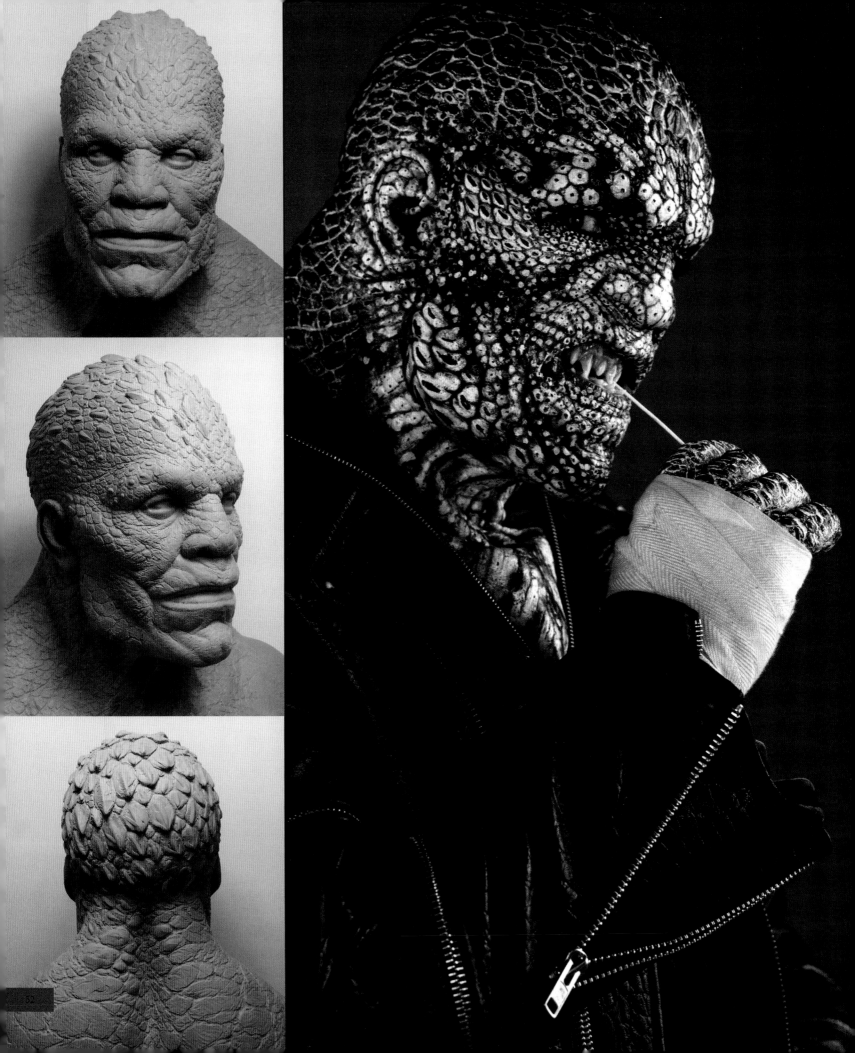

FIGHT CHOREOGRAPHERS developed specific techniques that allowed Akinnuoye-Agbaje to work within the physical constraints of his makeup and costume, and incorporated the movements actual crocodiles display when hunting their prey. The "croc roll," for example, is a fighting move that mimics the way a crocodile snaps its jaws shut on prey, drags it into water, and uses its own body weight to roll over and drown the victim. The "croc sandwich": Croc punches with two fists and snaps off the head of his victim. Even the "croc rock"—Croc's lighthearted attempt at dancing—resembles a crocodile moving through water. Akinnuoye-Agbaje watched footage of crocodiles before every take and it shows.

Akinnuoye-Agbaje had the additional challenge of having to work in water. An underwater fight sequence was filmed approximately twelve hours a day for four or five days. The underwater sequence was particularly trying for Akinnuoye-Agbaje, and put his fitness level to the test. For fans, though, the best part of seeing Croc in water is when he throws off his shirt and jacket. Fully submerged and saving the day, we see him—finally—as he really is: a hero.

THIS PAGE (TOP): *Storyboard for underwater scene.* (BOTTOM) *Concept art of the underwater scene.*

OPPOSITE (FAR LEFT): *Croc's molded prosthetics. The team custom-made prosthetics fitted to actor Akinnuoye-Agbaje's face.*

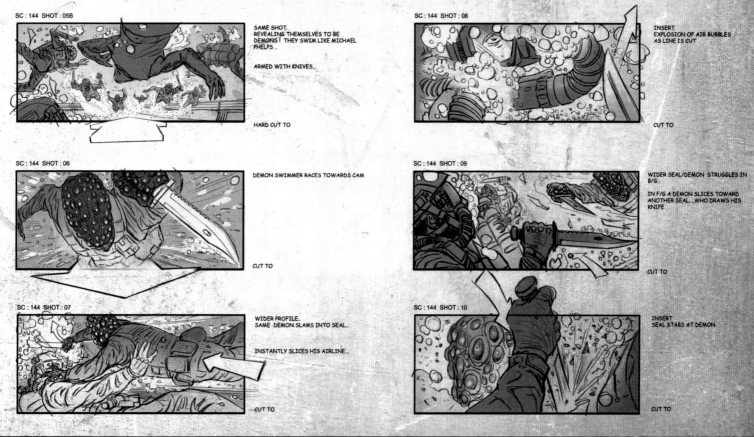

SC : 144 SHOT : 05B

SAME SHOT
REVEALING THEMSELVES TO BE
DEMONS ! THEY SWIM LIKE MICHAEL
PHELPS ..

ARMED WITH KNIVES...

HARD CUT TO

SC : 144 SHOT : 06

DEMON SWIMMER RACES TOWARDS CAM

CUT TO

SC : 144 SHOT : 07

WIDER PROFILE..
SAME DEMON SLAMS INTO SEAL..

INSTANTLY SLICES HIS AIRLINE..

CUT TO ..

SC : 144 SHOT : 08

INSERT
EXPLOSION OF AIR BUBBLES
AS LINE IS CUT

CUT TO

SC : 144 SHOT : 09

WIDER SEAL/DEMON STRUGGLES IN
B/G..

IN F/G A DEMON SLICES TOWARD
ANOTHER SEAL...WHO DRAWS HIS
KNIFE

CUT TO

SC : 144 SHOT : 10

INSERT
SEAL STABS AT DEMON

CUT TO

Jai Courtney

BOOMERANG

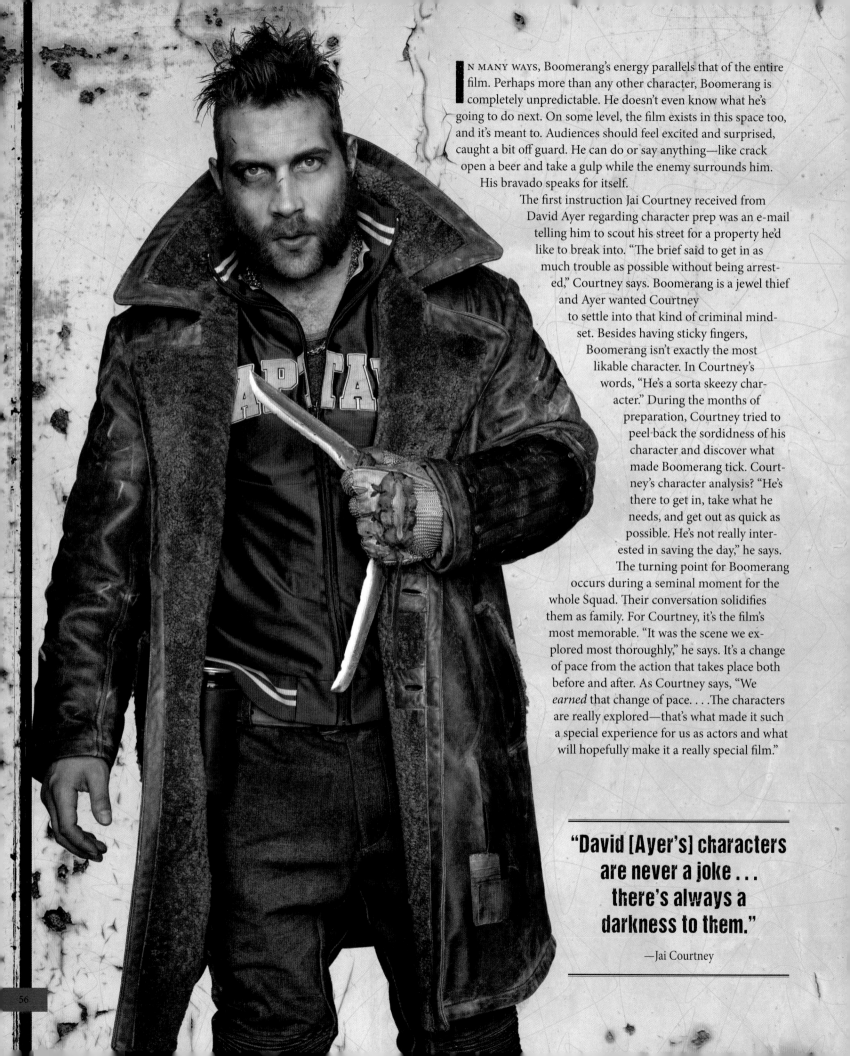

I N MANY WAYS, Boomerang's energy parallels that of the entire film. Perhaps more than any other character, Boomerang is completely unpredictable. He doesn't even know what he's going to do next. On some level, the film exists in this space too, and it's meant to. Audiences should feel excited and surprised, caught a bit off guard. He can do or say anything—like crack open a beer and take a gulp while the enemy surrounds him. His bravado speaks for itself.

The first instruction Jai Courtney received from David Ayer regarding character prep was an e-mail telling him to scout his street for a property he'd like to break into. "The brief said to get in as much trouble as possible without being arrested," Courtney says. Boomerang is a jewel thief and Ayer wanted Courtney to settle into that kind of criminal mindset. Besides having sticky fingers, Boomerang isn't exactly the most likable character. In Courtney's words, "He's a sorta skeezy character." During the months of preparation, Courtney tried to peel back the sordidness of his character and discover what made Boomerang tick. Courtney's character analysis? "He's there to get in, take what he needs, and get out as quick as possible. He's not really interested in saving the day," he says. The turning point for Boomerang occurs during a seminal moment for the whole Squad. Their conversation solidifies them as family. For Courtney, it's the film's most memorable. "It was the scene we explored most thoroughly," he says. It's a change of pace from the action that takes place both before and after. As Courtney says, "We *earned* that change of pace. . . .The characters are really explored—that's what made it such a special experience for us as actors and what will hopefully make it a really special film."

> ## "David [Ayer's] characters are never a joke . . . there's always a darkness to them."
>
> —Jai Courtney

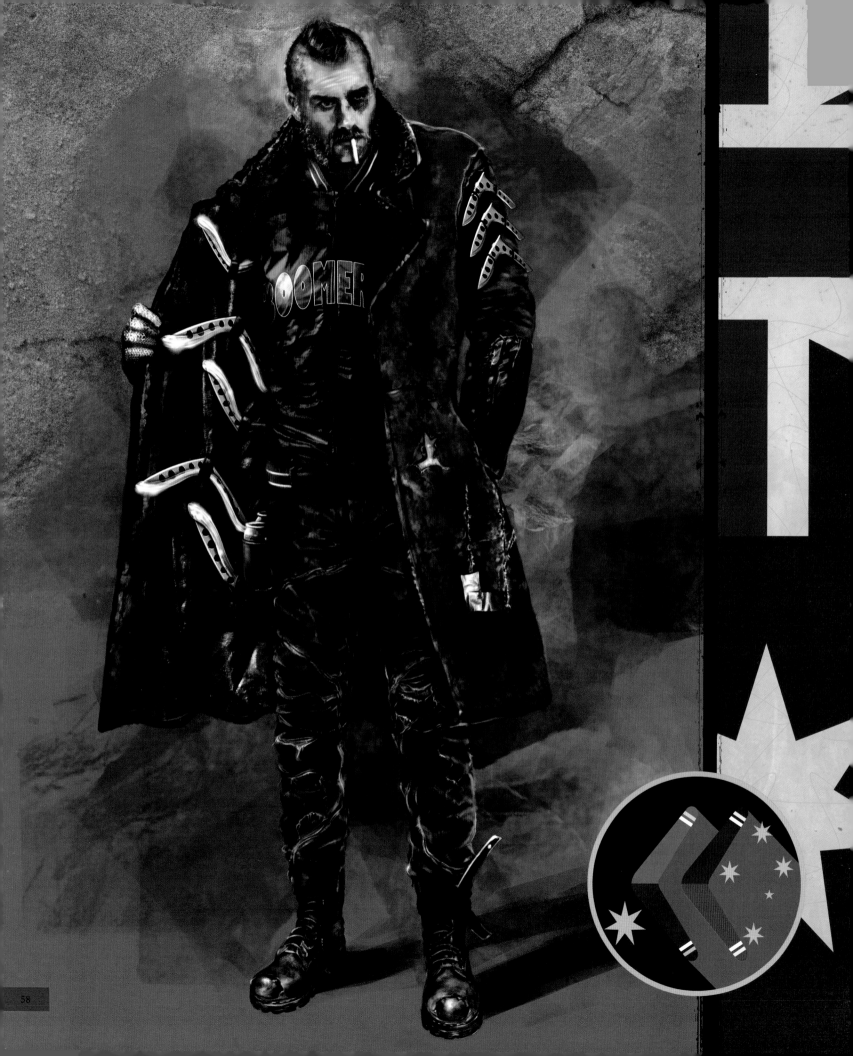

FOR A CHARACTER's costume to look authentic, it's essential that it look worn in, and that those costumes represent characters' lives off-screen. Boomerang wouldn't be caught dead in a department store shopping for undershirts, for example. Costume Designer Kate Hawley asks, "How do these characters make their clothes? It's not like they've got a trust fund and can go out and get a nice outfit. Boomerang has a chain-mail glove made from a butcher's glove and a redesigned kind of baseball glove to catch the boomerangs."

BOOMERANG's CHARACTER evolved significantly from pre-production to filming. When Prop Master Dan Sissons designed the boomerangs, he had no idea how rough-and-tumble the character would become. "So his boomerangs were actually sophisticated and smooth and shiny and quite nice," Sissons says. A problem, however, arose with the design of Boomerang's knife. Initially the team wanted a beautiful hook-shaped knife. The team soon realized, however,

that Boomerang was the kind of man who would never throw away something, least of all a boomerang. Instead, he would throw one, it would hit something, get chipped or cracked, and return to him. His knife should be the same. "Basically what we did," Sissons says, "is we fashioned two hand-to-hand knives that are boomerang shaped and are all beat up and chipped and worn and have an amazing patina to them." The handle is wrapped in military paracord so he could have a good hold on them. Courtney loved the knives so much that they became an integral part of the film's character. What was originally just an idea—maybe he should have a knife—turned into iconic weapons that helped define Boomerang's overall aesthetic.

THIS PAGE: *Boomerang's case of weapons. In order, front to back: droid boomerang, throwing boomerang, explosive boomerang, hand-to-hand combat boomerangs.*

OPPOSITE (FAR LEFT): *Hawley's costume illustration for Boomerang.* (BELOW AND OPPOSITE FAR RIGHT) *Boomerang's costume patches.*

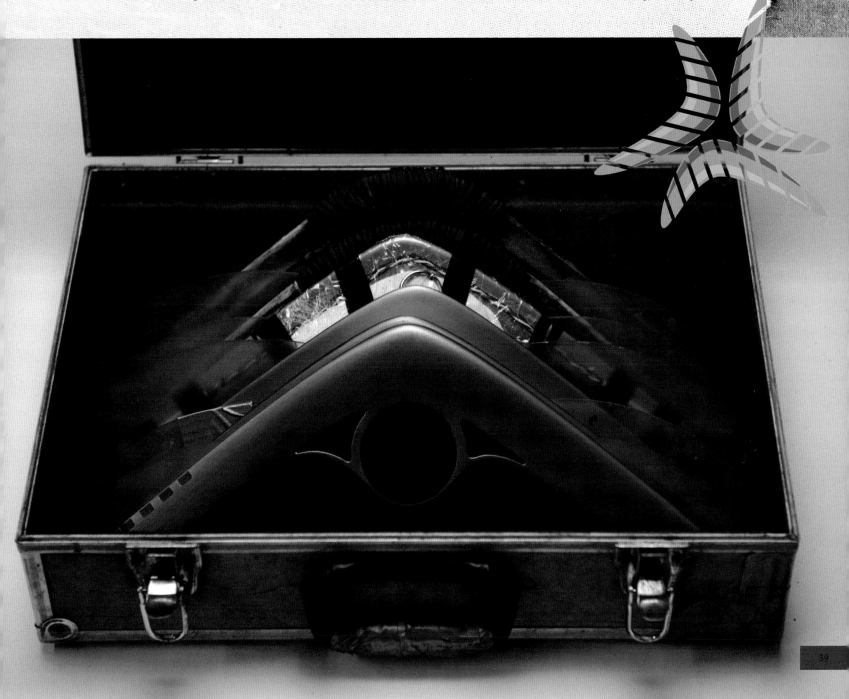

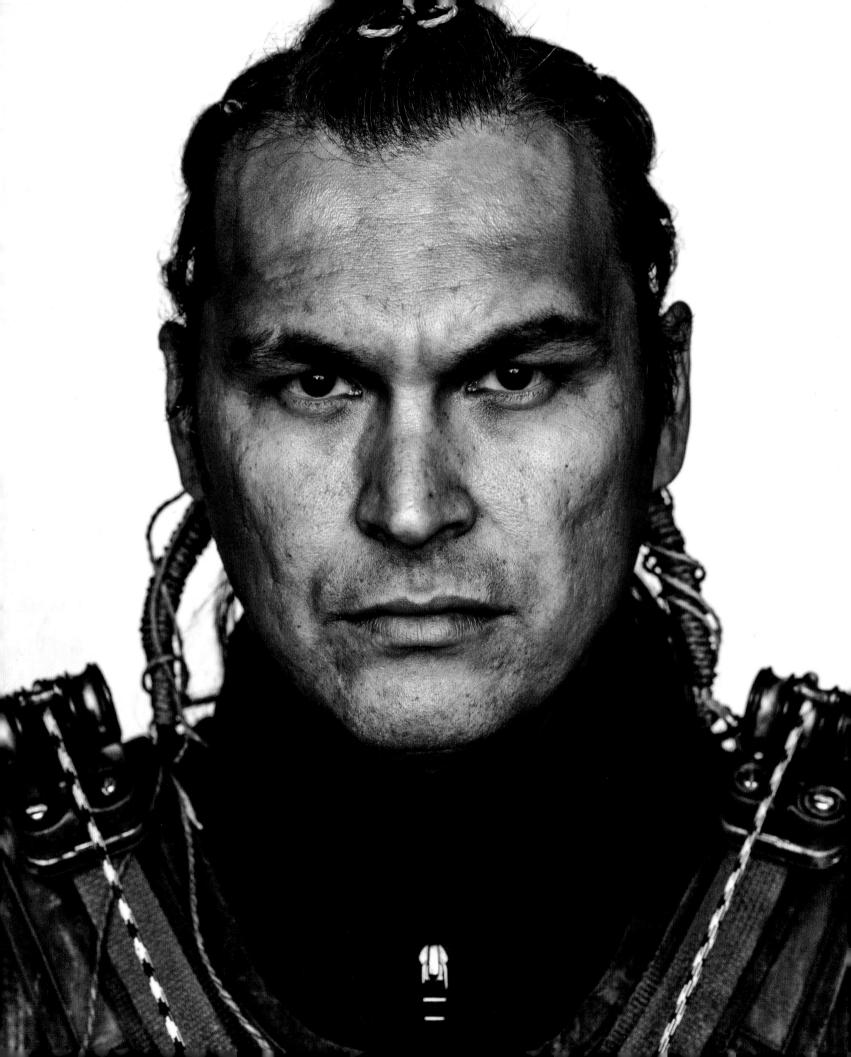

Adam Beach

SLIPKNUT

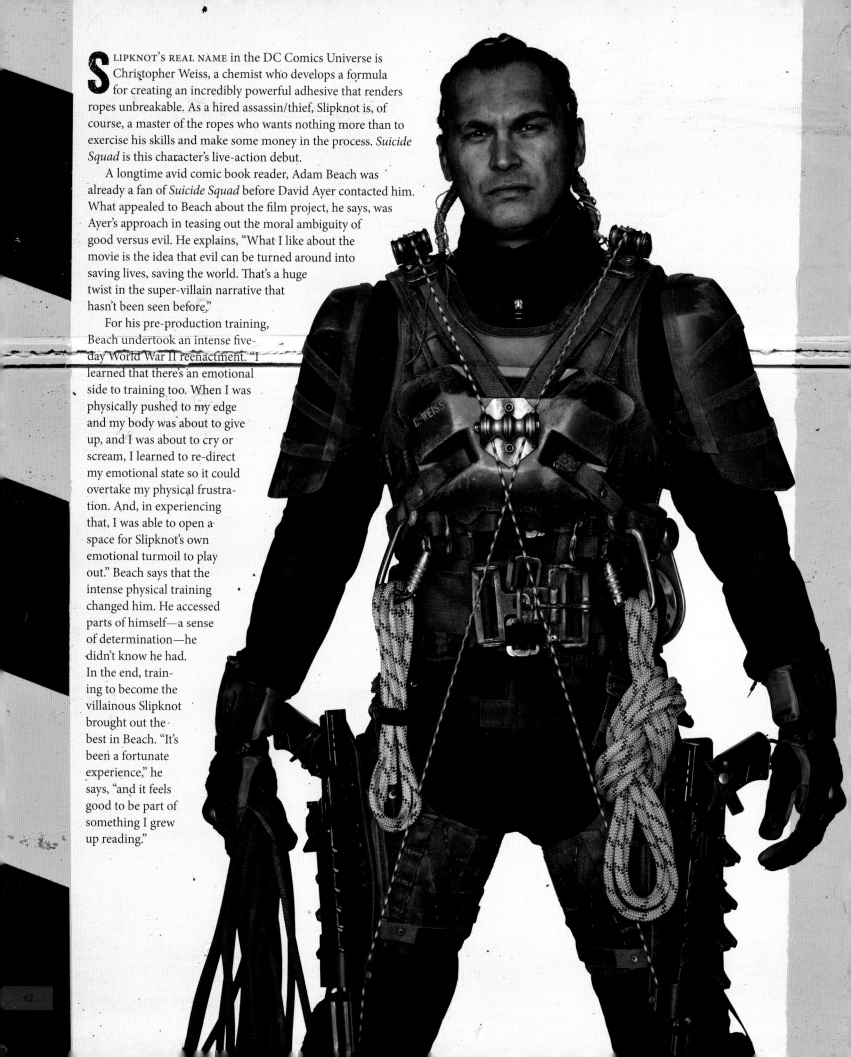

SLIPKNOT'S REAL NAME in the DC Comics Universe is Christopher Weiss, a chemist who develops a formula for creating an incredibly powerful adhesive that renders ropes unbreakable. As a hired assassin/thief, Slipknot is, of course, a master of the ropes who wants nothing more than to exercise his skills and make some money in the process. *Suicide Squad* is this character's live-action debut.

A longtime avid comic book reader, Adam Beach was already a fan of *Suicide Squad* before David Ayer contacted him. What appealed to Beach about the film project, he says, was Ayer's approach in teasing out the moral ambiguity of good versus evil. He explains, "What I like about the movie is the idea that evil can be turned around into saving lives, saving the world. That's a huge twist in the super-villain narrative that hasn't been seen before."

For his pre-production training, Beach undertook an intense five-day World War II reenactment. "I learned that there's an emotional side to training too. When I was physically pushed to my edge and my body was about to give up, and I was about to cry or scream, I learned to re-direct my emotional state so it could overtake my physical frustra-tion. And, in experiencing that, I was able to open a space for Slipknot's own emotional turmoil to play out." Beach says that the intense physical training changed him. He accessed parts of himself—a sense of determination—he didn't know he had. In the end, train-ing to become the villainous Slipknot brought out the best in Beach. "It's been a fortunate experience," he says, "and it feels good to be part of something I grew up reading."

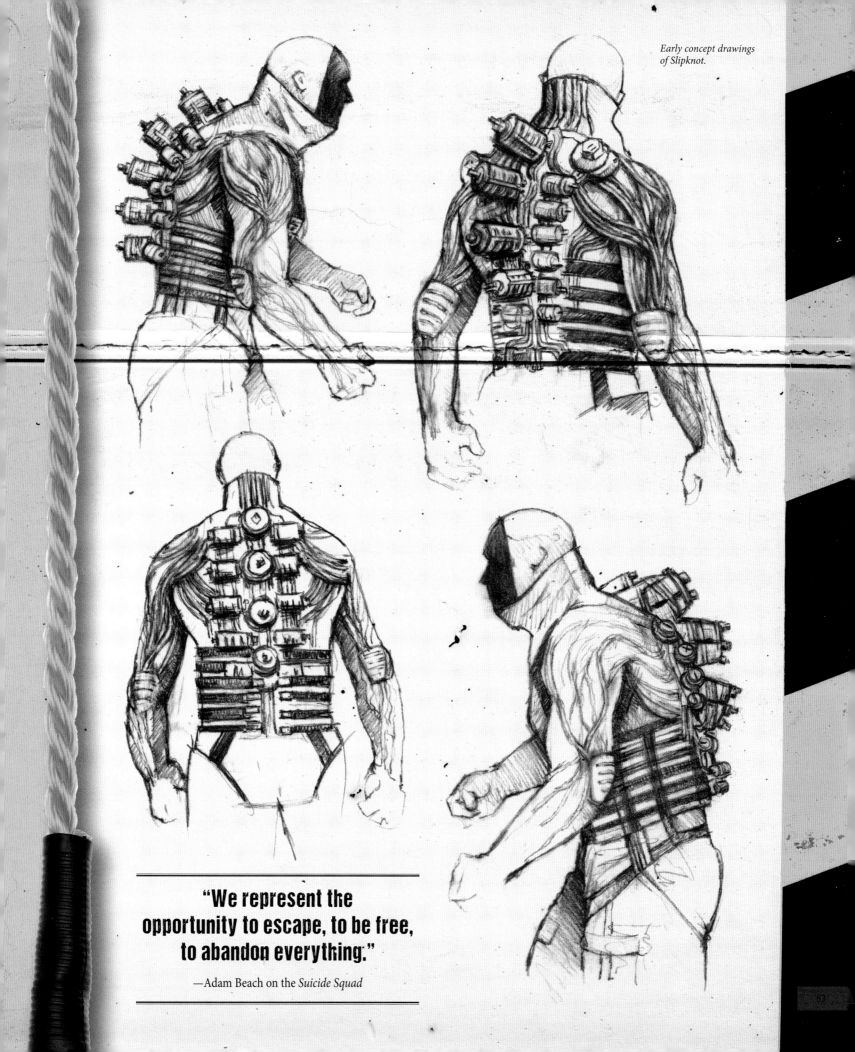

Early concept drawings of Slipknot.

"We represent the opportunity to escape, to be free, to abandon everything."

—Adam Beach on the *Suicide Squad*

I N THE REALM OF SUPER HEROES and villains, the suit makes the man. For the character of Slipknot, his costume is literally the source of his weaponry. His fifty-pound gear bag holds the world's most powerful and durable ropes known to man; it's the ropes that literally set Slipknot free from his former identity as chemist Christopher Weiss. Because Slipknot is an ace on the ropes, Beach became a master too. Not only did he practice climbing ropes every day, but once he learned that his costume weighed over fifty pounds, he trained with weighted vests too. "That was the game changer," Beach admits. "I have the [twenty pound] vest at home and I run with it, train with it, and I'm a different machine now, you know?" He also spent hours practicing Slipknot's signature knots and honing his martial arts knowledge. For Beach, the best part about being in *Suicide Squad* is knowing that he's both helping to continue Slipknot's legacy and introducing the character to audiences who may be more familiar with names like Batman and Superman.

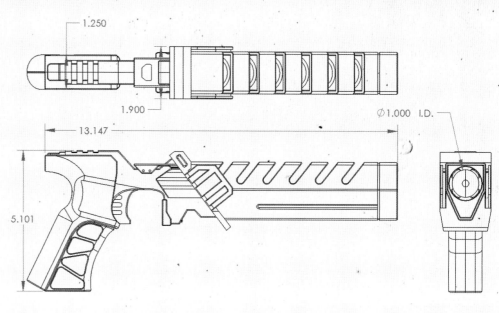

THIS PAGE (RIGHT): *Illustration of Slipknot's grappling gun.* (BELOW) *Film still of Slipknot taking aim.*

OPPOSITE (TOP): *Storyboard of Slipknot unsnapping the launcher holster of his grappling gun.* (BELOW) *This concept illustration of the grappling gun shows the weapon's functionality.*

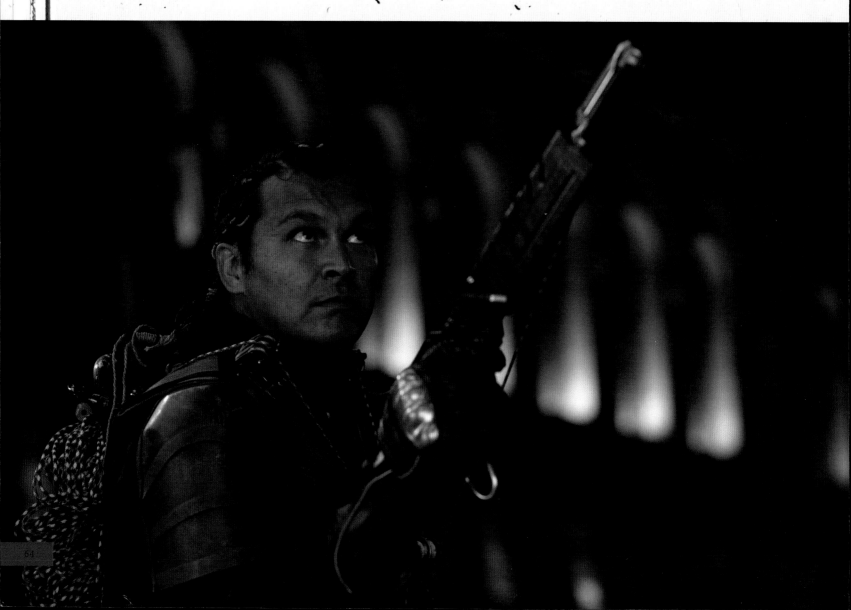

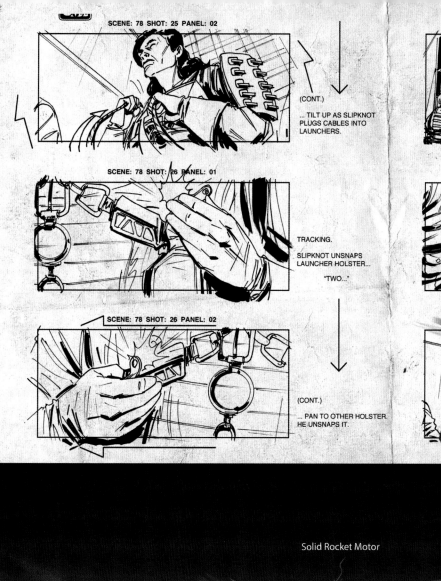

SCENE: 78 SHOT: 25 PANEL: 02

(CONT.)

... TILT UP AS SLIPKNOT PLUGS CABLES INTO LAUNCHERS.

SCENE: 78 SHOT: 26 PANEL: 01

TRACKING.

SLIPKNOT UNSNAPS LAUNCHER HOLSTER...

"TWO..."

SCENE: 78 SHOT: 26 PANEL: 02

(CONT.)

... PAN TO OTHER HOLSTER. HE UNSNAPS IT.

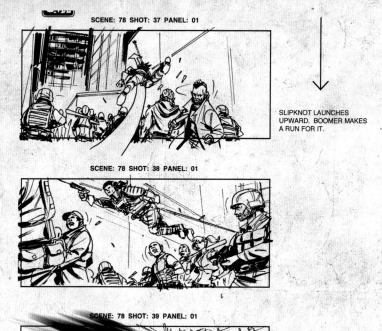

SCENE: 78 SHOT: 37 PANEL: 01

SLIPKNOT LAUNCHES UPWARD. BOOMER MAKES A RUN FOR IT.

SCENE: 78 SHOT: 38 PANEL: 01

SCENE: 78 SHOT: 39 PANEL: 01

HE BLURS BY, OVER DEADSHOT.

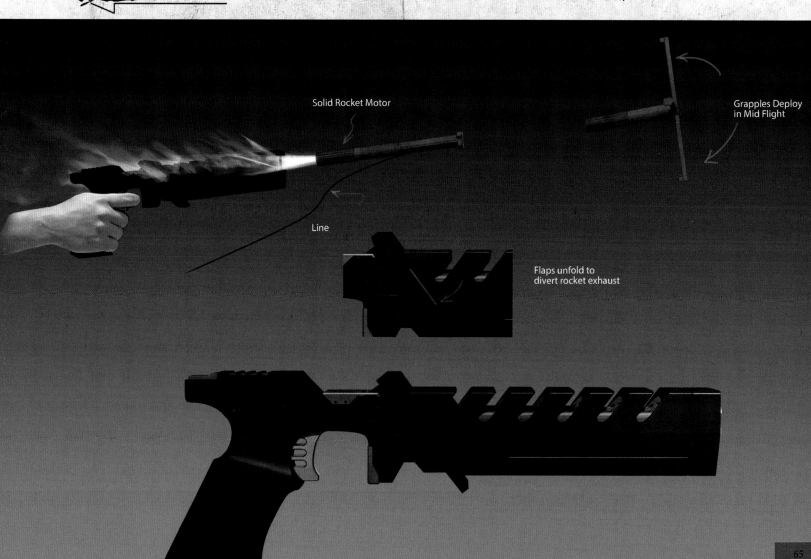

Solid Rocket Motor

Grapples Deploy in Mid Flight

Line

Flaps unfold to divert rocket exhaust

65

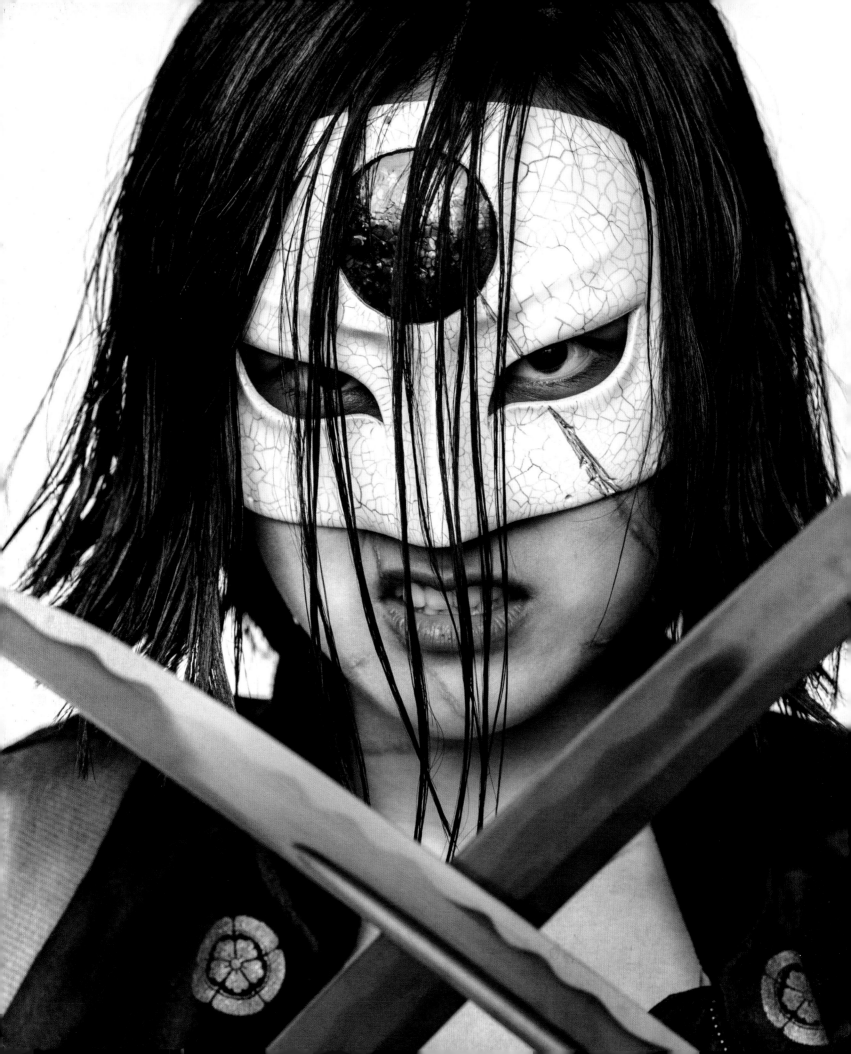

Karen Fukuhara

KATANA

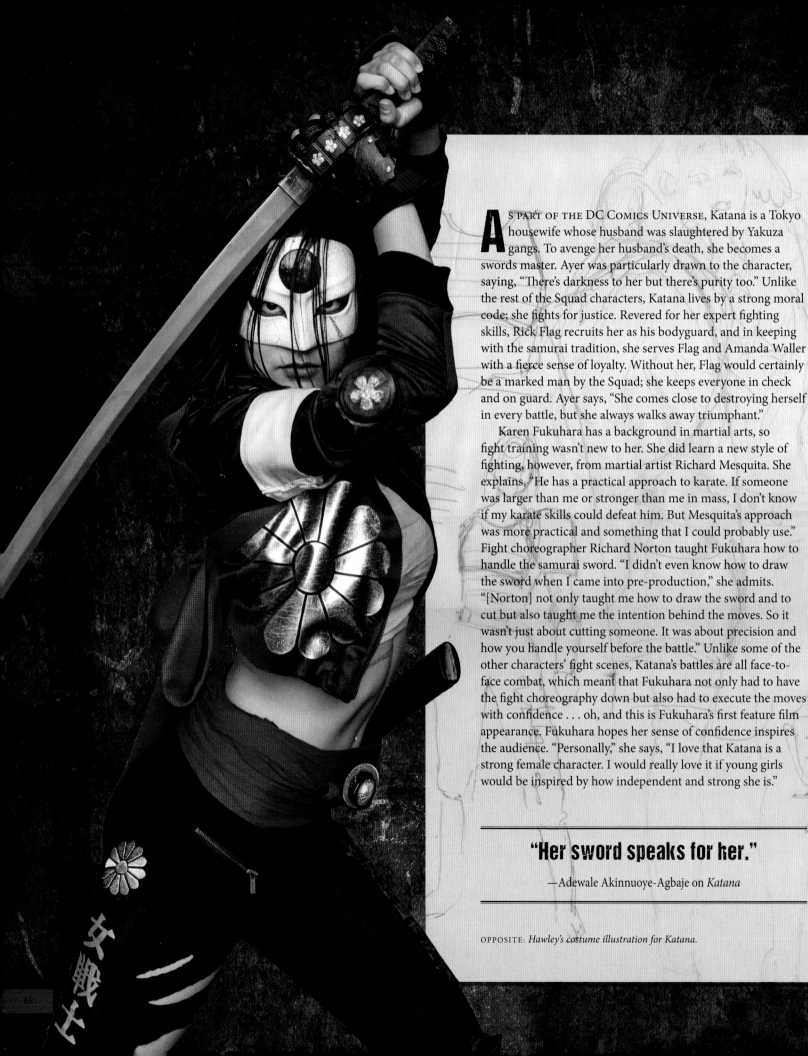

As part of the DC Comics Universe, Katana is a Tokyo housewife whose husband was slaughtered by Yakuza gangs. To avenge her husband's death, she becomes a swords master. Ayer was particularly drawn to the character, saying, "There's darkness to her but there's purity too." Unlike the rest of the Squad characters, Katana lives by a strong moral code; she fights for justice. Revered for her expert fighting skills, Rick Flag recruits her as his bodyguard, and in keeping with the samurai tradition, she serves Flag and Amanda Waller with a fierce sense of loyalty. Without her, Flag would certainly be a marked man by the Squad; she keeps everyone in check and on guard. Ayer says, "She comes close to destroying herself in every battle, but she always walks away triumphant."

Karen Fukuhara has a background in martial arts, so fight training wasn't new to her. She did learn a new style of fighting, however, from martial artist Richard Mesquita. She explains, "He has a practical approach to karate. If someone was larger than me or stronger than me in mass, I don't know if my karate skills could defeat him. But Mesquita's approach was more practical and something that I could probably use." Fight choreographer Richard Norton taught Fukuhara how to handle the samurai sword. "I didn't even know how to draw the sword when I came into pre-production," she admits. "[Norton] not only taught me how to draw the sword and to cut but also taught me the intention behind the moves. So it wasn't just about cutting someone. It was about precision and how you handle yourself before the battle." Unlike some of the other characters' fight scenes, Katana's battles are all face-to-face combat, which meant that Fukuhara not only had to have the fight choreography down but also had to execute the moves with confidence . . . oh, and this is Fukuhara's first feature film appearance. Fukuhara hopes her sense of confidence inspires the audience. "Personally," she says, "I love that Katana is a strong female character. I would really love it if young girls would be inspired by how independent and strong she is."

"Her sword speaks for her."

—Adewale Akinnuoye-Agbaje on *Katana*

OPPOSITE: *Hawley's costume illustration for Katana.*

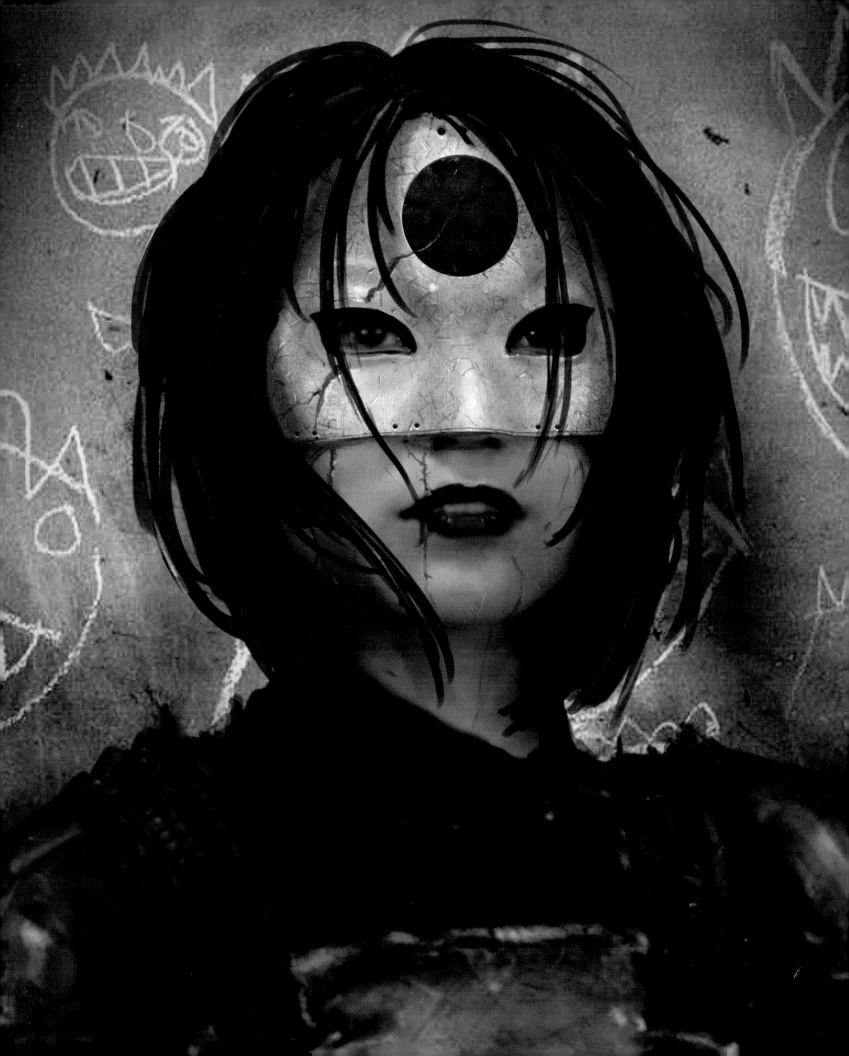

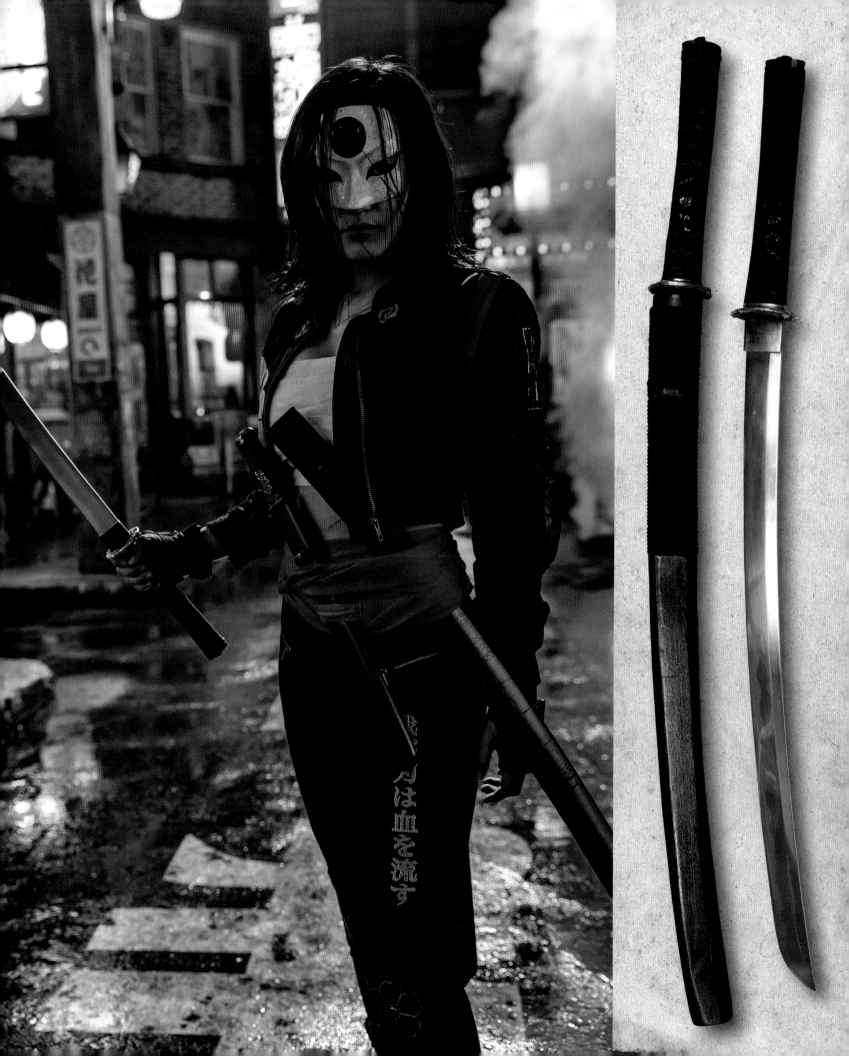

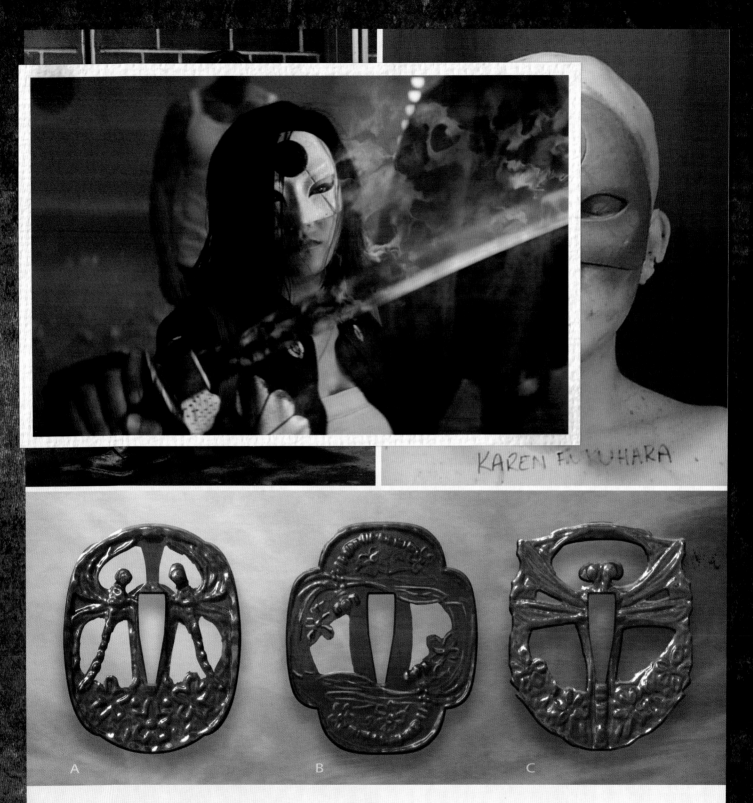

KAREN FUKUHARA

A B C

THIS PAGE (TOP LEFT): *Film still of Katana speaking to the soul of her husband trapped in her sword.* (TOP RIGHT) *Model of Katana's mask. The mask was custom-molded to Fukuhara's face.* (BOTTOM) *Digital renderings of early crossguard designs for the Soultaker. The art and production teams were creatively drawn toward the imagery of dragonflies for Katana's character.* OPPOSITE (FAR LEFT): *Film still.* (LEFT) *Model of Katana's Soultaker sword and its case.*

KATANA'S WEAPON OF CHOICE is a one-of-a-kind samurai sword called the Soultaker, which is capable of extracting and containing the souls from whomever it kills. According to DC Comics, once captured, Katana can converse with the dead souls via her sword. For the film, Prop Master Dan Sissons created a unique samurai sword for Fukuhara, decorating it with beautiful emblems and Japanese-inspired insignias. The Soultaker may look beautiful, but just like Katana, it cuts deep.

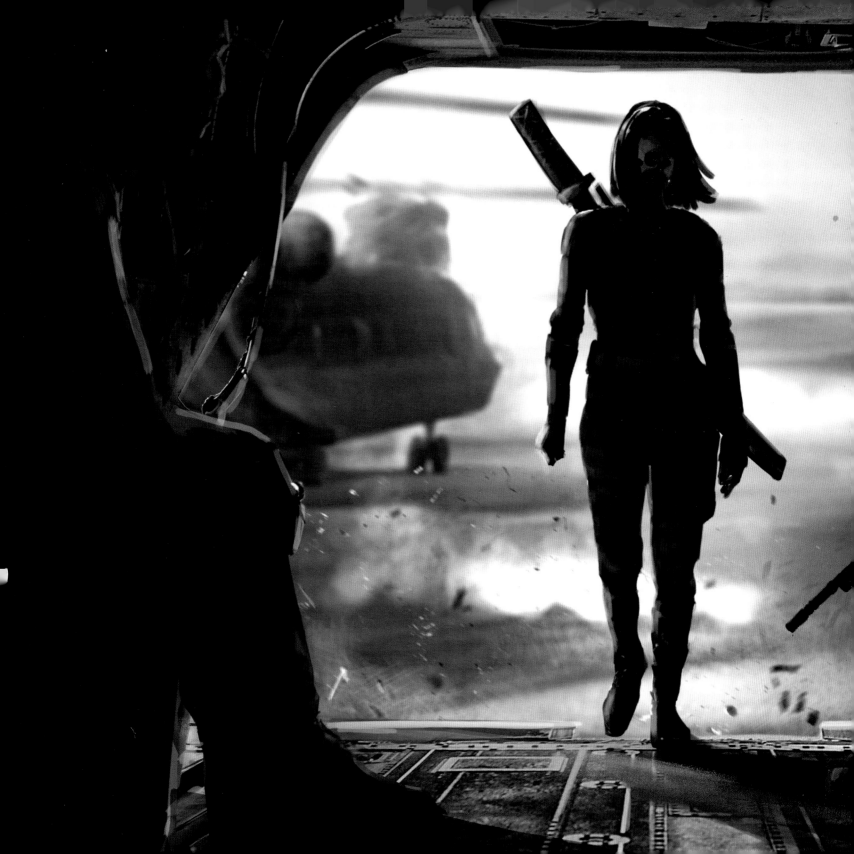

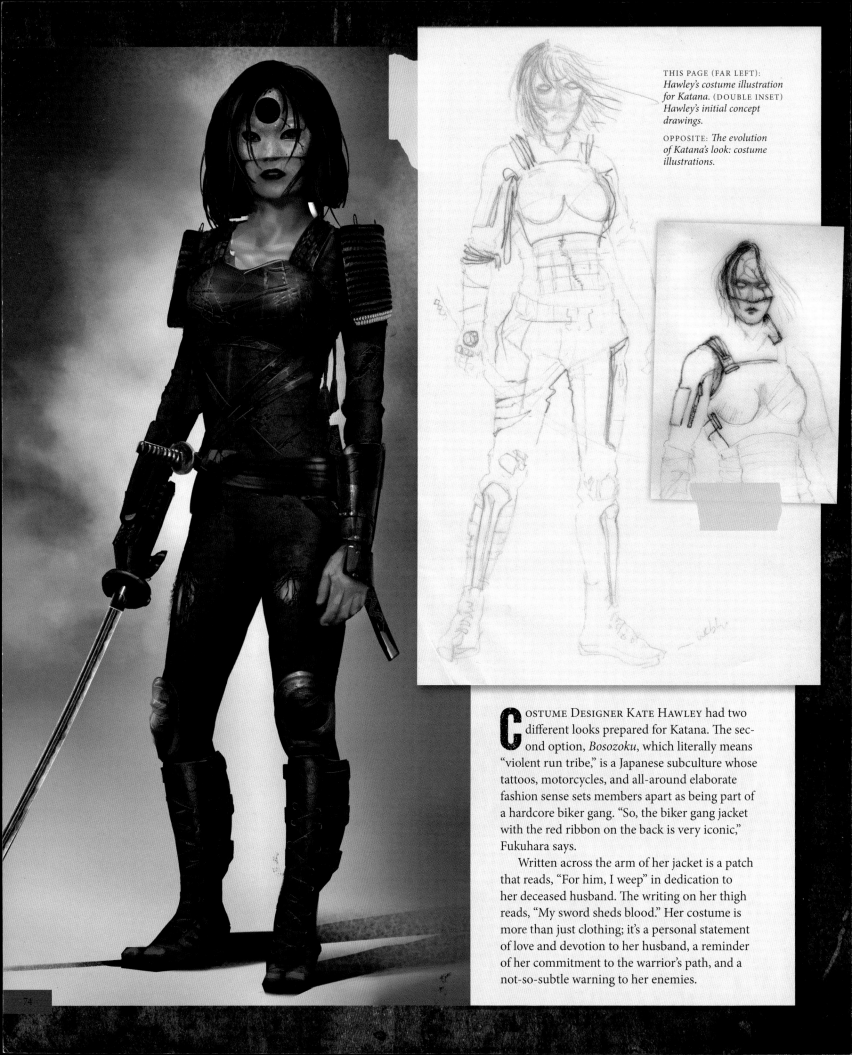

THIS PAGE (FAR LEFT): *Hawley's costume illustration for Katana.* (DOUBLE INSET) *Hawley's initial concept drawings.*

OPPOSITE: *The evolution of Katana's look: costume illustrations.*

COSTUME DESIGNER KATE HAWLEY had two different looks prepared for Katana. The second option, *Bosozoku*, which literally means "violent run tribe," is a Japanese subculture whose tattoos, motorcycles, and all-around elaborate fashion sense sets members apart as being part of a hardcore biker gang. "So, the biker gang jacket with the red ribbon on the back is very iconic," Fukuhara says.

Written across the arm of her jacket is a patch that reads, "For him, I weep" in dedication to her deceased husband. The writing on her thigh reads, "My sword sheds blood." Her costume is more than just clothing; it's a personal statement of love and devotion to her husband, a reminder of her commitment to the warrior's path, and a not-so-subtle warning to her enemies.

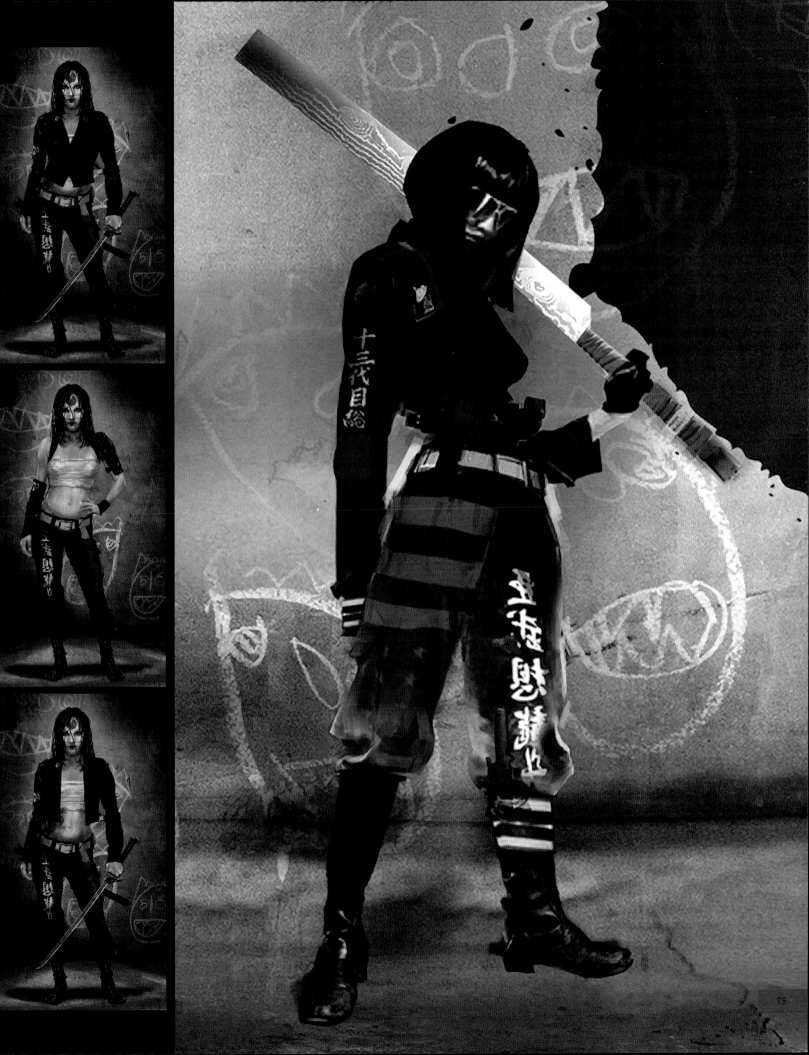

Joel Kinnaman

RickFlag

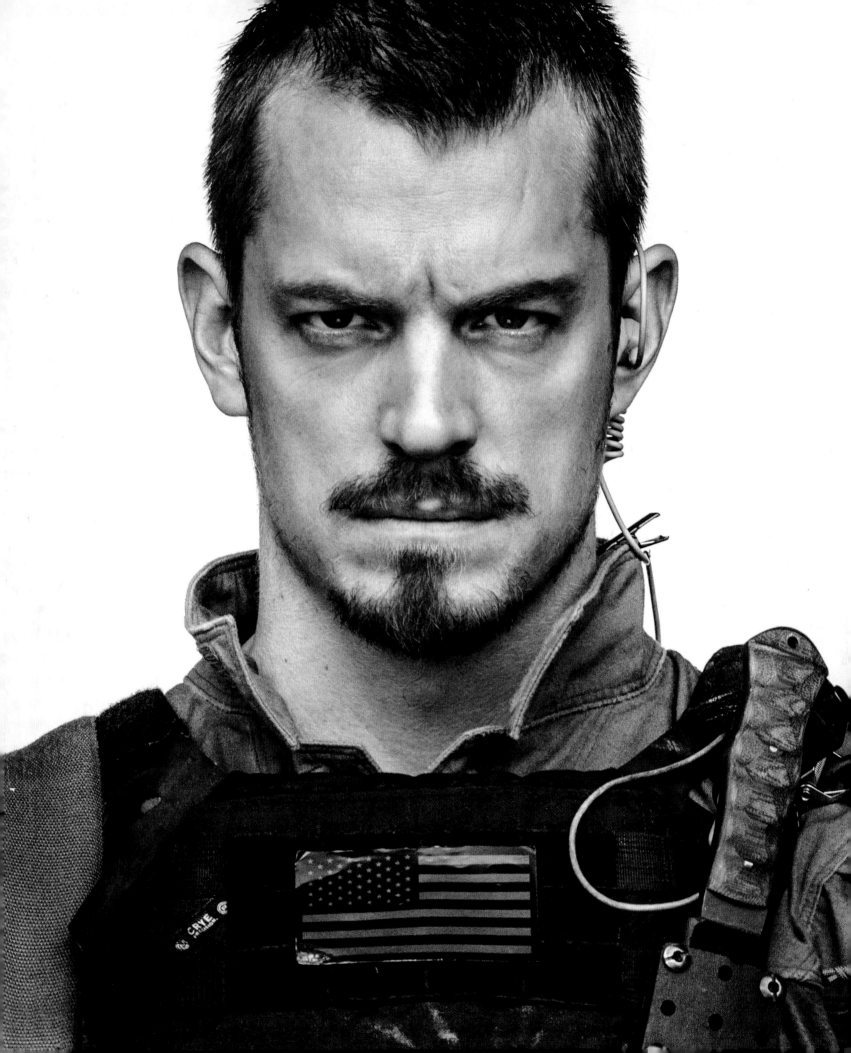

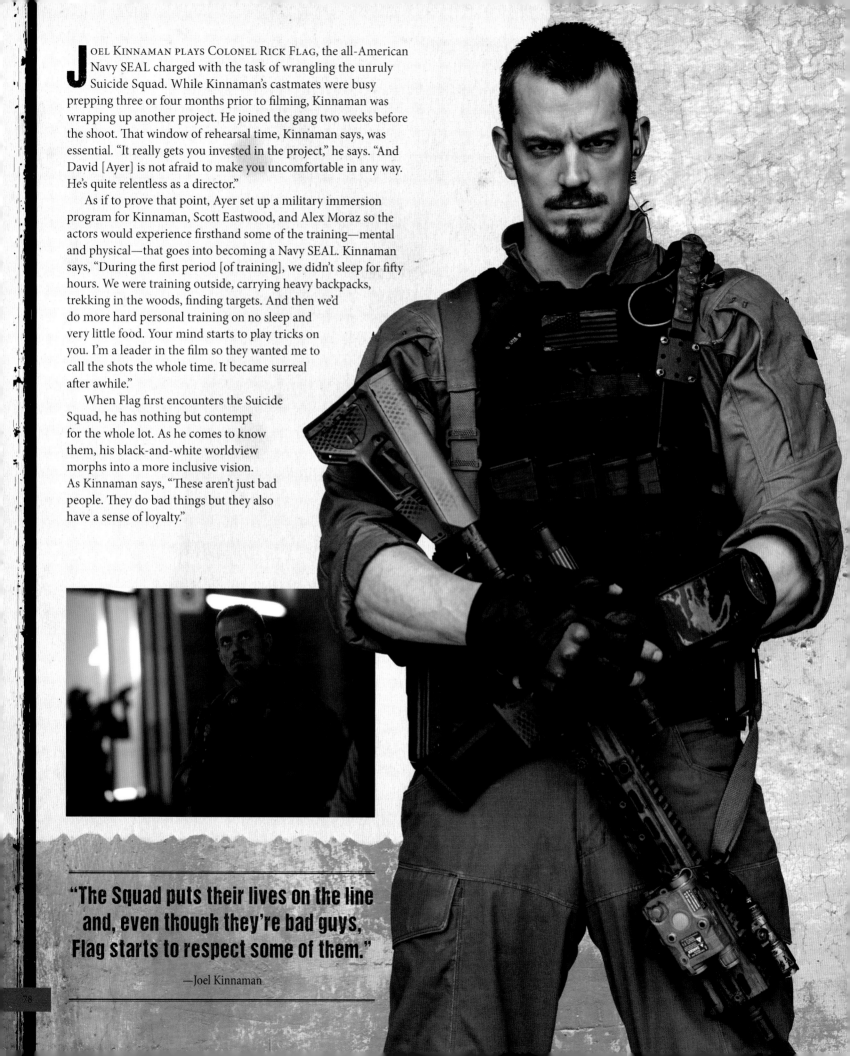

JOEL KINNAMAN PLAYS COLONEL RICK FLAG, the all-American Navy SEAL charged with the task of wrangling the unruly Suicide Squad. While Kinnaman's castmates were busy prepping three or four months prior to filming, Kinnaman was wrapping up another project. He joined the gang two weeks before the shoot. That window of rehearsal time, Kinnaman says, was essential. "It really gets you invested in the project," he says. "And David [Ayer] is not afraid to make you uncomfortable in any way. He's quite relentless as a director."

As if to prove that point, Ayer set up a military immersion program for Kinnaman, Scott Eastwood, and Alex Moraz so the actors would experience firsthand some of the training—mental and physical—that goes into becoming a Navy SEAL. Kinnaman says, "During the first period [of training], we didn't sleep for fifty hours. We were training outside, carrying heavy backpacks, trekking in the woods, finding targets. And then we'd do more hard personal training on no sleep and very little food. Your mind starts to play tricks on you. I'm a leader in the film so they wanted me to call the shots the whole time. It became surreal after awhile."

When Flag first encounters the Suicide Squad, he has nothing but contempt for the whole lot. As he comes to know them, his black-and-white worldview morphs into a more inclusive vision. As Kinnaman says, "These aren't just bad people. They do bad things but they also have a sense of loyalty."

"The Squad puts their lives on the line and, even though they're bad guys, Flag starts to respect some of them."

—Joel Kinnaman

AMANDA WALLER NOT ONLY TASKS Colonel Rick Flag with the job of leading the Suicide Squad but she also directs him to protect June Moone. If Flag didn't know he'd fall for the lovely scientist, Waller certainly did, and she uses their love to her strategic advantage. Flag may control the Squad—barely—but Waller certainly controls him. He's like a caught fish, and Waller's psychological hook is his love for June. She exacts a similar ploy with June. When Enchantress takes over June's body, Flag has yet another mission: Make sure Enchantress doesn't get out of control.

Ironically, while Flag is trying to control Enchantress, June Moone gives herself over to love completely. "[June's] relationship with Flag is really special. I think both of them are tortured characters, and they find each other," says Cara Delevingne, the actress who plays June Moone / Enchantress. Secretly, June's an adventure-seeker who's always wanted some excitement in her life. Little did she know that when she went spelunking in Skull Cave that she would unleash Enchantress and catapult herself into the world of the supernatural.

BELOW: *Rick Flag and June Moone share an intimate moment in the Belle Reve office.*

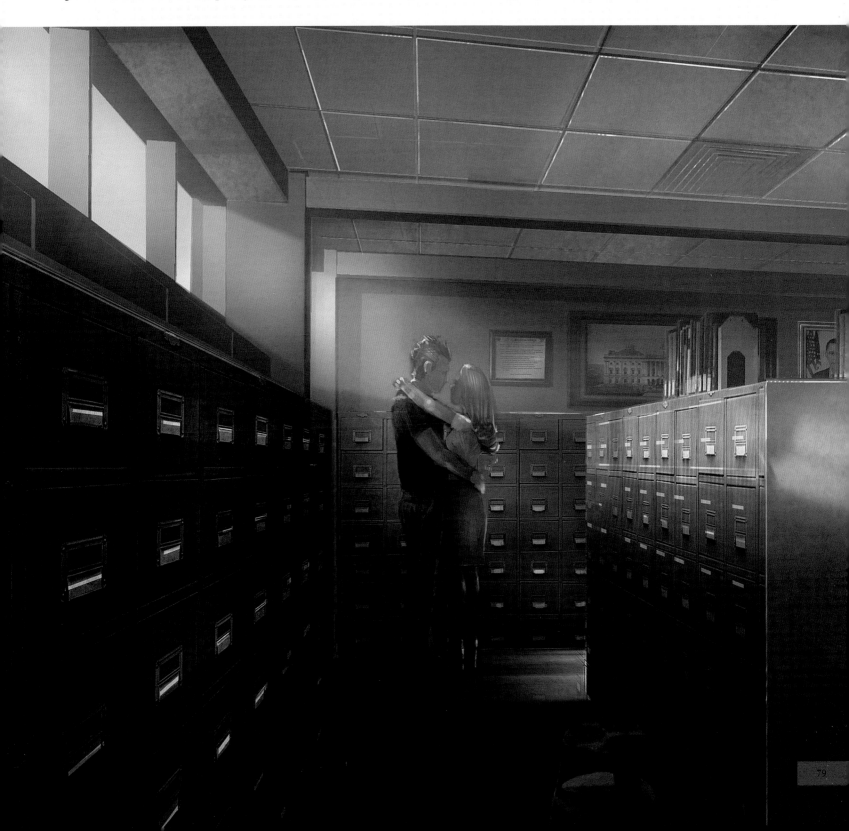

MEN ON A MISSION

NAVY SEALs ARE NOTHING IF NOT PREPARED, and they're always outfitted with the right gear to get the job done. Kevin Vance explains, "Normally mission and the intel for those missions dictate how guys are going to gear up. And so what we've done with a lot of the characters is made a lot of variances with gear." SEALs carry different types of gear: one might carry a saw and med pouch, another carries grenades, someone else has different-size caliber weapons, and another might have a different weapons system altogether. Depending on what each man carries in his pack, he adapts his outfit accordingly, and each character's set of weaponry is tailormade specifically for him; there are no duplicates. As team leader, GQ, played by Scott Eastwood, has to run light. As such, his equipment is light too: multiple communications systems, light assault. His job is to keep command, pivot, and move.

Prop Master Dan Sissons oversaw an entire department purely dedicated to all things military on the set and screen. Having a naval background himself, Writer/Director David Ayer is incredibly detail-oriented when it comes to getting the military outfits, kits, and equipment "right." As Sissons says, "You can't compromise the military. I mean, the helmet's an example. The helmets have to be adjusted perfectly. [Ayer] will notice a crooked helmet—there's a finger rule to helmets. He'll notice that it's too high or two low. That's just a small detail. . . . The amount of kit and the detail of kit was staggering."

THIS PAGE: *A collection of military-grade weapons used solely by the military personnel in the film.*

OPPOSITE: *David Ayer (*MIDDLE*) surrounded by men on a mission: a Navy SEAL on his immediate right, an Army Ranger on his far right, and actors portraying SEALs on his left.*

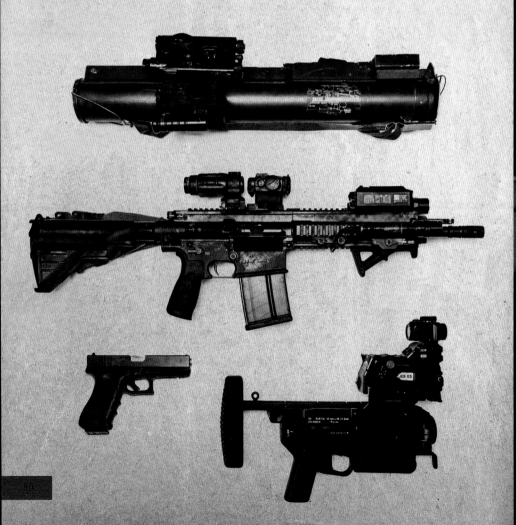

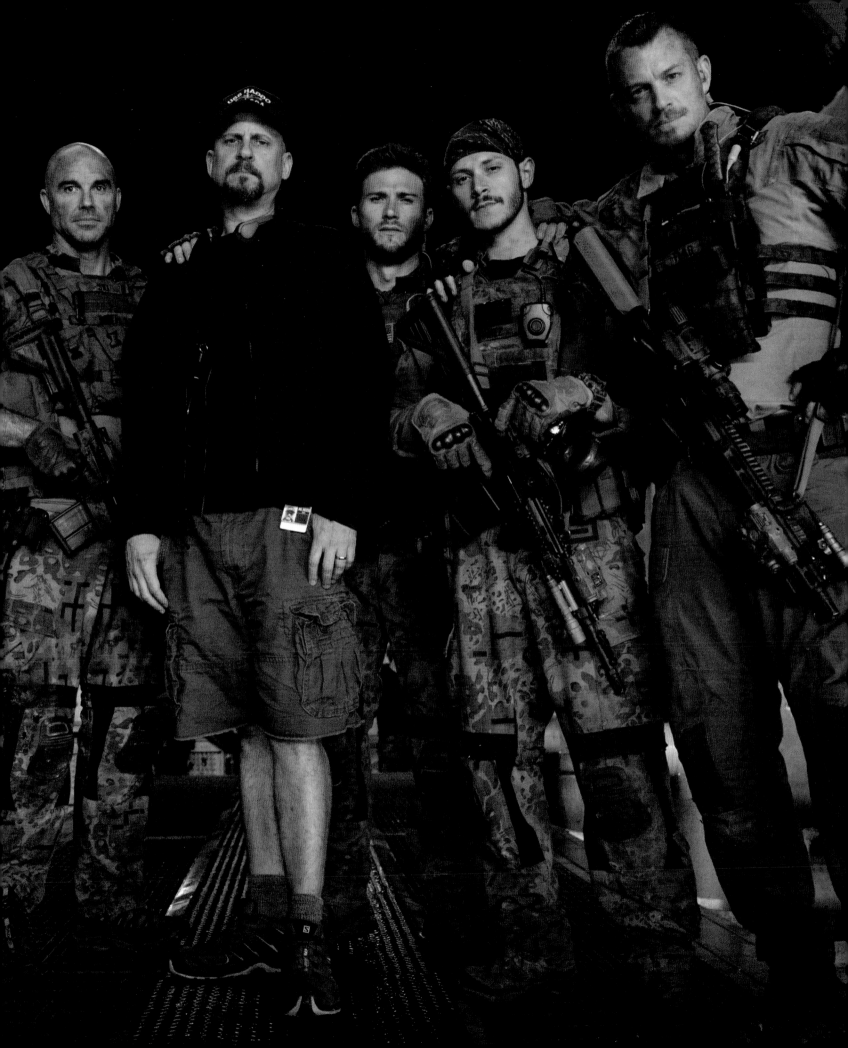

SMASH AND GRAB
STUNTWORK & PHYSICAL TRAINING

THE CHARACTERS IN *Suicide Squad* do stunts that are physically unbelievable. But most of their powers are attainable; they just happen to be the very best at what they do. Part of Harley Quinn's background, for example, is that she's an expert gymnast. Rather than having a stunt double execute a move, Robbie trained for months to capture a gymnast's sense of flexibility and awareness. And it shows. Producer Richard Suckle says, "I remember the day in which we shot the scene where Harley is in the elevator in the Federal Building. And I remember looking at the monitor and thinking, Where are the wires? The wires have to be somewhere. They've done an amazing job. And after, like, the third take, I'm, like, where are the wires? And I had to walk up and look, and I realized, of course, there were no wires. She was actually doing that move. She was literally walking inside the elevator 360 degrees upside down, and she did it over and over and over again."

Action Unit Director Guy Norris admits that the majority of the cast is naturally athletic. After one day of weapons or fight training, for example, Will Smith was already weeks ahead of where one might imagine a performer being. Norris says, "And so with everybody, it's looking at what their strengths are and then combining that with their character's traits and trying to meld them together. . . . It's not trying to get actors to do a physical movement that doesn't work for them or doesn't work for the character."

Each character employs different moves and Norris's team, along with the fight choreographers and personal trainers, adapted specific fighting techniques and stuntwork for each individual. "With Croc," says Norris, "we had to come up with a whole new language because how would a half-man, half-crocodile fight? That was really interesting."

Authenticity takes times but it yields an embarrassment of riches. Norris explains, "If the [actors] are involved in [stuntwork] and the production allows that, then we get this amazing opportunity where, through the course of the show, the amount of time we actually had to use stunt doubles I can count on one hand. . . . And that totally changes how you design your coverage, where you can put the camera and how you can flow your choreography because you're not having to cut all the time between an actor and a double."

> ## "I want to shoot the actor from the front, not the double from the back."
>
> —Guy Norris, *action unit director / supervising stunt coordinator*

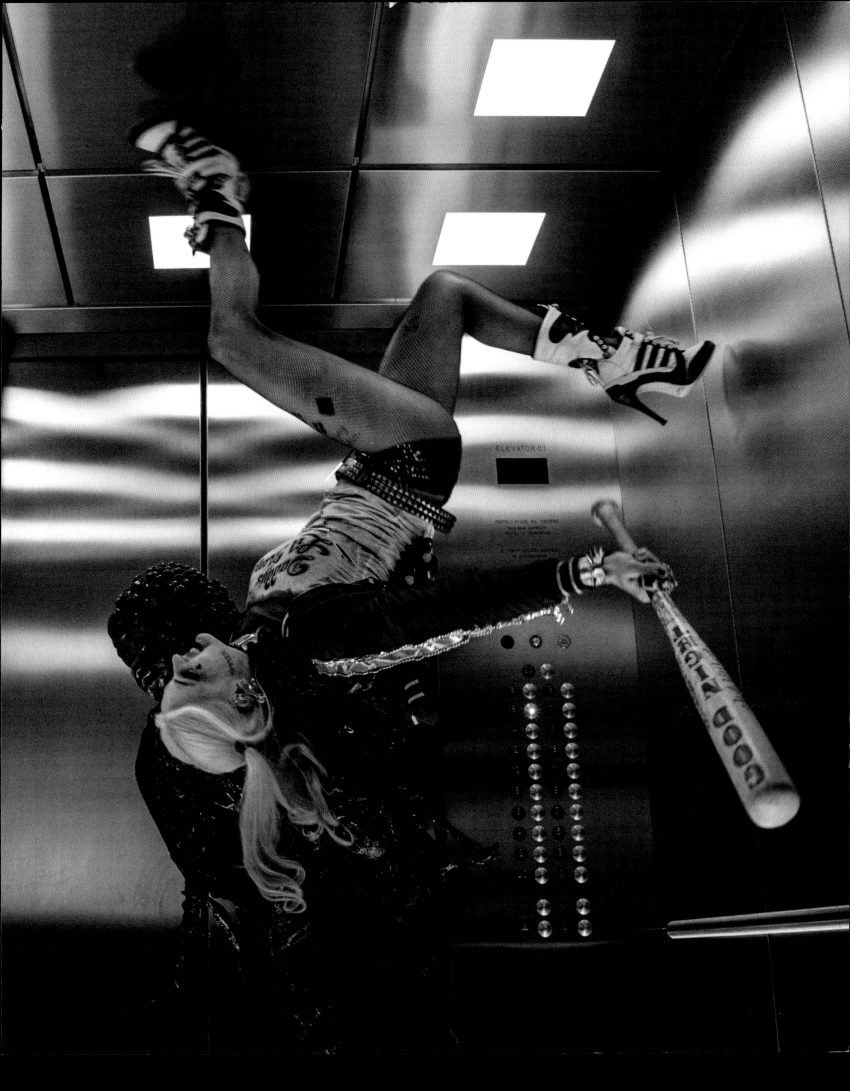

> ### "Once she's in makeup, she's Harley Quinn. And then our job was, okay, well, she certainly looks the part, how can we get her to physically BE the part?"
>
> —Guy Norris, *action unit director / supervising stunt coordinator*

FOR THE ACTORS, getting a real and practical sense of how to hold a gun or wield a sword lends credibility to their performances. In order to safely and effectively execute the stuntwork, the actors first had to get into peak physical form. Enter Gym Jones. Gym Jones is a high-performance training facility based around the Great Salt Lake region that specializes in getting actors ready for feature-length action films (and in training high-level individuals). The Gym Jones philosophy is to never tell yourself you can't do something. Trainer Pieter Vodden elaborates, saying, "You must have the power of mind to get through it; it's not just about training your body, it's about training your mind to have the strength to get through these things too. Once you have that strength of mind, it's amazing what you can accomplish." In working with the cast for Suicide Squad, the goals were two-fold: get the actors is peak physical form and make the action sequences look real. Vodden explains, "The work that we do behind the scenes is to functionally and athletically prepare them for the work that they're going to do on-screen," the belief being that if actors are functionally confident in their stuntwork, that confidence will translate on-screen and will show in the quality of the action sequences themselves.

Vodden was initially hired to work as Margot Robbie's trainer, but by the end of the film, he was training up to eight cast members at one time. When a group of producers and other crew members approached Vodden for workout and training tips, Vodden set up an on-set training camp for everyone. By the end of production, Vodden was running three training sessions a day of up to thirty-five to forty-five people. The entire cast and crew physically evolved during the course of filming.

Actors performing stuntwork and working the wires.

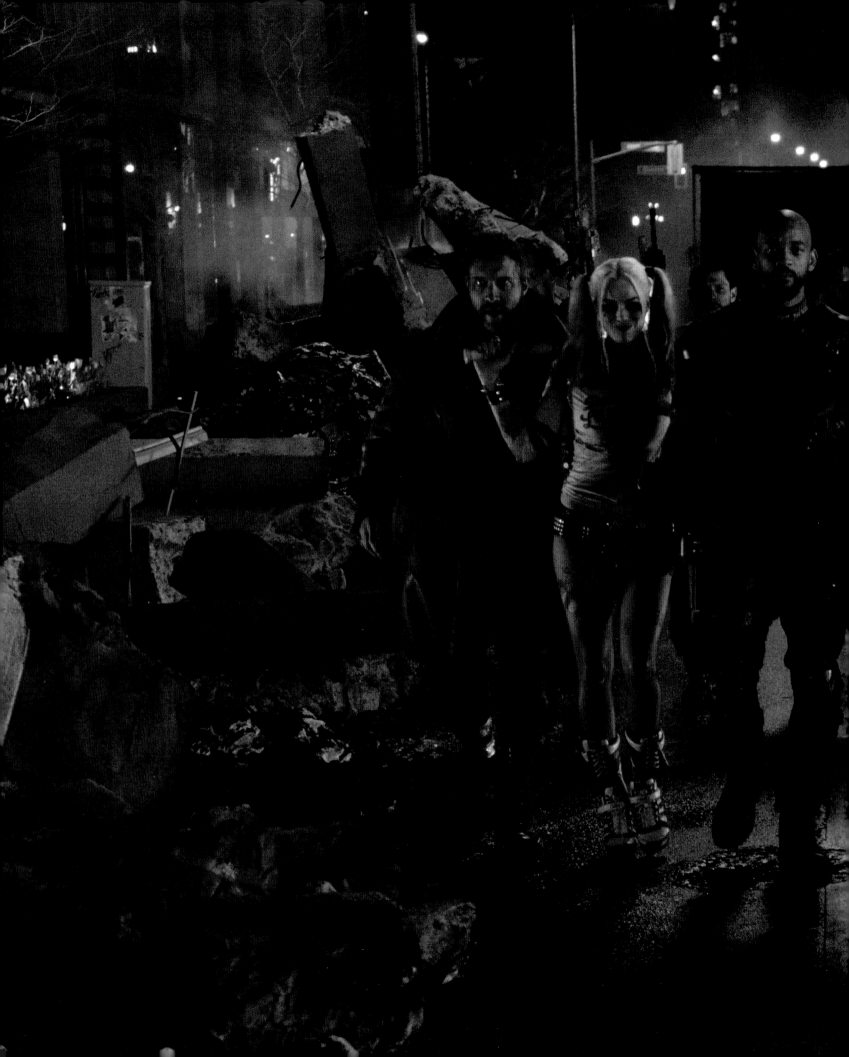

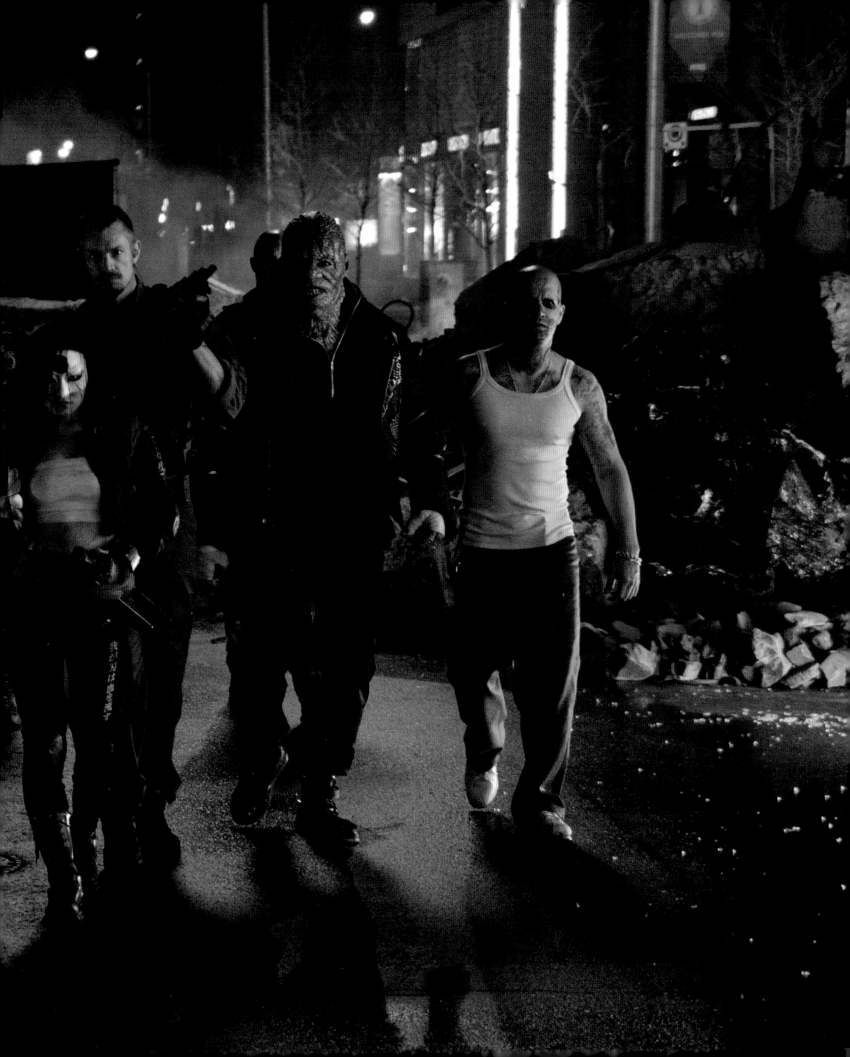

Welcome to
Belle Reve

'TILL DEATH DO US PART

Special Security Barracks

PRISONERS OF CRIME

WELCOME TO BELLE REVE

Whenever Amanda Waller needs built-in deniability for one of her suicide missions, she recruits her soldiers directly from the cells of Belle Reve Penitentiary. In the DC Comics Universe, it's the nightmarish high-security prison that houses the world's worst super-villains. Several members of Task Force X—better known as the Suicide Squad—are imprisoned in Belle Reve, having been incarcerated for a variety of nefarious crimes.

Famously located in the middle of a swamp in Louisiana, Belle Reve Penitentiary made its comic book debut in *Suicide Squad #1*. The prison is an isolated structure resembling a concrete monolith. Barbed wire encloses it from the outside world. Aerial shots reveal its enormity; the building appears to seemingly float atop swampy water like an oil spill or toxic sludge. Complete with a sewer-like cell for Croc, a water tank for Diablo (to extinguish his flames), and a cage within a cage for the prison's craziest resident, Harley Quinn, Belle Reve puts regular maximum-security facilities to shame. It's not only the cells that give Belle Reve a bad name—it's hard to say which is worse: the prisoners or their masters.

To create the iconic prison, Production Designer Oliver Scholl worked closely with David Ayer and collaborated with Costume Designer Kate Hawley so that the building—from its elaborately rendered "Welcome" sign to its color scheme—matched the film's overall aesthetics. While it looks like the prison is indeed shored up in a swamp, it was actually built on a stage at Pinewood Toronto Studios in Canada. The massive set took up the length of the entire stage, and then quickly gave way after shooting to make room for the next build: the train station. If only the Suicide Squad could have escaped the prison walls as fast and as clean.

"Let's just say I put them in a hole and threw away the hole."

—Amanda Waller

OPPOSITE: *David Ayer in front of Belle Reve mural.*

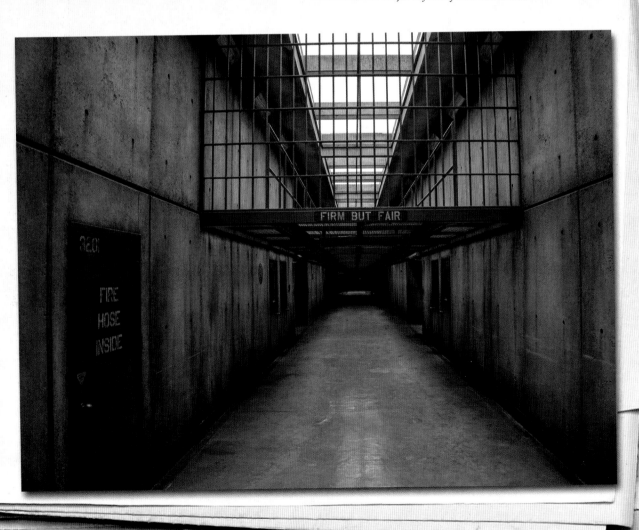

FIRM BUT FAIR

360

FIRE HOSE INSIDE

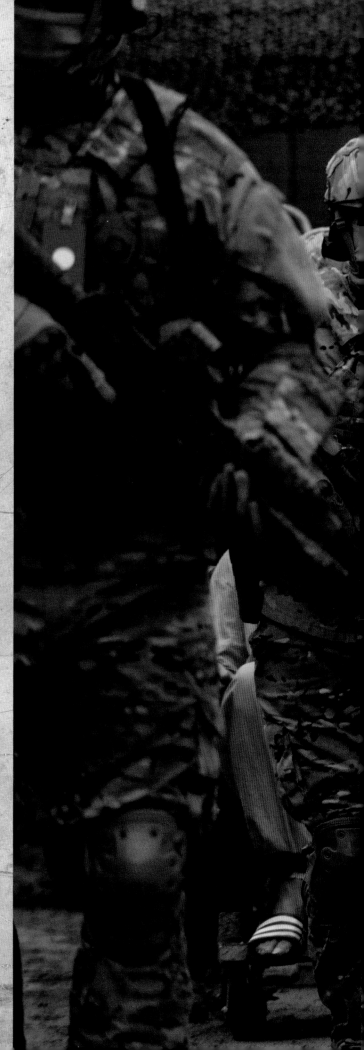

THE GUARDS

AS IF THE CONSTANT ROTATION of the prison guards and the specially calibrated cells weren't enough security, the guards also wear intense protective gear—militaristic bulletproof suits and helmets—while carrying an arsenal of heavy weaponry to keep them safe from the inmates. From the looks of it, the only surefire way to escape Belle Reve is in a body bag.

"This is my house . . ."

—Captain Griggs

BELOW (TOP AND BOTTOM): *Concept art showing the extraction of the Squad members from Belle Reve.*

RIGHT: *Film still of Captain Griggs (Ike Barinholtz) escorting Harley Quinn.*

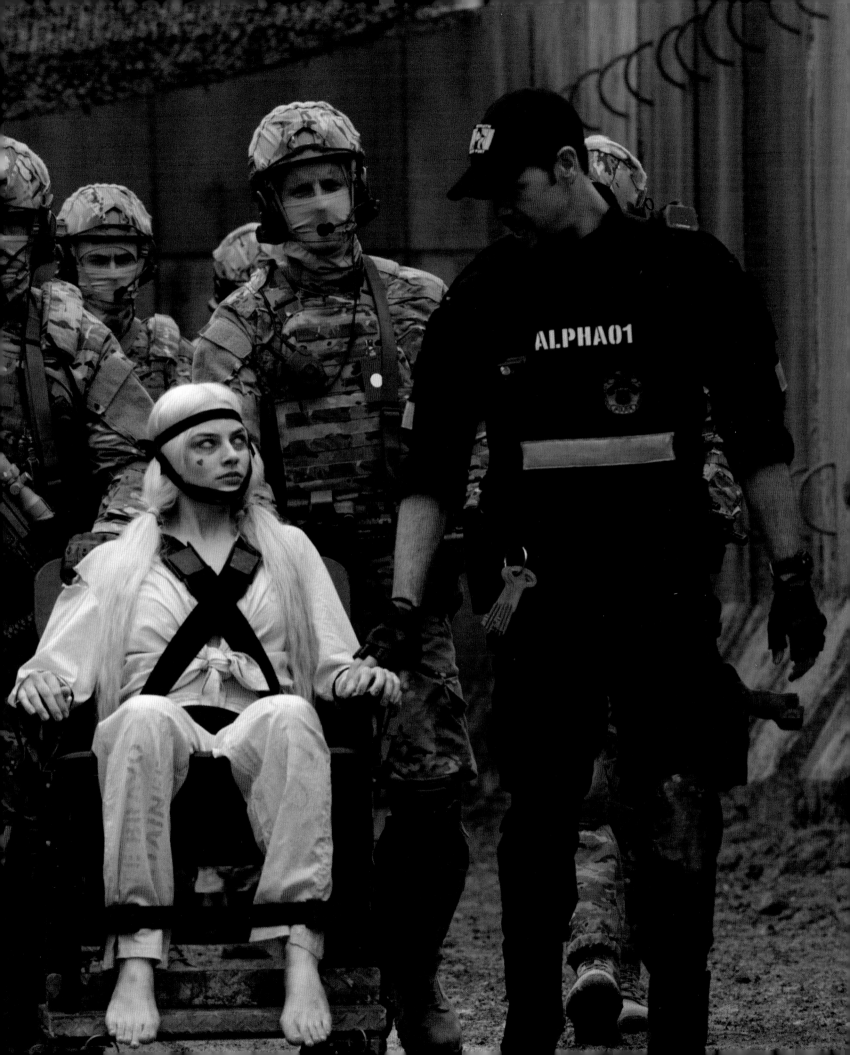

THE CELLS

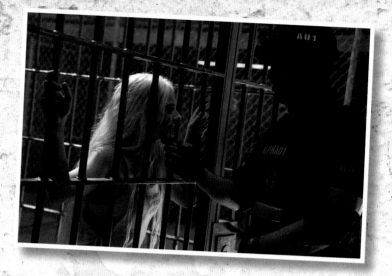

EACH CELL IN BELLE REVE is as unique as the criminal who occupies it. In fact, the cells are tailormade and constructed to restrain even the most eccentric—and specific—skills of the world's worst criminals.

DEADSHOT

On first glance, Deadshot's cell looks like any other but take a second look: reinforced walls keep him doubly isolated from the rest of the inmates.

HARLEY QUINN

Harley Quinn is housed in a cage within a cage—no toilet, no chair, nothing. For her personal entertainment, she taunts the guards by swinging from strips of her own torn clothing, a deranged bird of paradise. The wire fencing of her cage is electric.

DIABLO

Diablo's cell is custom-built to withstand the possibility of a (literal) flareup from the gangster. Building the cell was a welcome challenge. SPFX Coordinator Scott Fisher says, "Diablo's tank was fun. . . .We could fill in that tank [with water] in probably five seconds, top to bottom, with a guy in it."

CROC

Croc isn't just relegated to a sewer-like cavern; he's also forced to wear a full-on face mask (to keep him from eating Belle Reve staff) and is strapped in, and transported with a fork lift, when they have to move him.

THESE PAGES: *Concept art and film stills of Harley Quinn's so-called canary cage, and Deadshot's and Croc's cells at Belle Reve.*

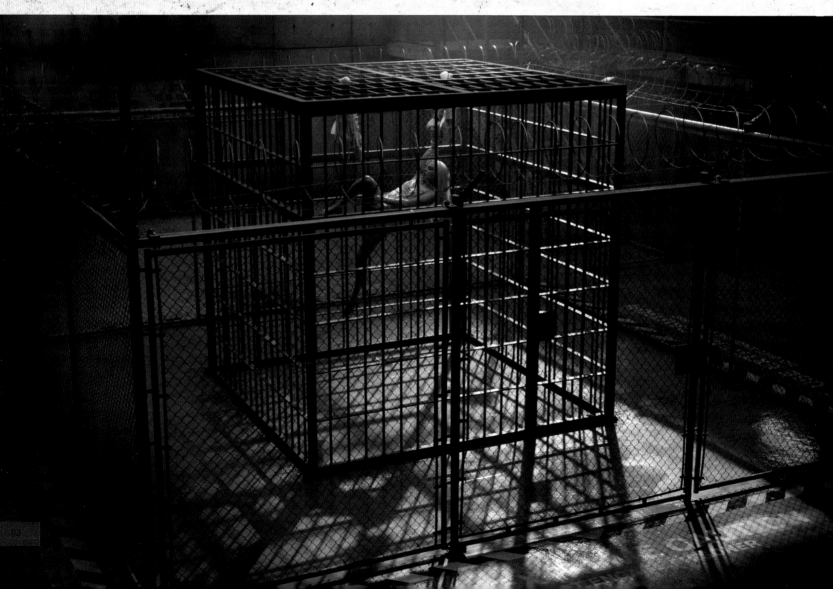

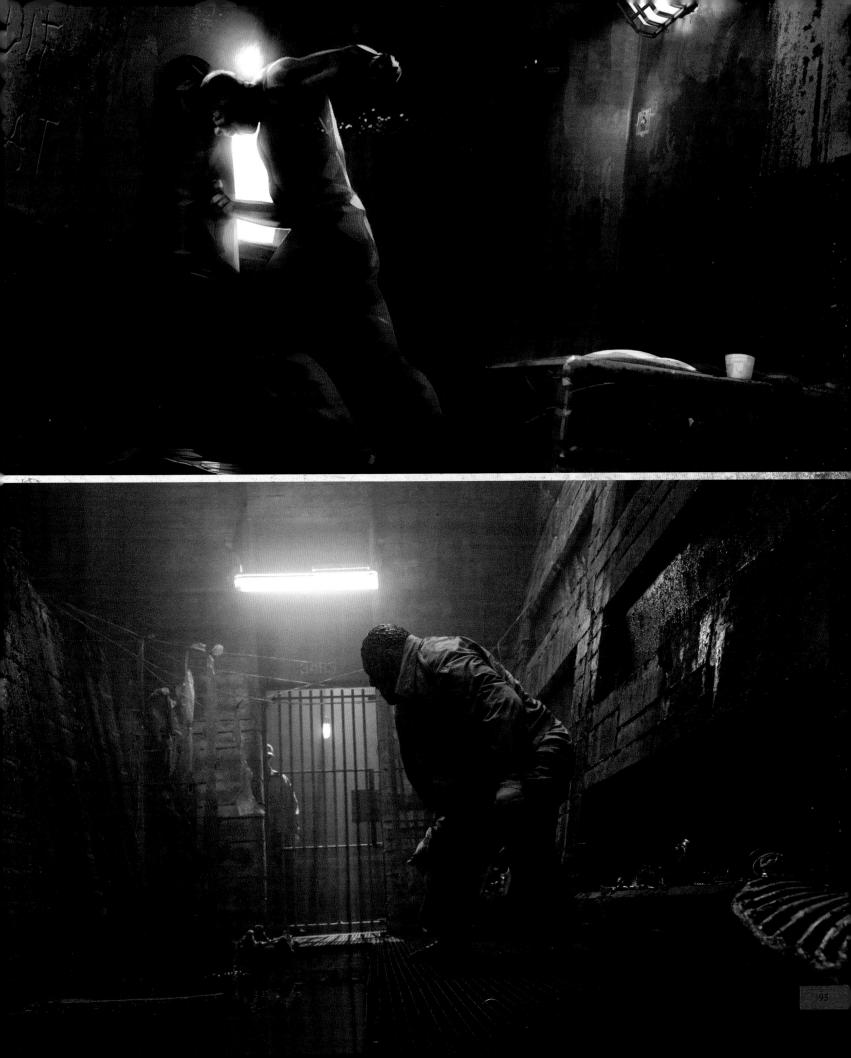

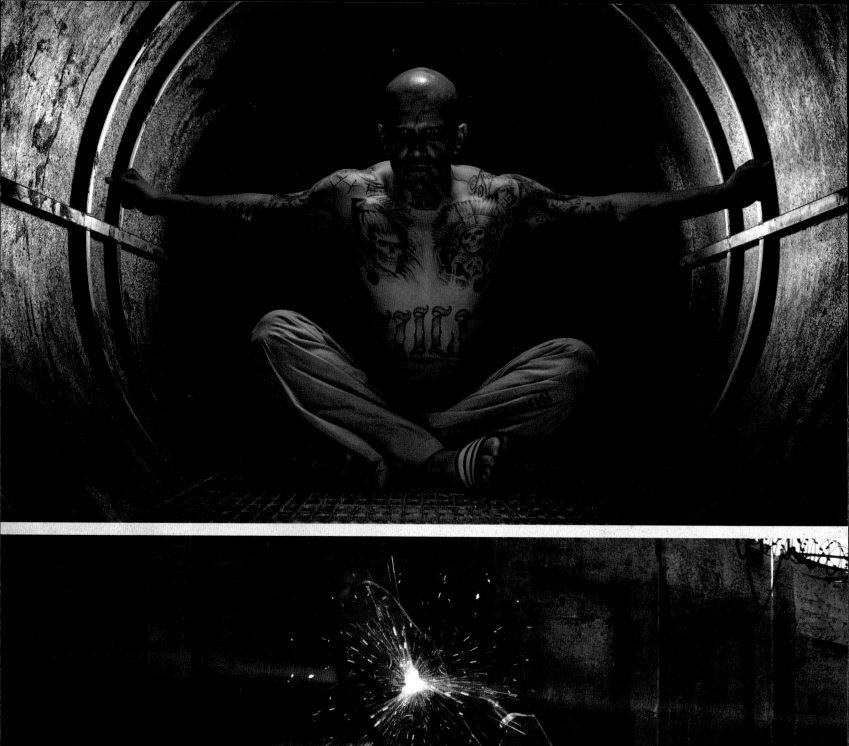

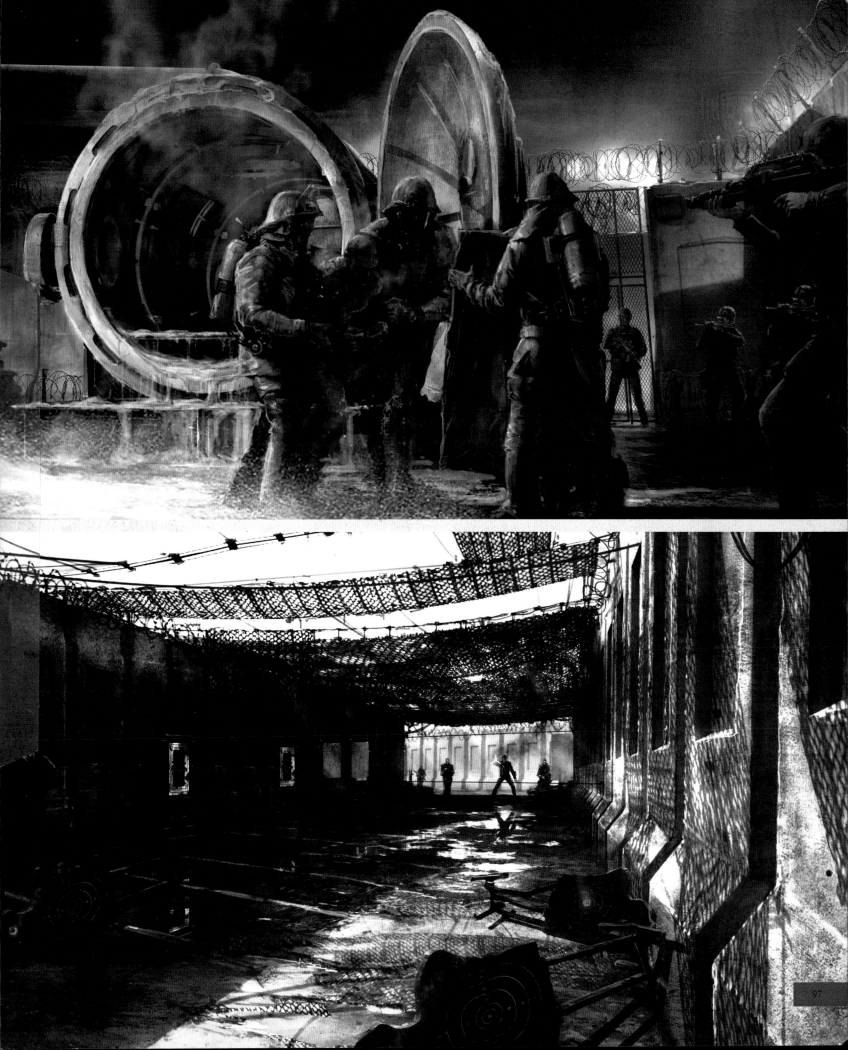

MIDWAY CITY

IN DC COMICS, Midway City is roughly based on a major city in Michigan. To create it, the cast and crew headed to Canada and transformed Toronto's financial district and shopping strip into a fictional version of the midwestern city. Toronto's Bay Street between Queen and King Streets was made over as Midway's Norton Street. The art and graphics departments created city banners for fake exhibitions and festivals. In a nod to the comic book writer, the Bay Adelaide Center was re-named the John F. Ostrander Federal Building.

One of the film's highlights is the Batmobile chase during which the car weaves down one of Toronto's busiest streets. The first time the sequence was filmed, a few thousand people came down to watch. The second day of filming, thirty-plus thousand people showed up for the Batmobile's wild ride. Some spectators brought foldout chairs and stationed themselves on the sidewalk for hours, watching the action unfold.

Art Director Brad Ricker and his team were charged with the task of creating a city full of destruction. Painters and sculptors

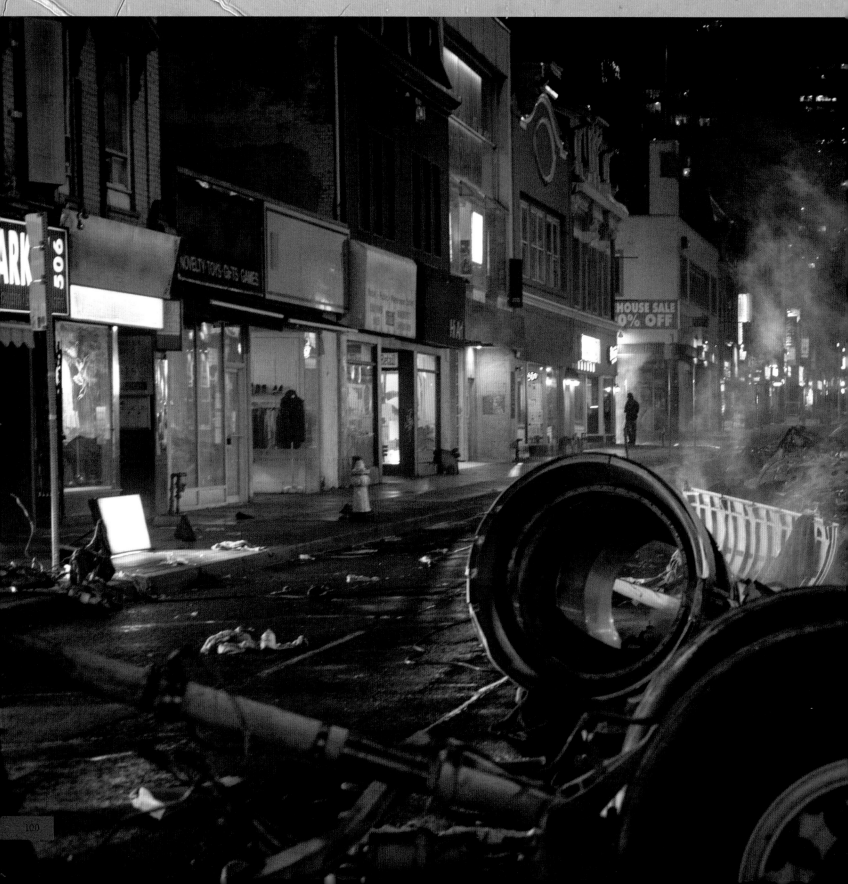

created huge amounts of debris from cardboard and foam painted as concrete and built onto trailers that unfold. Once the trailers opened, the streets were covered with instant debris and, perhaps more important, everything could be quickly folded up and driven away so Toronto residents could continue using their streets. Observant viewers may notice that shiny bits of material are nestled into the debris. These metallic pieces are strangely textured and designed to look otherworldly. Production Designer Oliver Scholl and his team physically built these remnants of fractal damage as real, tangible objects that could be moved around and incorporated into the larger piles of shattered glass, broken concrete, and demolished cars, further incorporating supernatural elements with the film's realism.

THIS PAGE AND FOLLOWING PAGES: *On set in Toronto, Canada. The Art Department had one day to take over a street in Toronto and wreak havoc. The crew completely dissembled an airplane, scattered debris, and then cleaned it up for morning commuters the next day. They even "crashed" a Chinook helicopter into a bus* (BOTTOM IMAGE, PAGE 104–105).

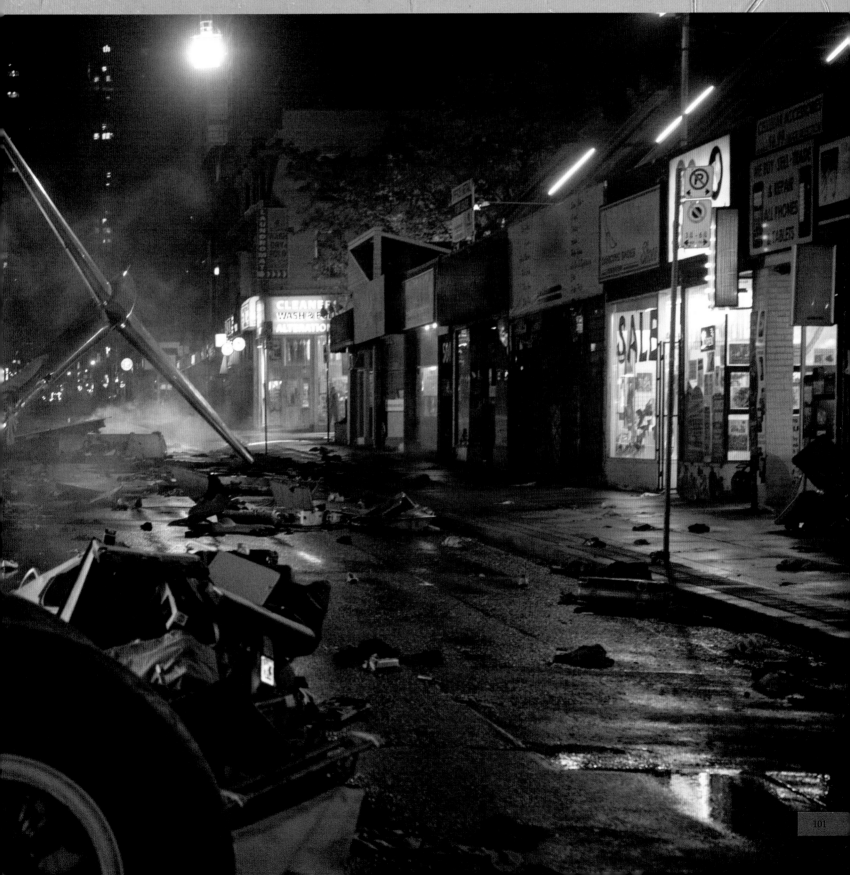

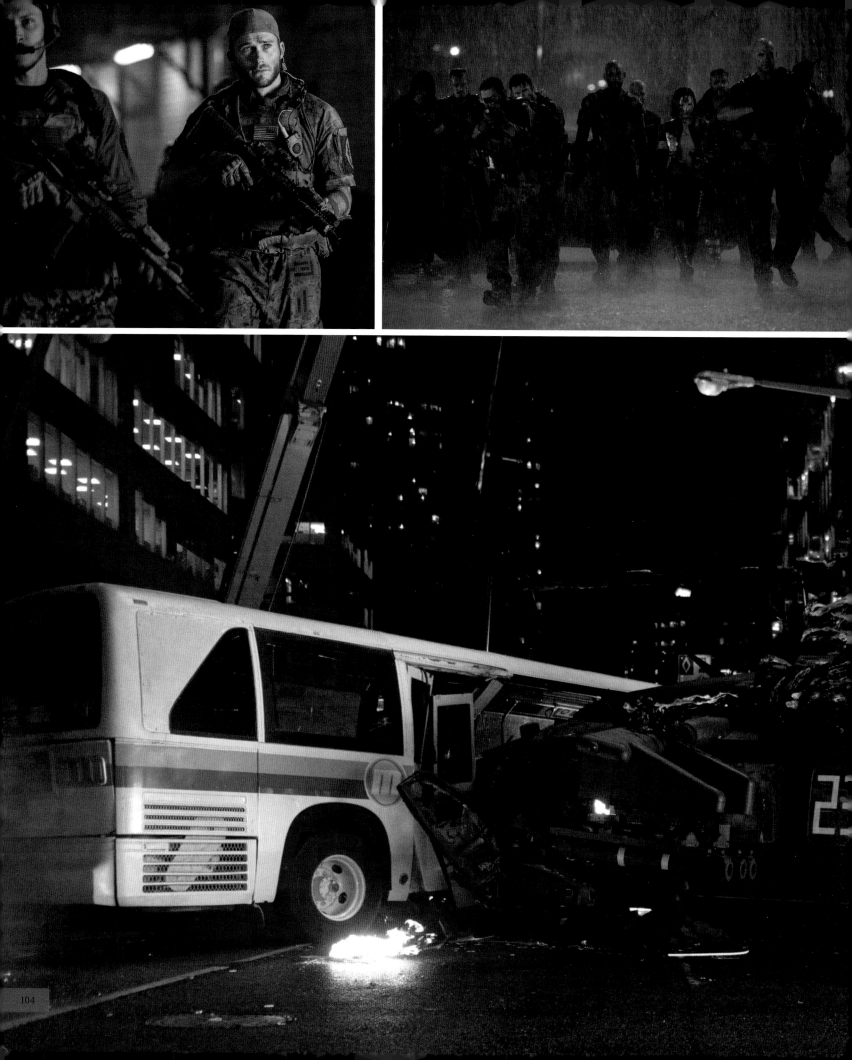

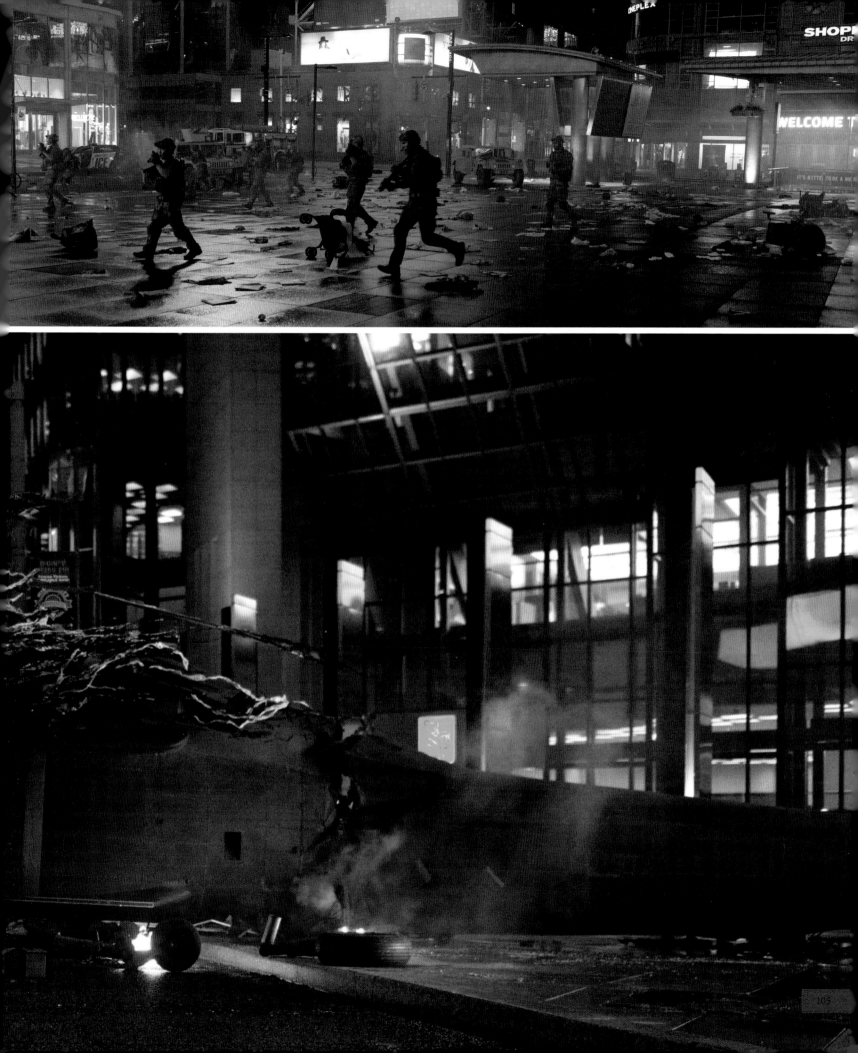

THE FEDERAL BUILDING

THIS PAGE (BOTTOM): *Sketch of Federal Building by Oliver Scholl (Production Designer).*

OPPOSITE: *Concept art of Federal Building with Deadshot, center.*

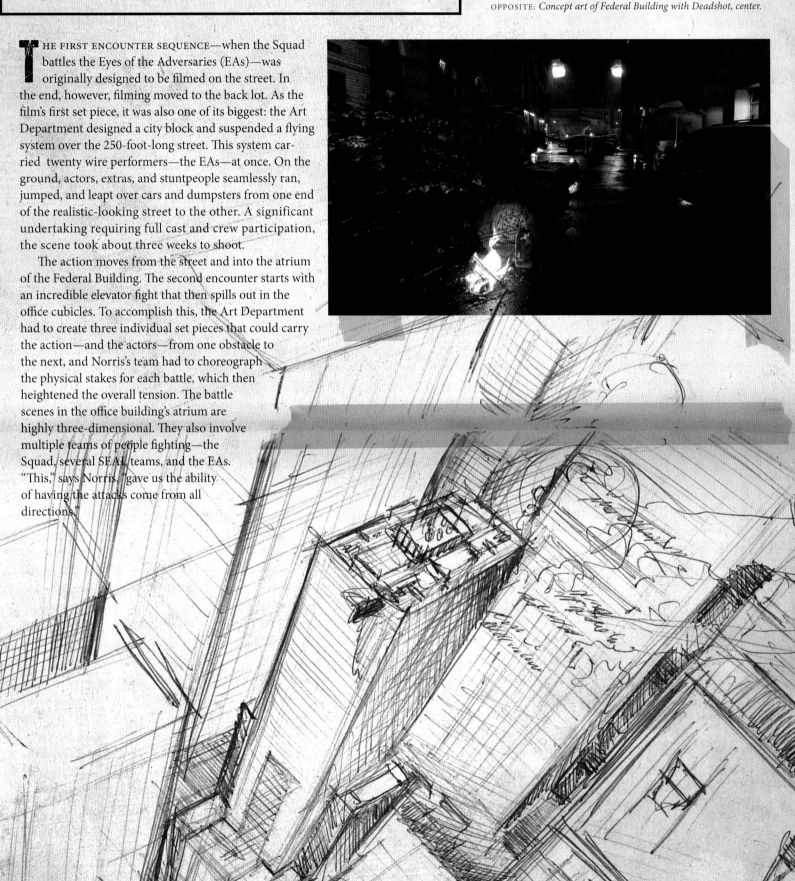

THE FIRST ENCOUNTER SEQUENCE—when the Squad battles the Eyes of the Adversaries (EAs)—was originally designed to be filmed on the street. In the end, however, filming moved to the back lot. As the film's first set piece, it was also one of its biggest: the Art Department designed a city block and suspended a flying system over the 250-foot-long street. This system carried twenty wire performers—the EAs—at once. On the ground, actors, extras, and stuntpeople seamlessly ran, jumped, and leapt over cars and dumpsters from one end of the realistic-looking street to the other. A significant undertaking requiring full cast and crew participation, the scene took about three weeks to shoot.

The action moves from the street and into the atrium of the Federal Building. The second encounter starts with an incredible elevator fight that then spills out in the office cubicles. To accomplish this, the Art Department had to create three individual set pieces that could carry the action—and the actors—from one obstacle to the next, and Norris's team had to choreograph the physical stakes for each battle, which then heightened the overall tension. The battle scenes in the office building's atrium are highly three-dimensional. They also involve multiple teams of people fighting—the Squad, several SEAL teams, and the EAs. "This," says Norris, "gave us the ability of having the attacks come from all directions."

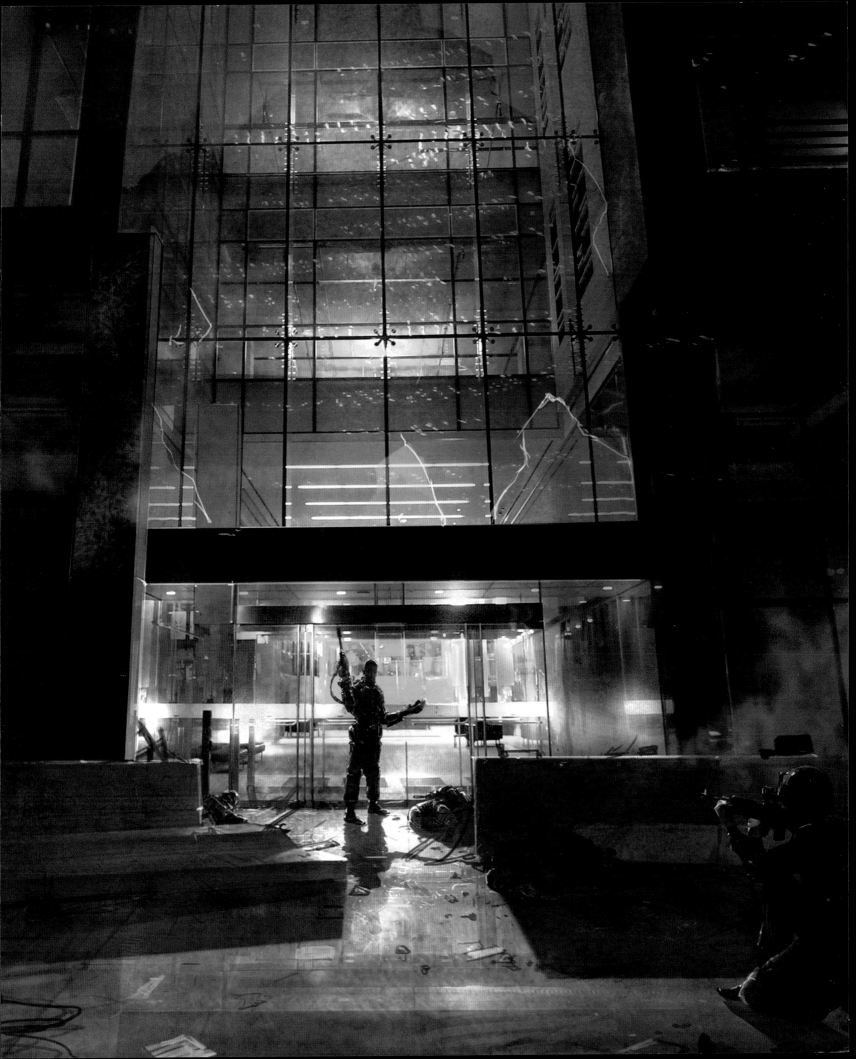

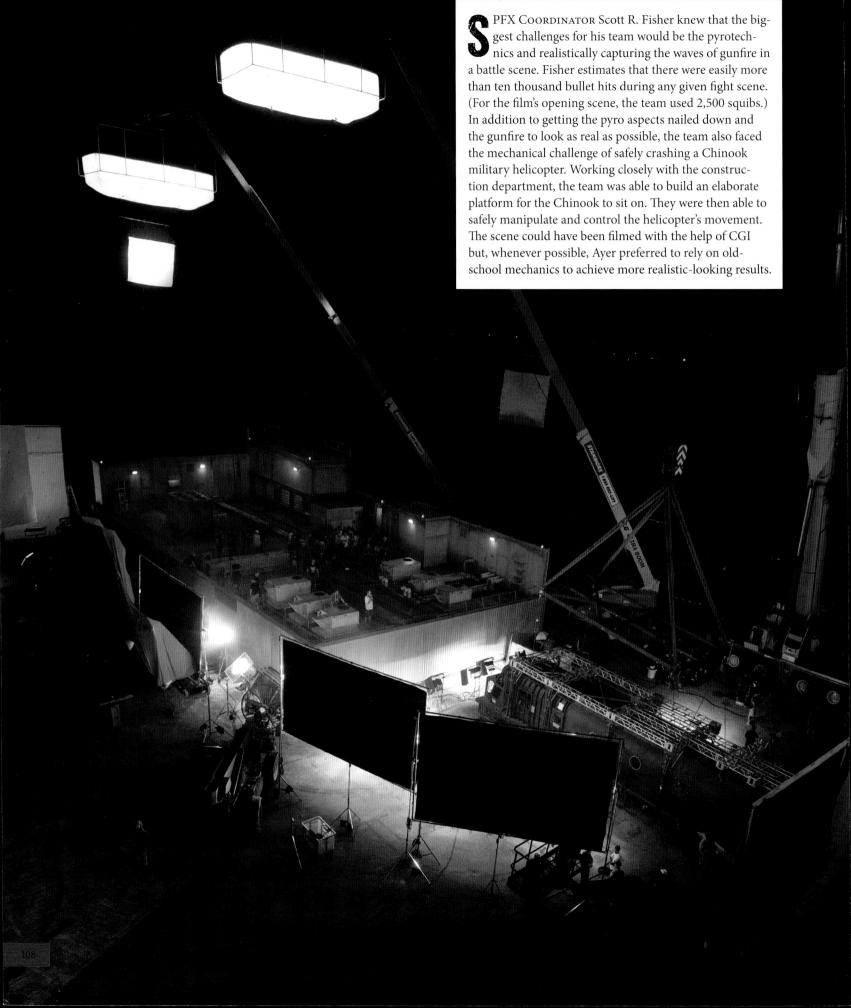

SPFX COORDINATOR Scott R. Fisher knew that the biggest challenges for his team would be the pyrotechnics and realistically capturing the waves of gunfire in a battle scene. Fisher estimates that there were easily more than ten thousand bullet hits during any given fight scene. (For the film's opening scene, the team used 2,500 squibs.) In addition to getting the pyro aspects nailed down and the gunfire to look as real as possible, the team also faced the mechanical challenge of safely crashing a Chinook military helicopter. Working closely with the construction department, the team was able to build an elaborate platform for the Chinook to sit on. They were then able to safely manipulate and control the helicopter's movement. The scene could have been filmed with the help of CGI but, whenever possible, Ayer preferred to rely on old-school mechanics to achieve more realistic-looking results.

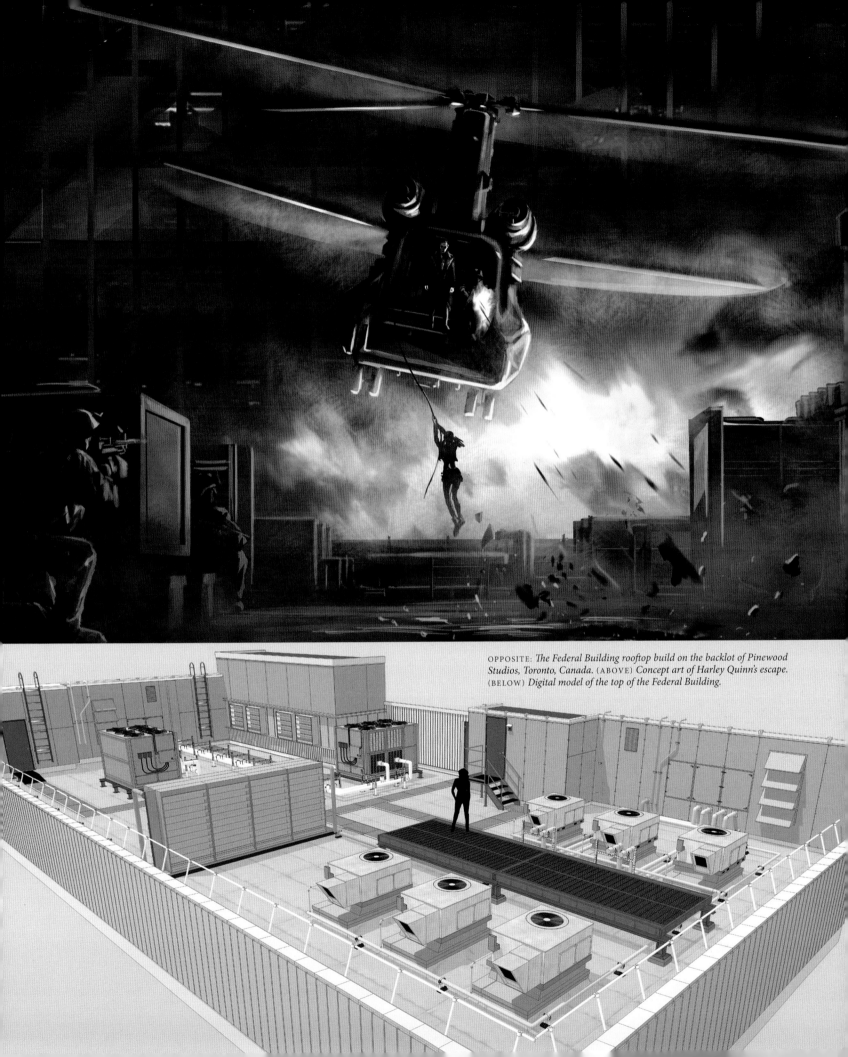

OPPOSITE: *The Federal Building rooftop build on the backlot of Pinewood Studios, Toronto, Canada.* (ABOVE) *Concept art of Harley Quinn's escape.* (BELOW) *Digital model of the top of the Federal Building.*

DOUBLE TROUBLE

SUPERNATURAL SIBLINGS

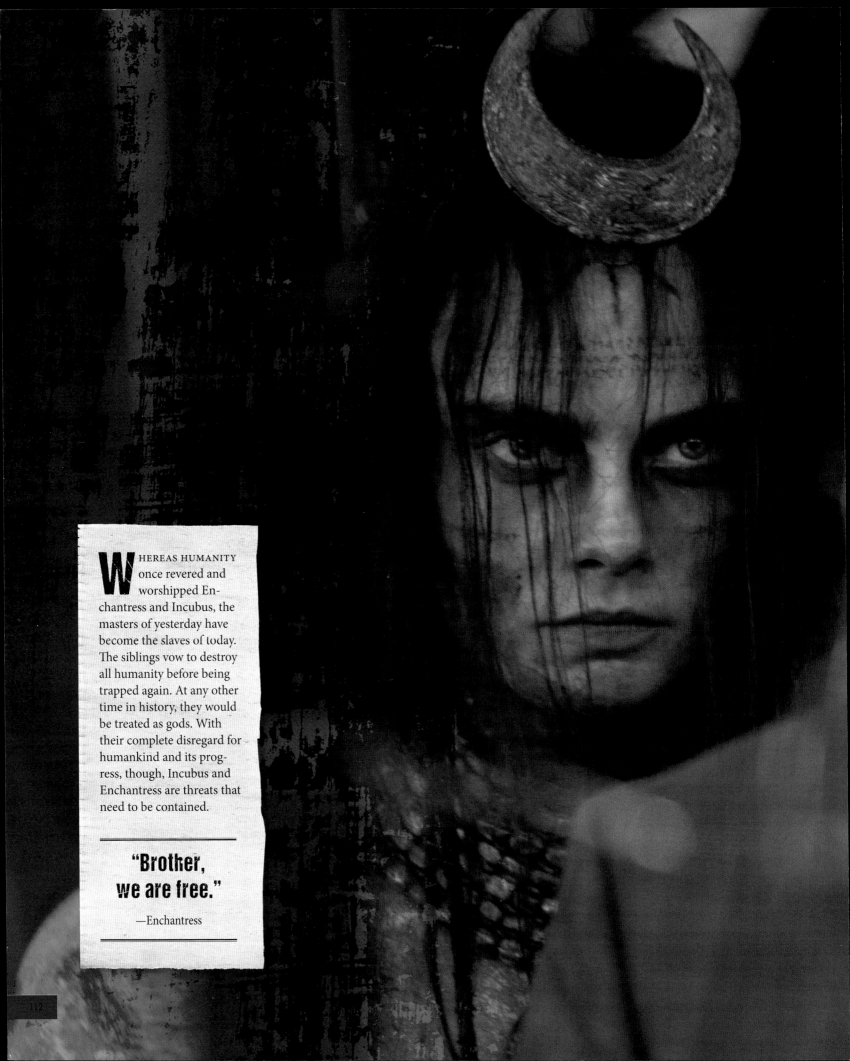

WHEREAS HUMANITY once revered and worshipped Enchantress and Incubus, the masters of yesterday have become the slaves of today. The siblings vow to destroy all humanity before being trapped again. At any other time in history, they would be treated as gods. With their complete disregard for humankind and its progress, though, Incubus and Enchantress are threats that need to be contained.

"Brother, we are free."

—Enchantress

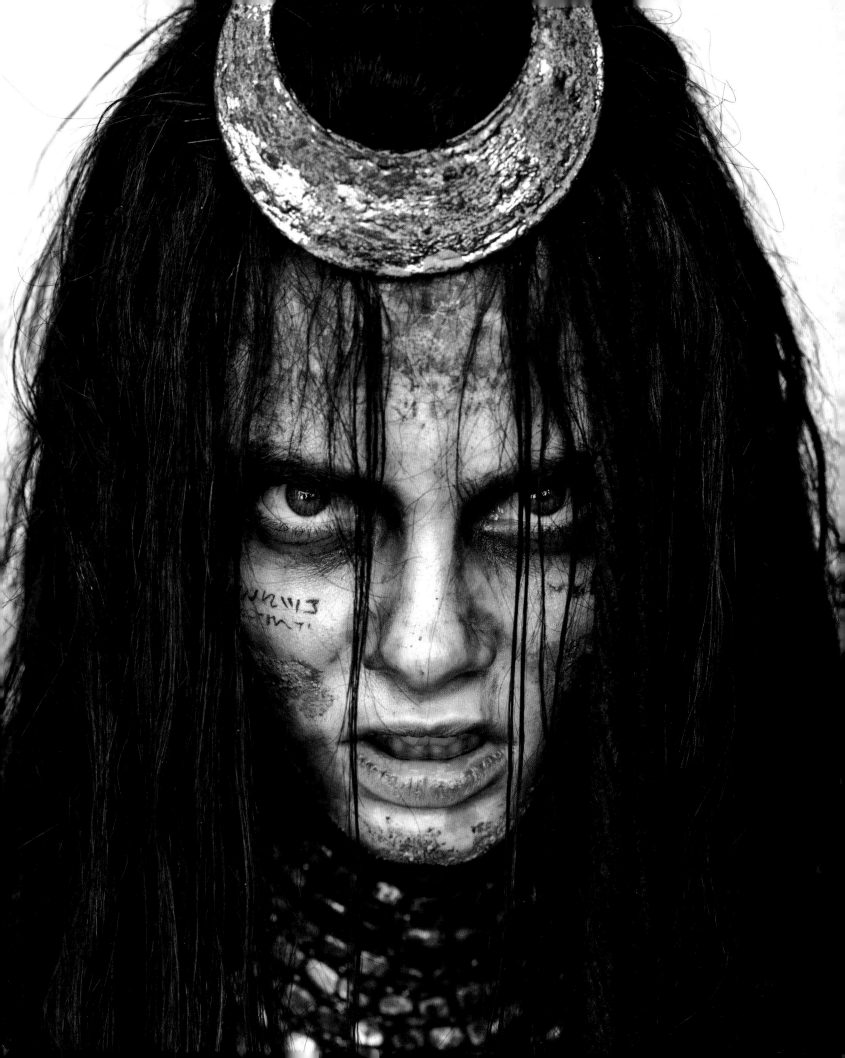

Cara Delevingne

ENCHANTRESS

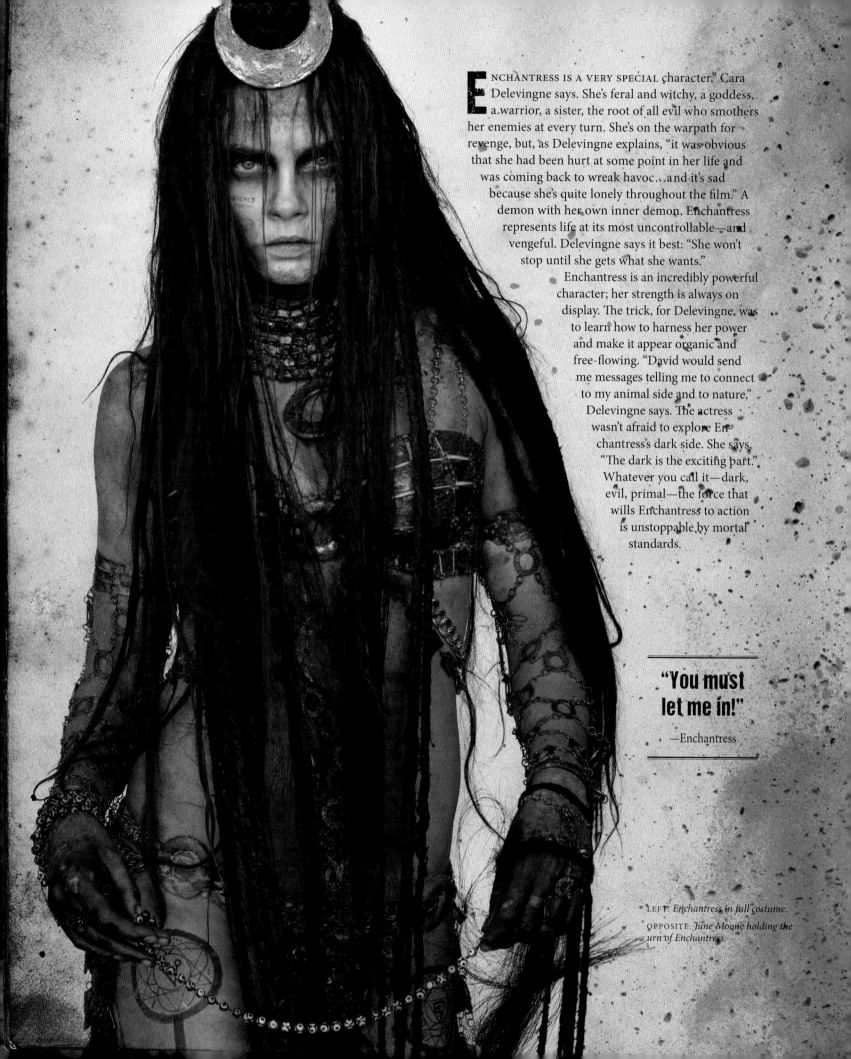

"ENCHANTRESS IS A VERY SPECIAL character," Cara Delevingne says. She's feral and witchy, a goddess, a warrior, a sister, the root of all evil who smothers her enemies at every turn. She's on the warpath for revenge, but, as Delevingne explains, "it was obvious that she had been hurt at some point in her life and was coming back to wreak havoc…and it's sad because she's quite lonely throughout the film." A demon with her own inner demon, Enchantress represents life at its most uncontrollable—and vengeful. Delevingne says it best: "She won't stop until she gets what she wants."

Enchantress is an incredibly powerful character; her strength is always on display. The trick, for Delevingne, was to learn how to harness her power and make it appear organic and free-flowing. "David would send me messages telling me to connect to my animal side and to nature," Delevingne says. The actress wasn't afraid to explore Enchantress's dark side. She says, "The dark is the exciting part." Whatever you call it—dark, evil, primal—the force that wills Enchantress to action is unstoppable by mortal standards.

"You must let me in!"

—Enchantress

LEFT: *Enchantress in full costume.*

OPPOSITE: *June Moone holding the urn of Enchantress.*

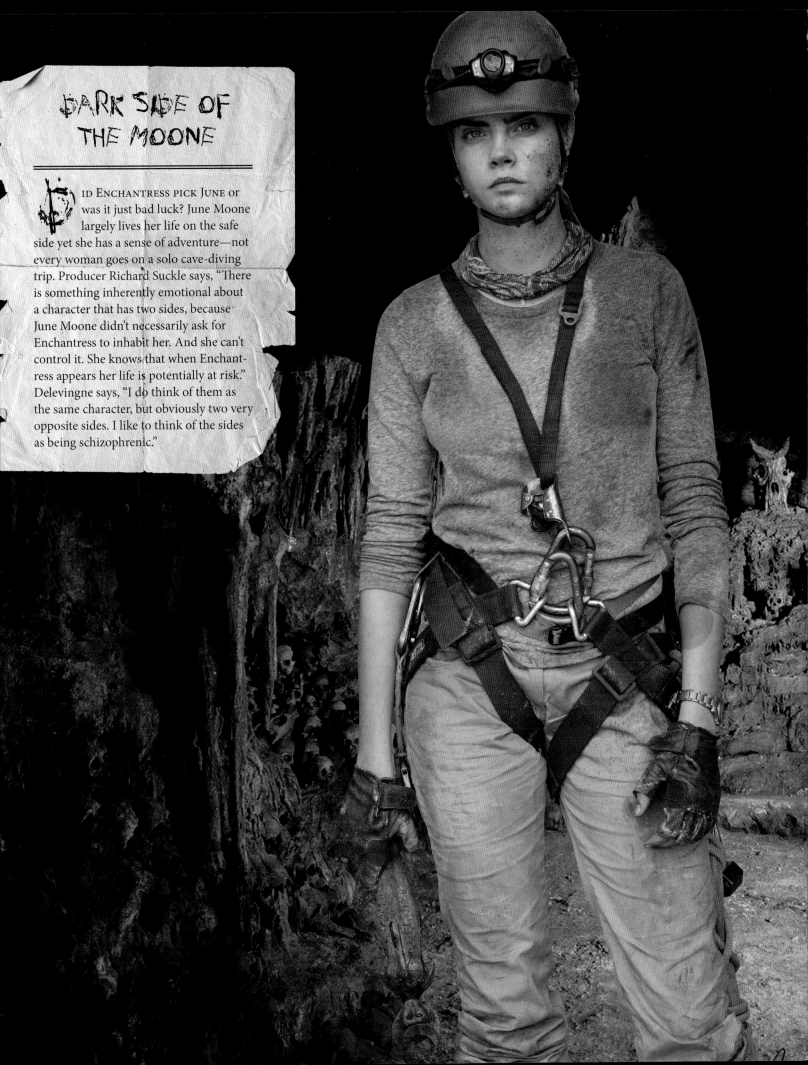

DARK SIDE OF THE MOONE

ID ENCHANTRESS PICK JUNE or was it just bad luck? June Moone largely lives her life on the safe side yet she has a sense of adventure—not every woman goes on a solo cave-diving trip. Producer Richard Suckle says, "There is something inherently emotional about a character that has two sides, because June Moone didn't necessarily ask for Enchantress to inhabit her. And she can't control it. She knows that when Enchantress appears her life is potentially at risk." Delevingne says, "I do think of them as the same character, but obviously two very opposite sides. I like to think of the sides as being schizophrenic."

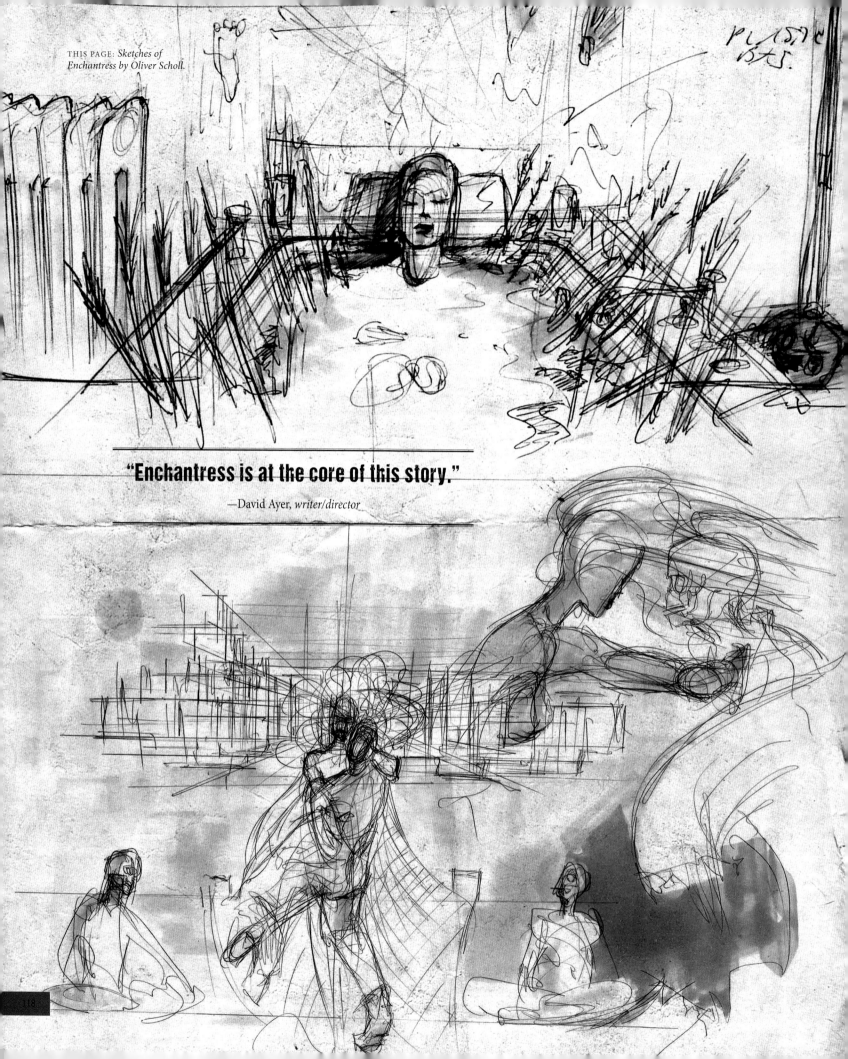

THIS PAGE: *Sketches of Enchantress by Oliver Scholl.*

PLASTIC ISIS.

"Enchantress is at the core of this story."

—David Ayer, *writer/director*

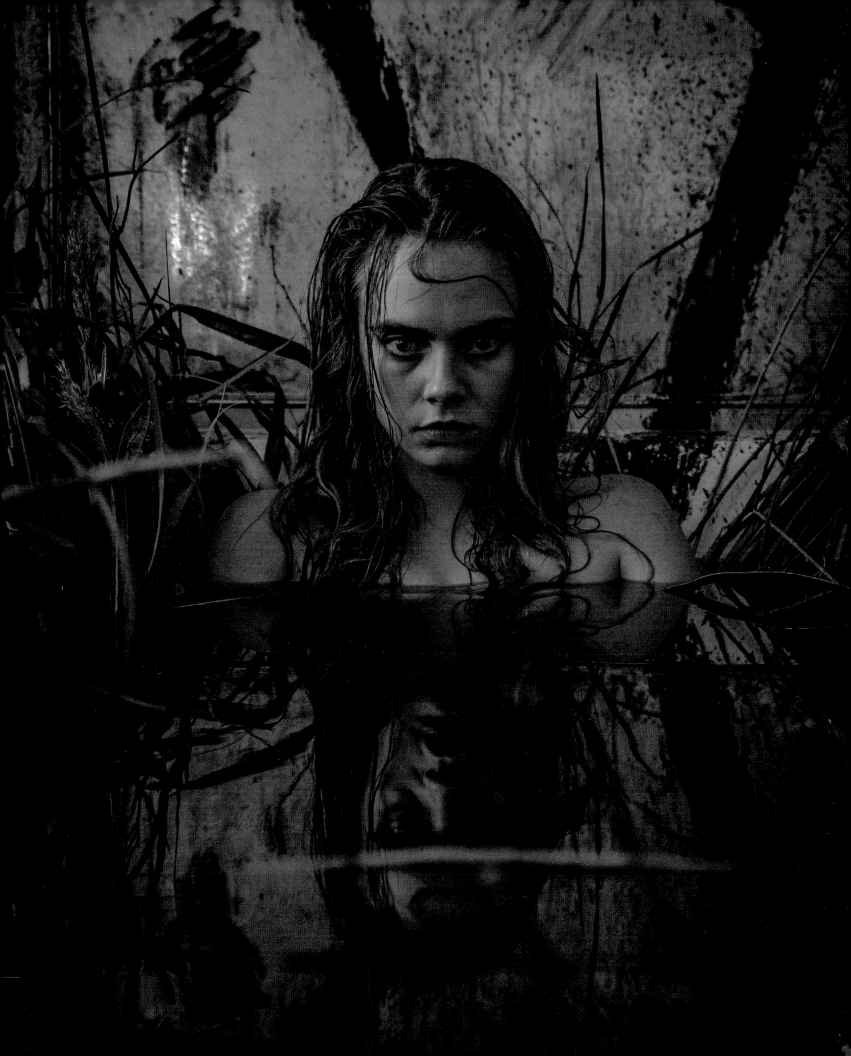

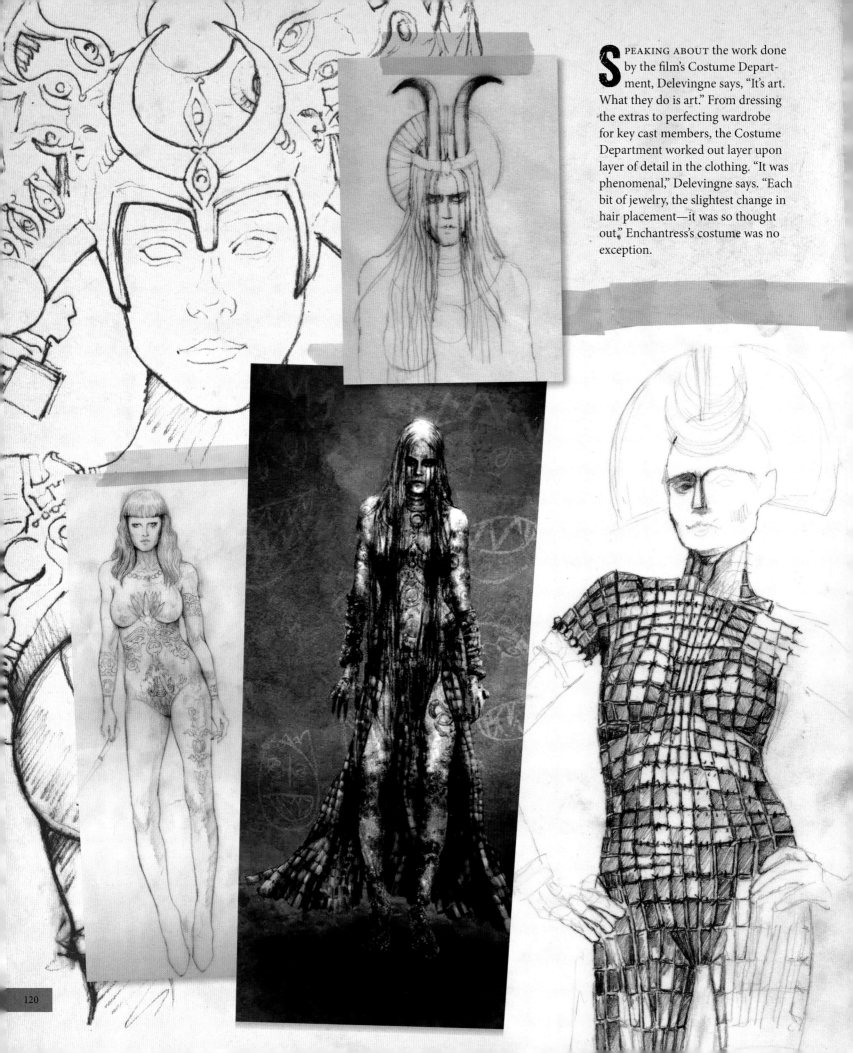

SPEAKING ABOUT the work done by the film's Costume Department, Delevingne says, "It's art. What they do is art." From dressing the extras to perfecting wardrobe for key cast members, the Costume Department worked out layer upon layer of detail in the clothing. "It was phenomenal," Delevingne says. "Each bit of jewelry, the slightest change in hair placement—it was so thought out," Enchantress's costume was no exception.

Costume Designer Kate Hawley says, "There's not a lot that we know about Enchantress. We played with the iconography of the color green." The greens of Enchantress's costume are earthy while her jewelry is sparkling jade and eye-catching emerald. The jewelry design references some occult-like motifs; similarly themed symbols worked their way into her costume as tattoos. Her wardrobe, like Enchantress herself, is simultaneously primitive—a bustier seemingly made from shells, rocks, and dirt—and polished.

Delevingne spent three hours in hair and makeup daily. Enchantress's hair is actually a mop, dyed black, mixed with hair from a wig, and interlaced with mud, feathers, and dust. Makeup and Hair Designer Alessandro Bertolazzi says, "We started with the idea of Enchantress being in the cave." The team imagined her hair—and much of her costume too—as being comprised of organic materials found lying about in Skull Cave. This idea expanded even further with the symbols scrawled on her body. Look closely— throughout the film, these symbols and their placement change.

"Bad guys are intriguing, you know? You want to understand them more."

—Cara Delevingne

THIS PAGE AND OPPOSITE: *A mix of Hawley's costume illustrations and early concept art for Enchantress's costume.*

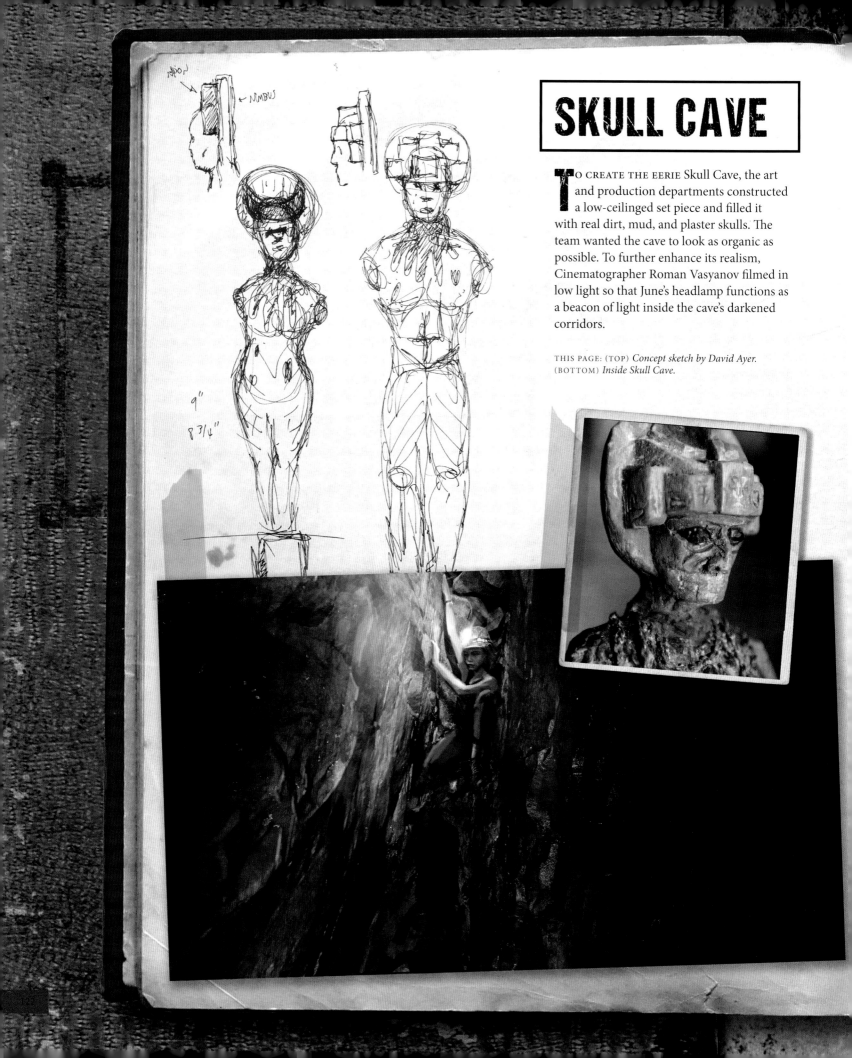

SKULL CAVE

TO CREATE THE EERIE Skull Cave, the art and production departments constructed a low-ceilinged set piece and filled it with real dirt, mud, and plaster skulls. The team wanted the cave to look as organic as possible. To further enhance its realism, Cinematographer Roman Vasyanov filmed in low light so that June's headlamp functions as a beacon of light inside the cave's darkened corridors.

THIS PAGE: (TOP) *Concept sketch by David Ayer.* (BOTTOM) *Inside Skull Cave.*

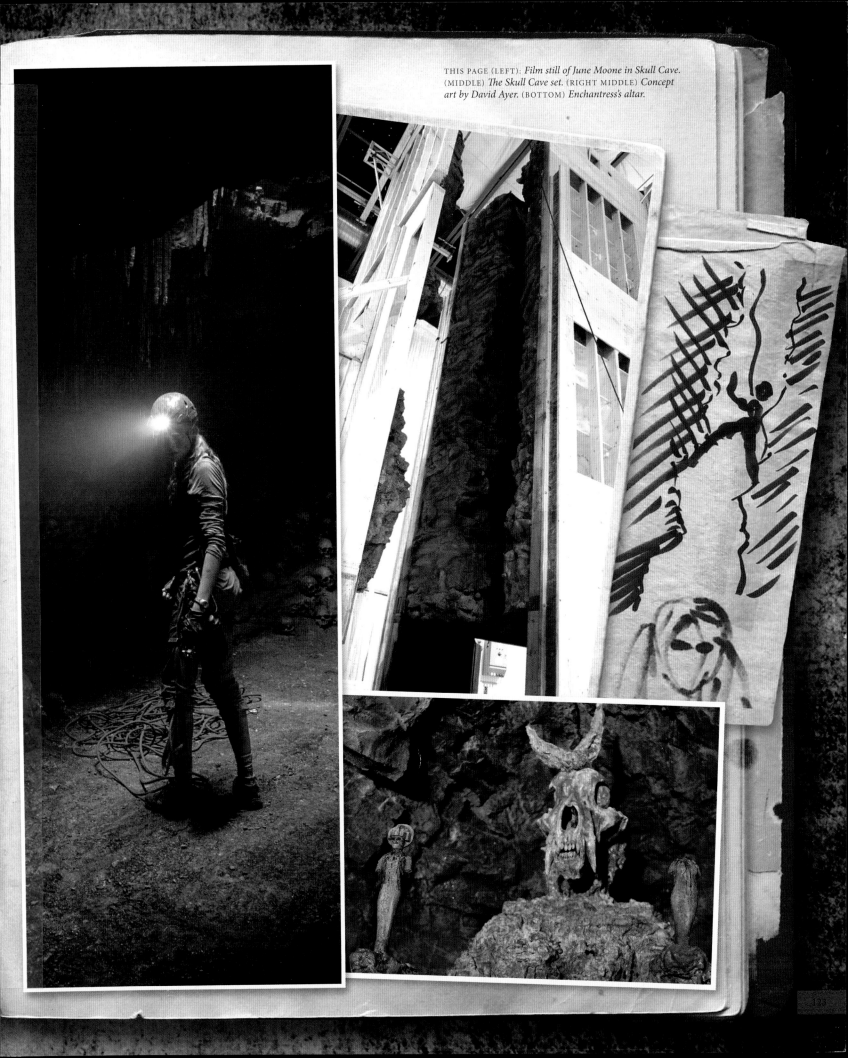

THIS PAGE (LEFT): *Film still of June Moone in Skull Cave.* (MIDDLE) *The Skull Cave set.* (RIGHT MIDDLE) *Concept art by David Ayer.* (BOTTOM) *Enchantress's altar.*

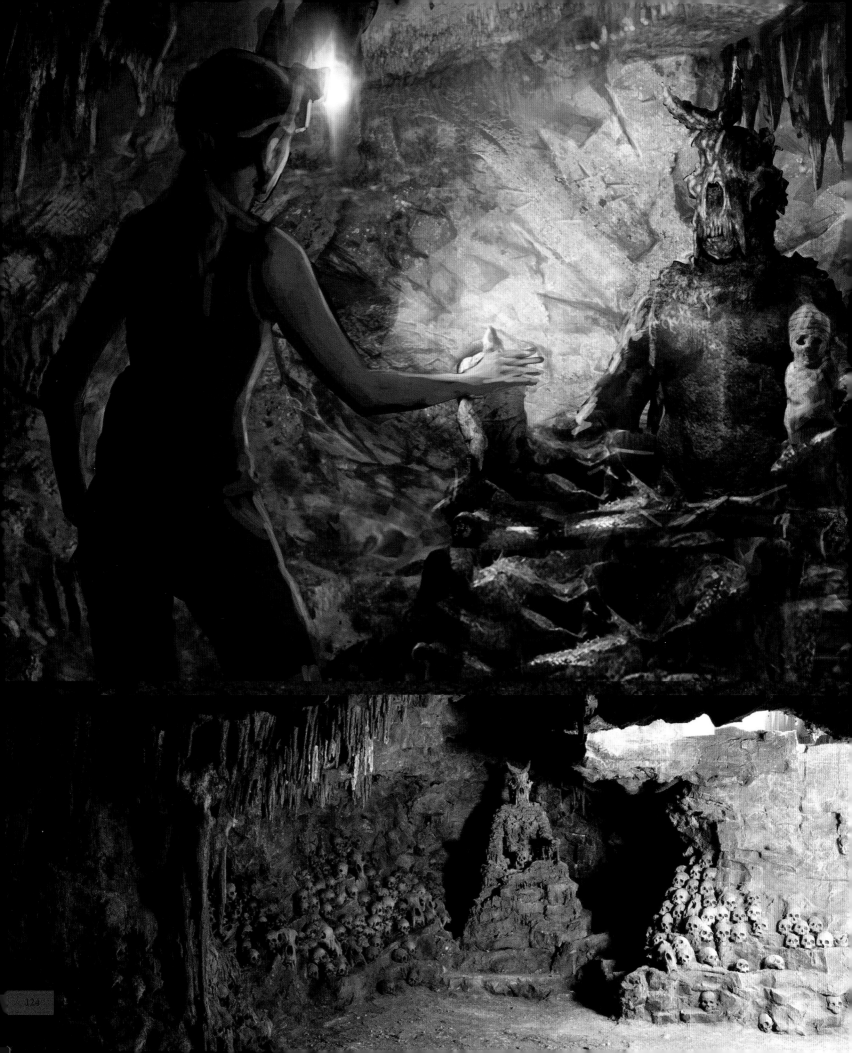

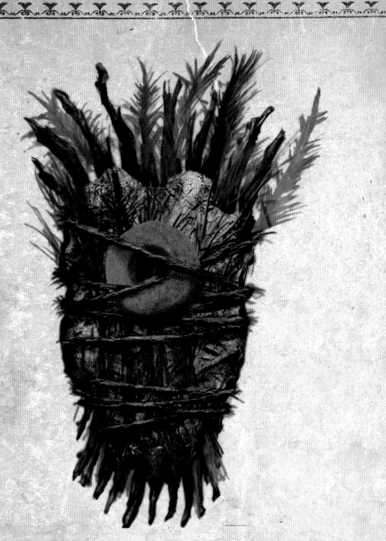

THE HEART OF THE MATTER

> **"Some say witches have a secret buried heart. Whoever finds it can kill the witch."**
>
> —Amanda Waller

NOT ONLY DOES Amanda Waller manipulate June Moone's romantic relationship with Colonel Rick Flag to her advantage but she also keeps Enchantress's heart in a box—literally. In searching the Skull Cave, Waller finds a mummified human heart. Waller traps the heart in a box; she alone has its key.

This trapped heart is the source of Enchantress's power. To protect it, she's forced to follow Waller's every command. What Waller doesn't know, however, is Enchantress has other plans. As June Moone says, "Waller thinks she has a servant. But Waller serves the witch." Waller may be excellent at manipulating coworkers and criminals, but she's no match for magic.

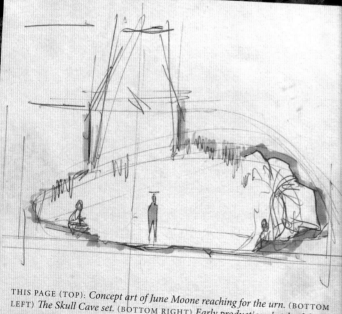

THIS PAGE (TOP): *Concept art of June Moone reaching for the urn.* (BOTTOM LEFT) *The Skull Cave set.* (BOTTOM RIGHT) *Early production sketch of the cave.*
ABOVE RIGHT: *Art model of Enchantress's heart.*

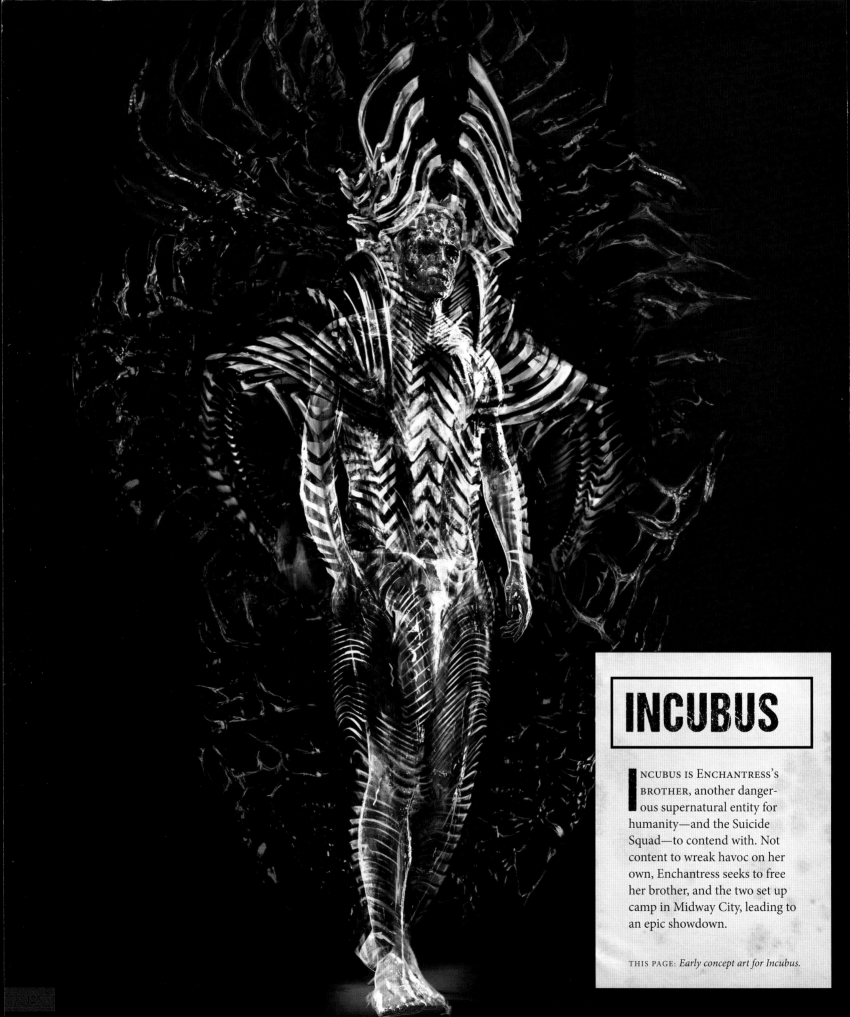

INCUBUS

INCUBUS IS ENCHANTRESS'S
BROTHER, another danger-
ous supernatural entity for
humanity—and the Suicide
Squad—to contend with. Not
content to wreak havoc on her
own, Enchantress seeks to free
her brother, and the two set up
camp in Midway City, leading to
an epic showdown.

THIS PAGE: *Early concept art for Incubus.*

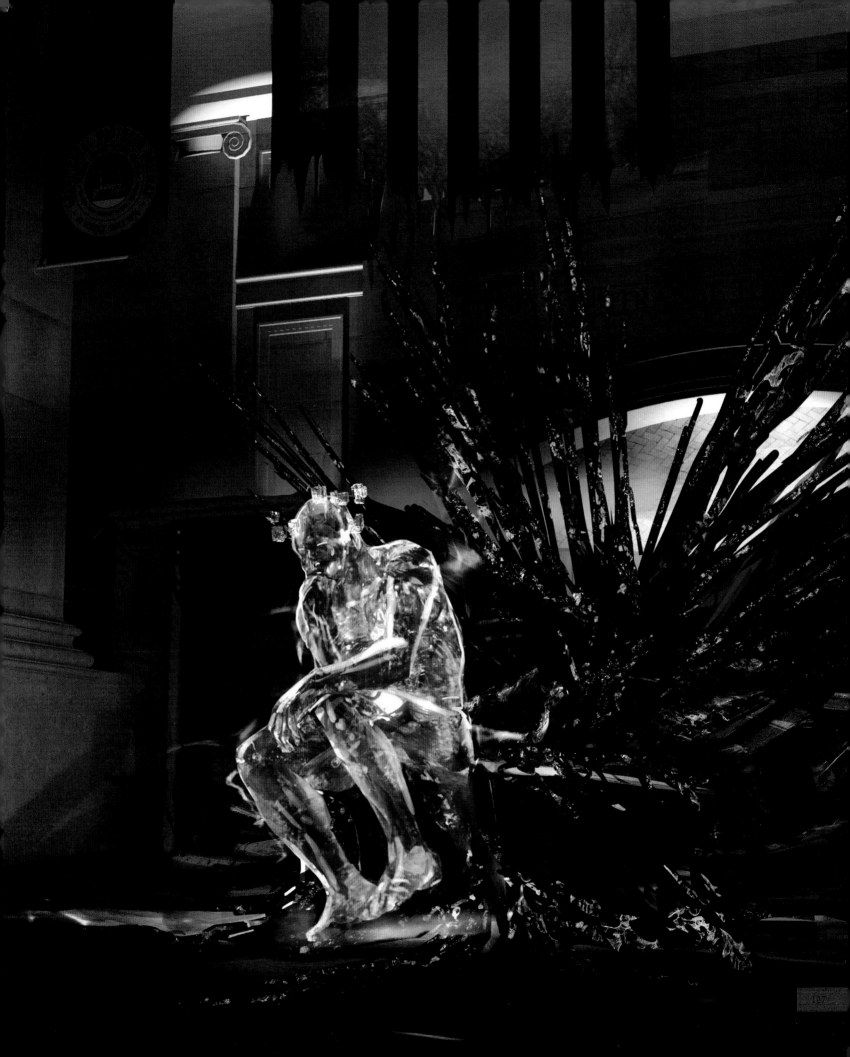

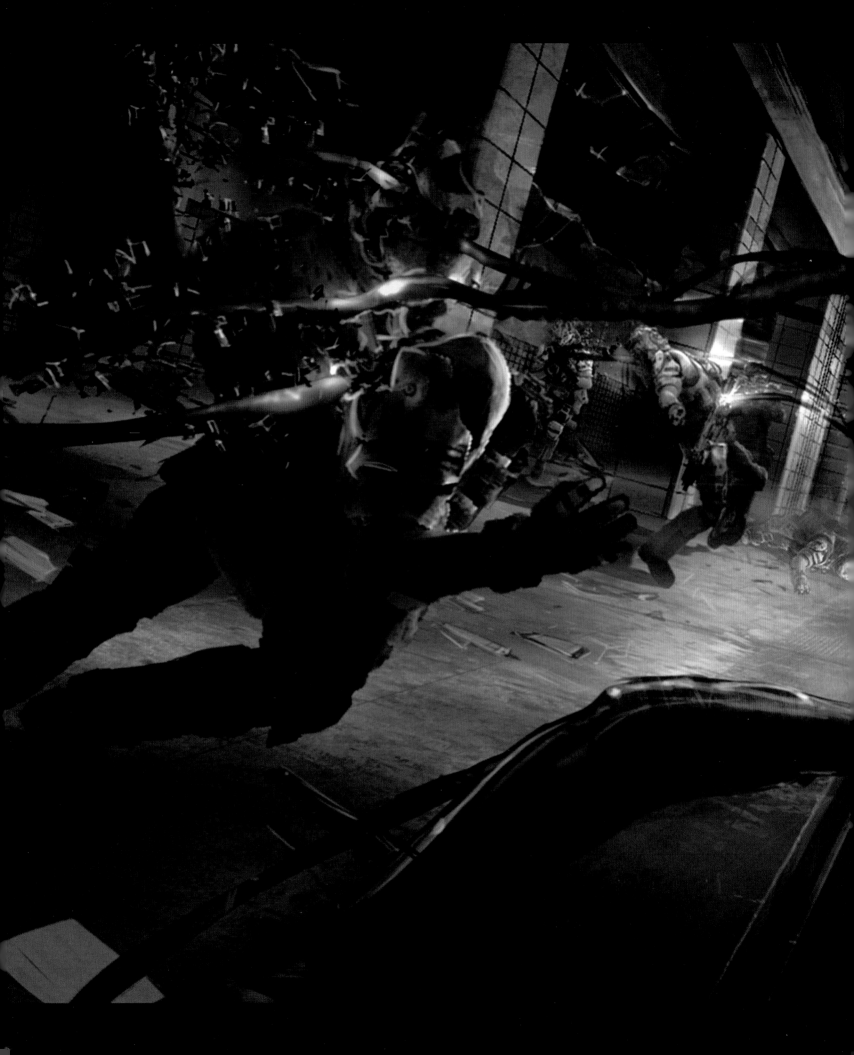

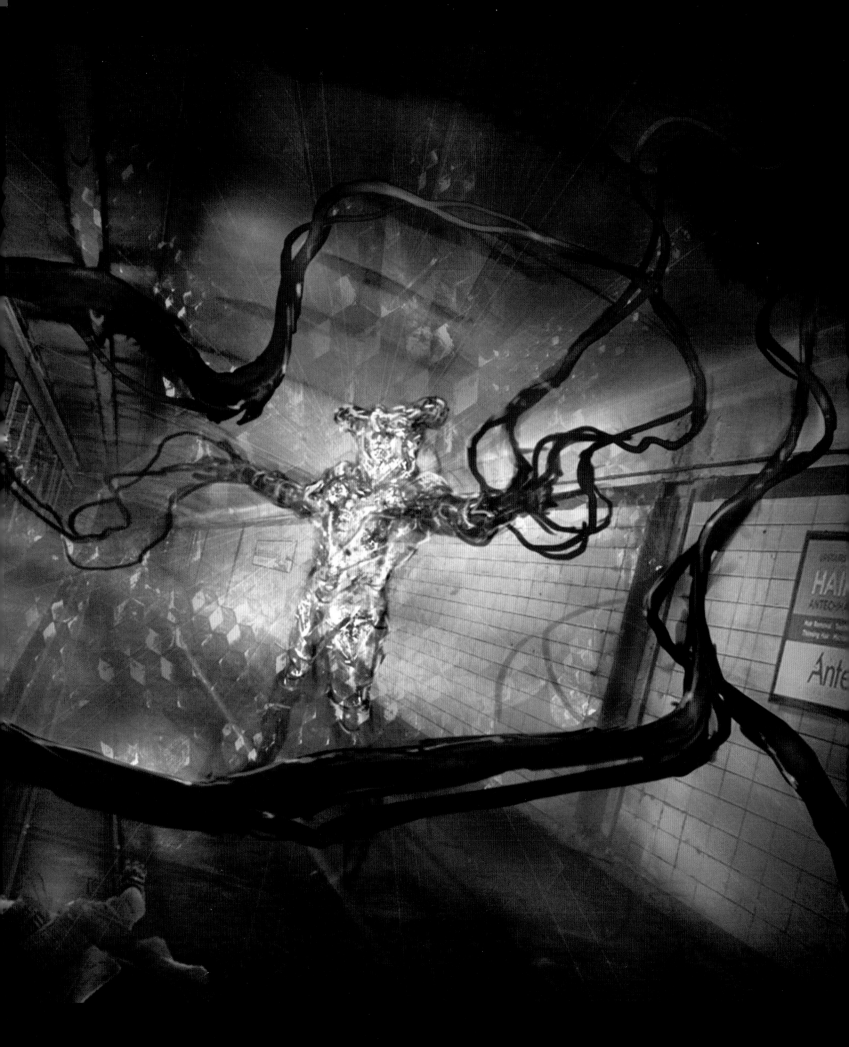

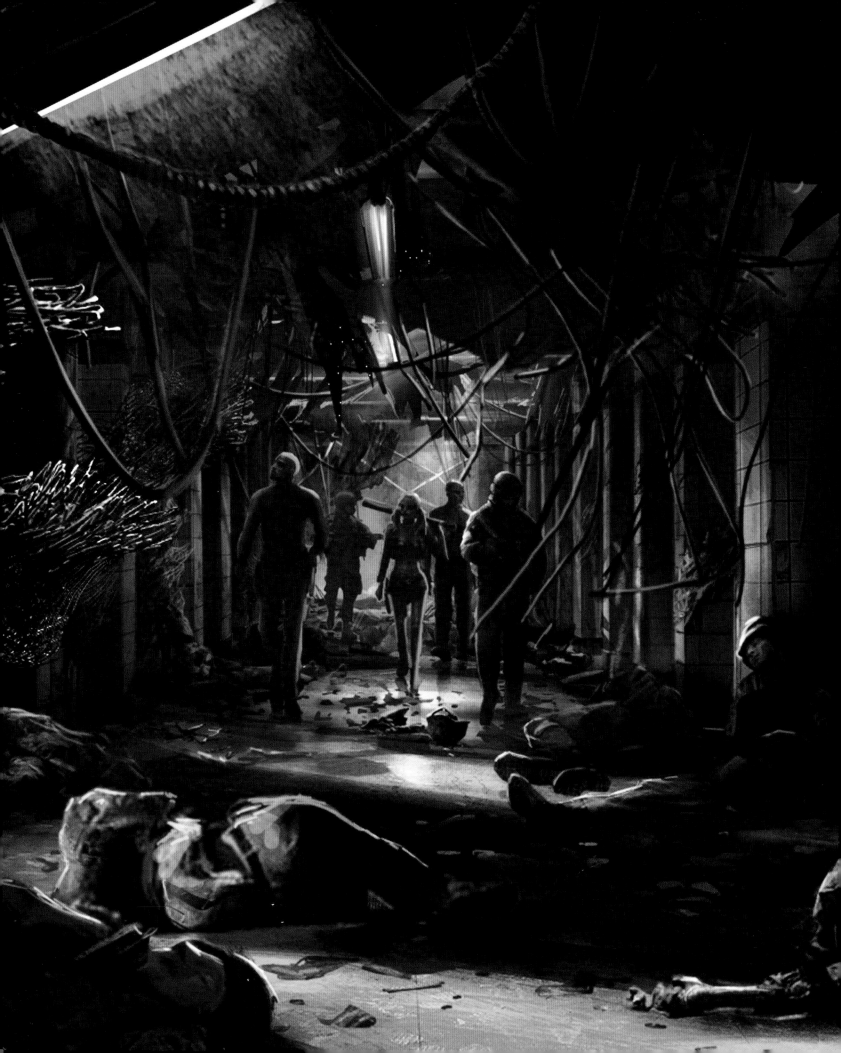

THE EYES OF THE ADVERSARY

THEIR ARMY IS A GROUP of EAs or "Eyes of the Adversary"— human beings converted into alien-like creatures covered in eyeballs. Nothing seems to stop their advances. Working together, brother and sister restore each other's strength and turn their attention towards wreaking vengeance against mankind. Just when it looks like humanity is on its knees, the Suicide Squad steps up to the plate. This time, it's the bad guys versus evil. Fighting together to defeat Enchantress, Incubus, and their legion of EAs, the Suicide Squad proves that even bad guys can be good.

Like Argus, the one-hundred-eyed mythological Greek creature, the EAs are all-seeing, their bodies literally covered in eyeballs. Originally, Ayer thought he would use CGI to create the EAs. Action Unit Director Guy Norris, however, was more intrigued with the idea of making the adversarial creatures move in a way that hadn't been seen before on film. He says, "How can we believe it, how could they interact with the cast at the same time?" Because the EAs are in the film for such a large amount of time, Norris and Ayer decided, in the end, that they couldn't rely completely on CGI. "I don't like the idea of a major actor trying to do a performance against a piece of green," says Norris. "And so the hard work for us was really figuring out what . . . *how* could we do this." That conundrum brought the team around to doing movement studies and analyzing how people move in particular ways. "Then," says Norris, "we introduced wire work but we wanted to make it *look* like they weren't on wires. . . . They just move faster than

we do. They can jump and leap higher. They have no feeling. And they can take an enormous amount of ammunition and . . . damage before they are killed or disposed of."

That high-wire act—having stuntpeople work on wires so effortlessly that it would appear there were no wires at all—became the team's main focus. Norris says, "Each film has some nut to crack, and on this film, it was how do we get the adversaries to move, and how do we make that believable, scary, imposing, dangerous . . . all of those things."

> ## "Each film has some nut to crack, and on this film, it was how do we get the adversaries to move."
>
> —Guy Norris, *action unit director / supervising stunt coordinator*

THIS PAGE: *Harley Quinn battles an EA.*

OPPOSITE: *Early concept art: the Squad readies itself for battle.*

FOLLOWING PAGE: *Film still and early concept art, detail of hands, of the EAs. The EAs came to Ayer in a fevered dream. When he woke, he drew their bodies, covered in so many all-seeing eyes.*

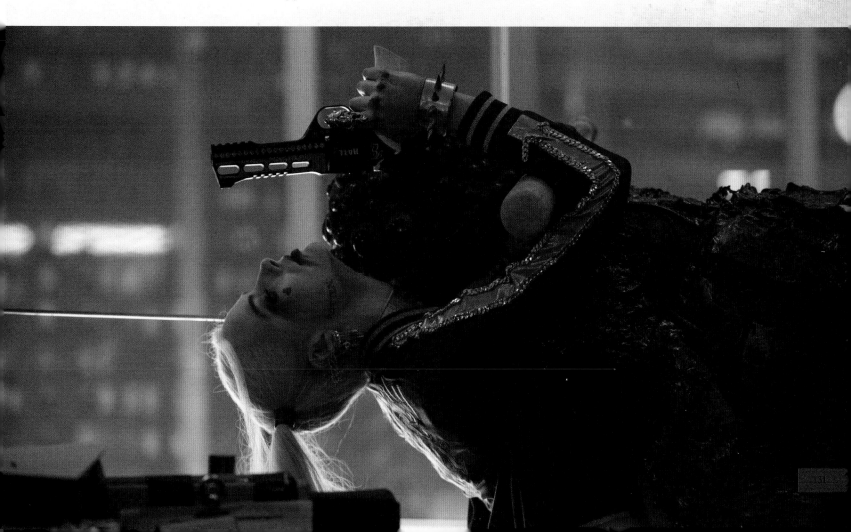

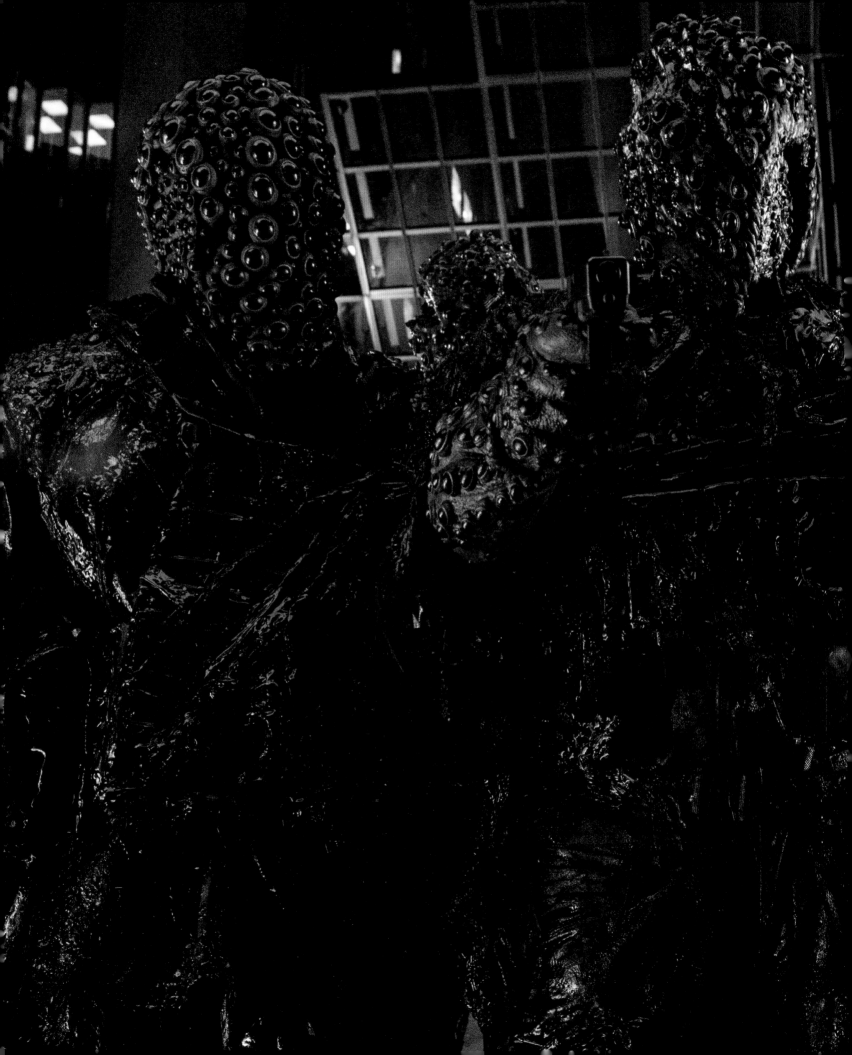

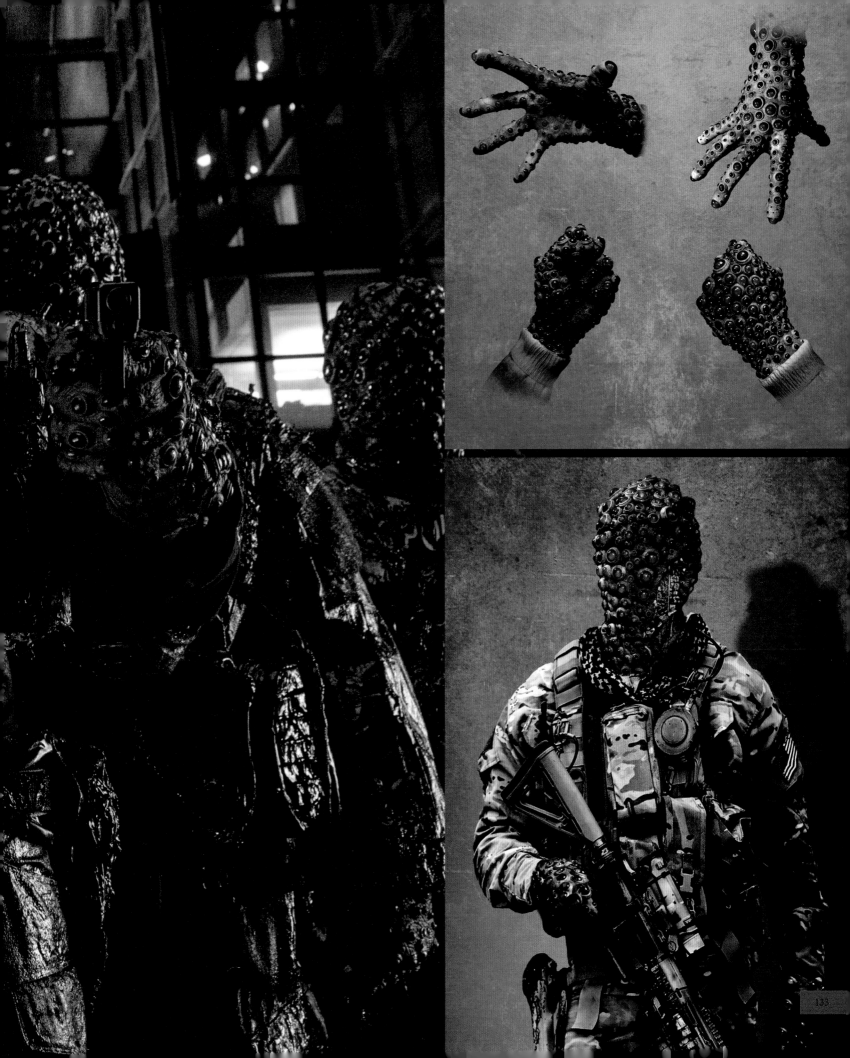

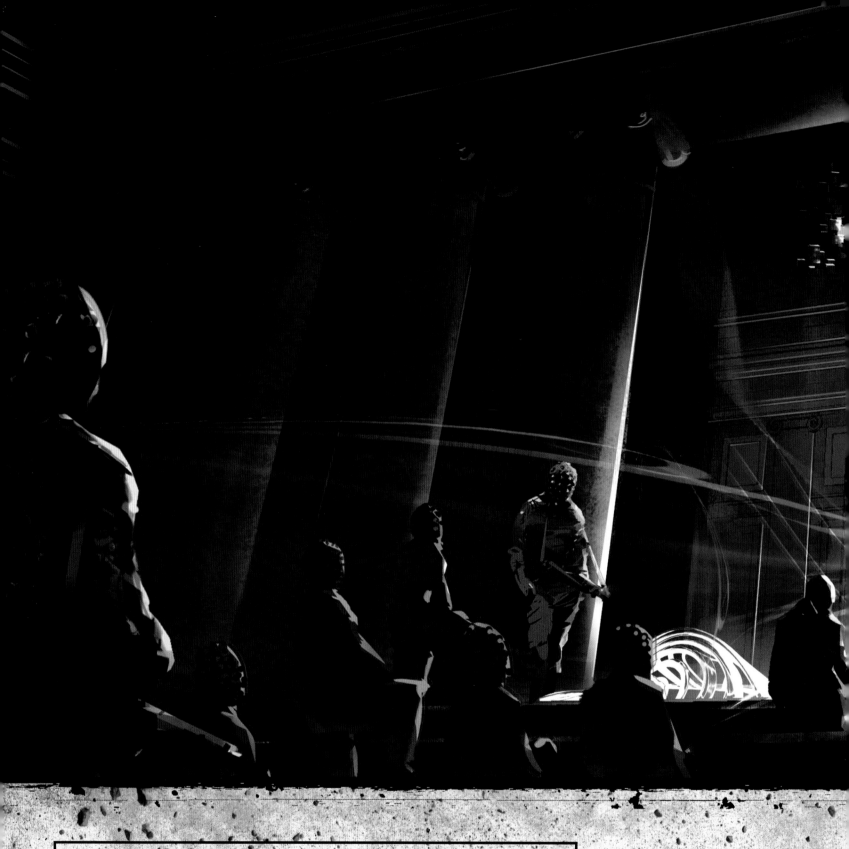

ENCHANTRESS'S MACHINE

THIS PAGE: *Early concept art of Enchantress's Machine.*

ENCHANTRESS AND INCUBUS set up camp inside the Midway City train station, and dedicate their efforts towards building a machine to wipe out the world. The engine of this great machine is stoked entirely by a fleet of magical men/creatures—evil monks of mystical origins. Supernatural by design, the Machine is slightly futuristic looking yet, in a nod to Enchantress's more primal side, it also bears primitive markings and iconography. Like Enchantress and Incubus, it is both of the past and from the future—timeless and otherworldly. And, like Enchantress and Incubus, it's completely deadly.

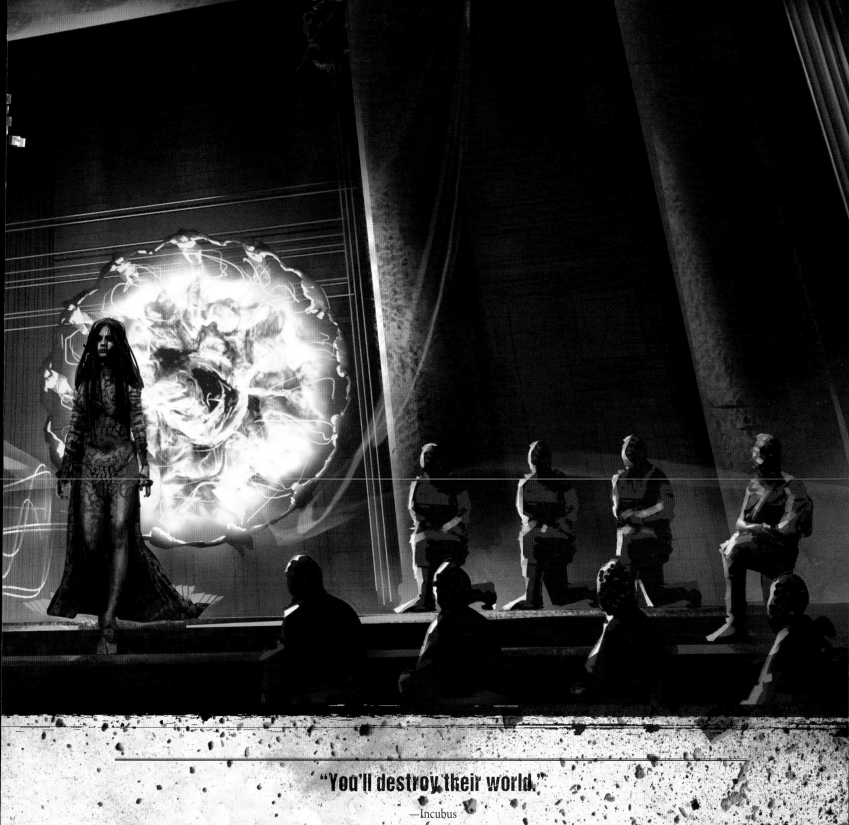

"You'll destroy their world."

—Incubus

"No, we will grind it into our dreams. And make of it what we want. And be gods again. And the human animals will despair what they did to us, Forever."

—Enchantress

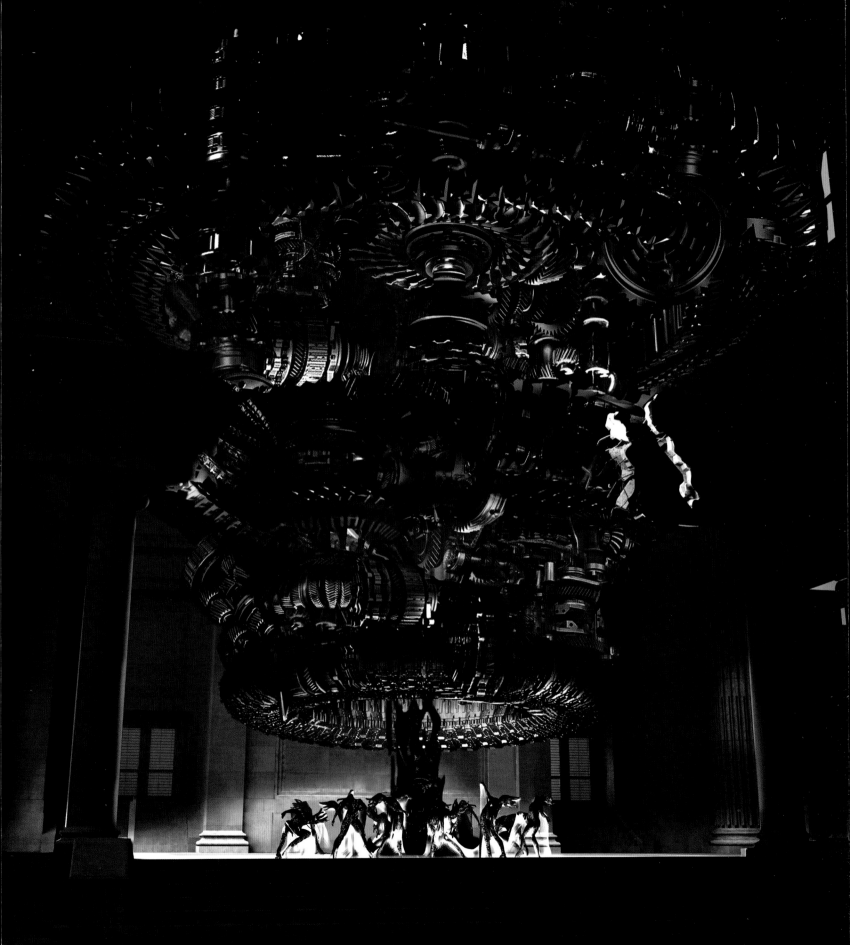

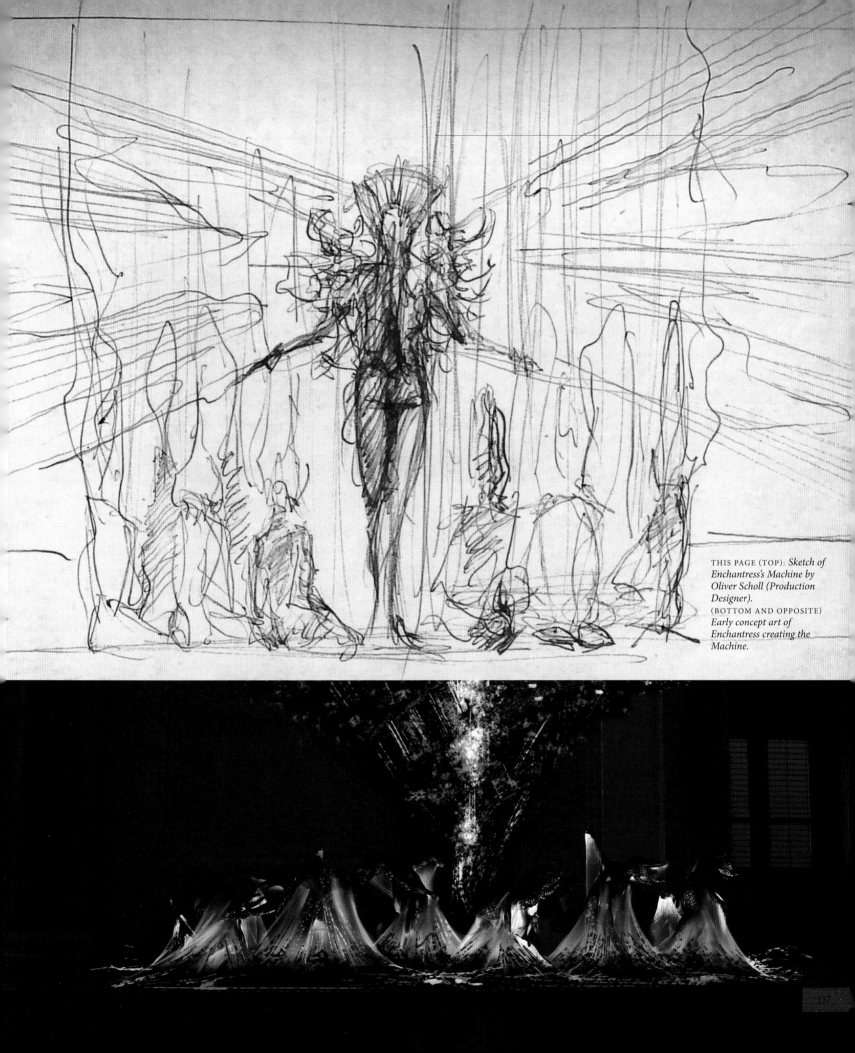

THIS PAGE (TOP): *Sketch of Enchantress's Machine by Oliver Scholl (Production Designer).* (BOTTOM AND OPPOSITE) *Early concept art of Enchantress creating the Machine.*

BATTLE ROYALE

> "Diablo. Melt that fool."
>
> —Deadshot

WHEN INCUBUS TURNS HIS FURY on the members of the Suicide Squad, they stand their ground . . . together, as a family. Boomerang hits Incubus with the full force of his weapons but the boomerangs ricochet off the superhuman. Deadshot uses his wrist magnums, blasting Incubus's face armor to little effect. Diablo, in a final attempt to protect his friends, levitates and transforms into a massive skeleton of fire. The ensuing battle is epic and victory seems out of reach.

For the first time, though, the Suicide Squad is working together as a team and doing what they do best—kicking ass. Even if they lose this fight, they've won the battle, their friendship forged in scars.

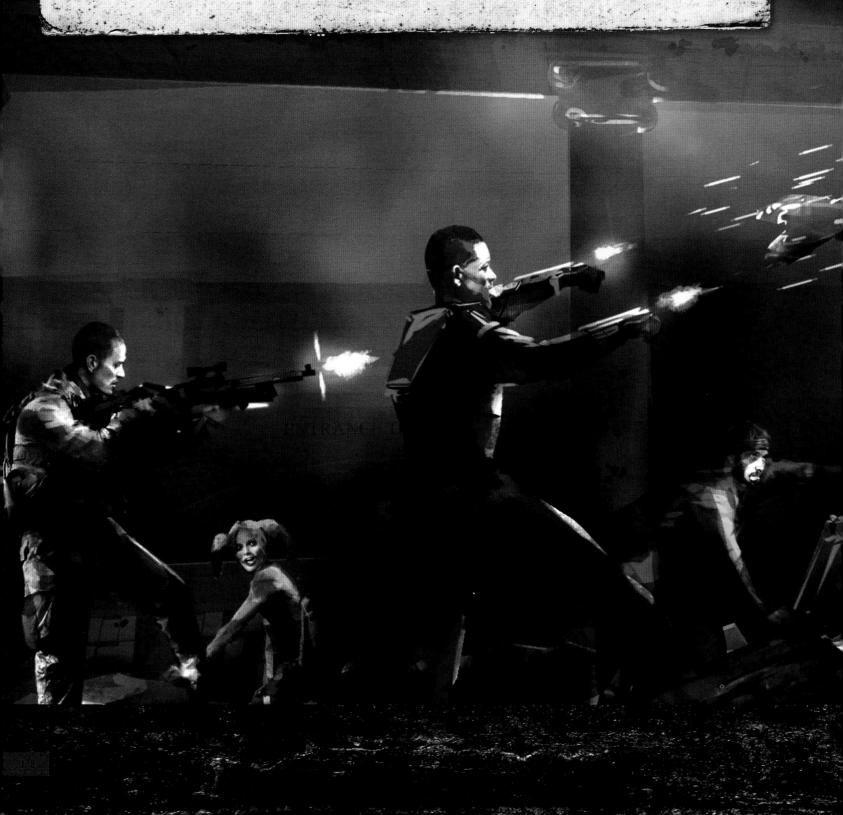

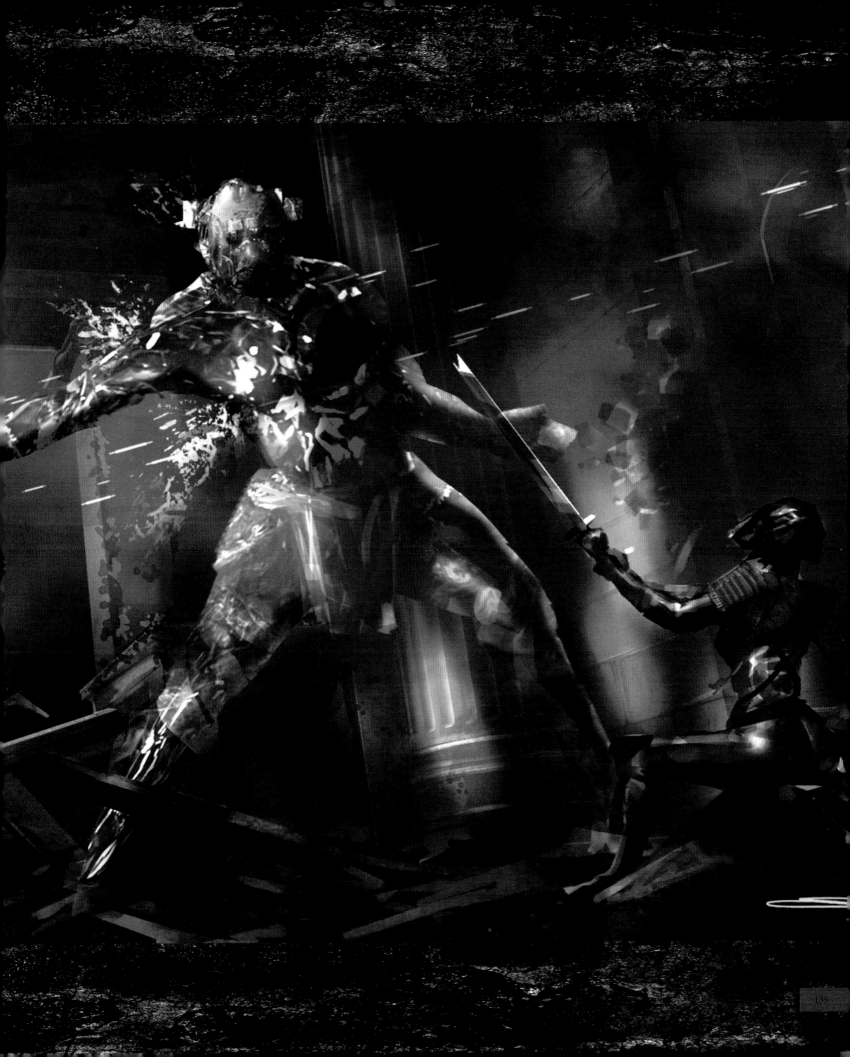

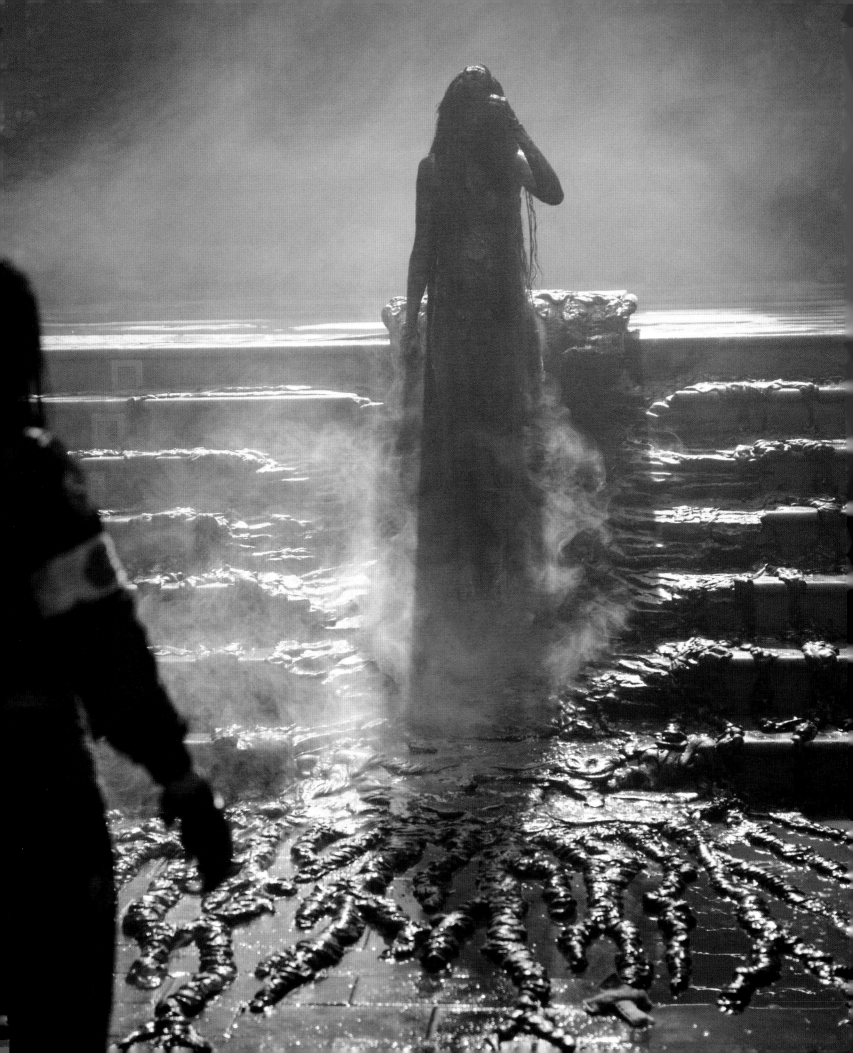

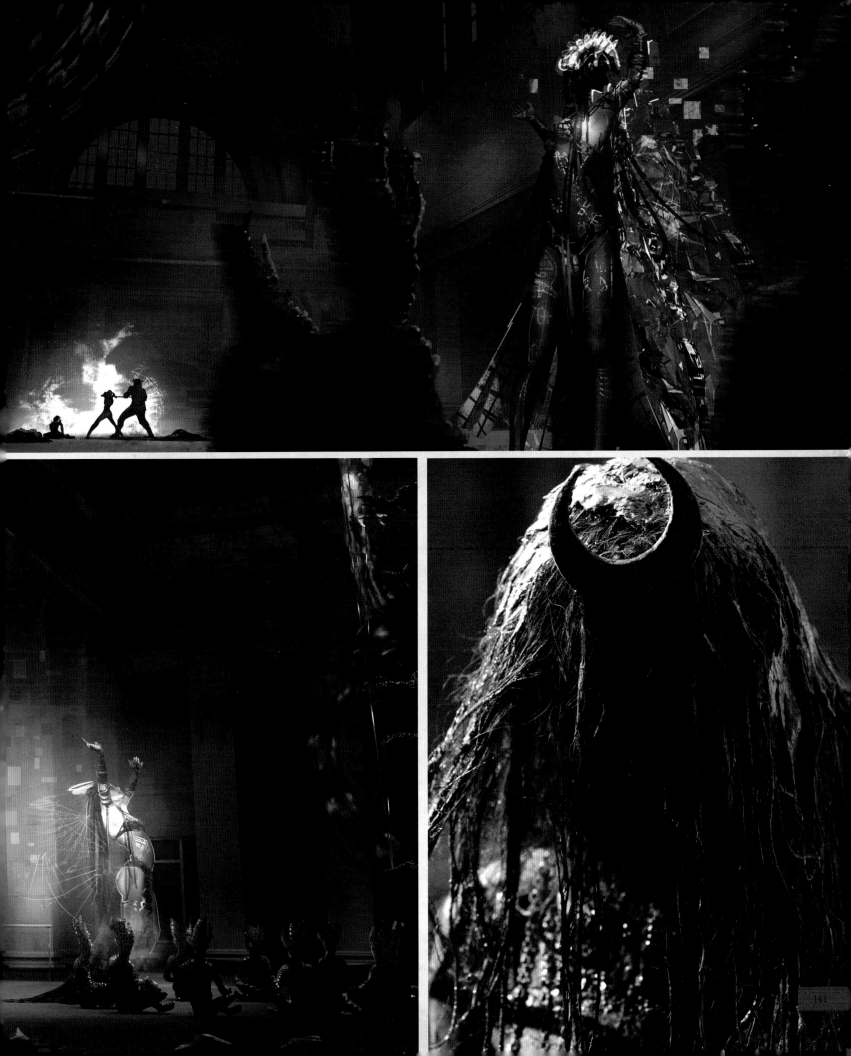

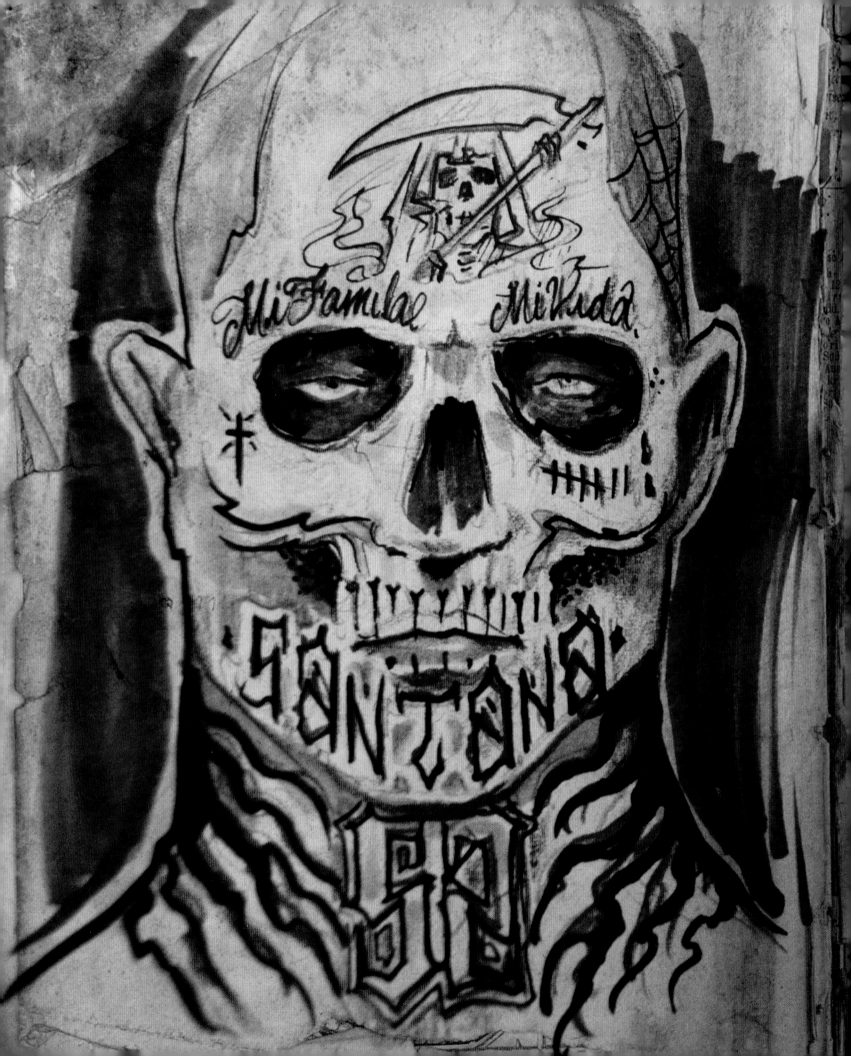

ALL INKED UP

THE SUICIDE SQUAD
TATTOO PARLOR

WHAT WOULD THE SUICIDE SQUAD be without its tattoos? Every character has one. Some have several. From GQ's tat of an old-school military cannon (on his arm) to Deadshot's scriptural tattoo (on his torso), to the tats that cover Diablo's entire body, Tattoo Artist Rob Coutts created them all.

From a sentimental portrait of his wife to a fierce Aztec warrior, Diablo's life story is told in shades of gray; his backstory is literally written on his skin. Tattoos are talismans and Diablo has a treasure's chest full of them. But perhaps the most telling of all his tats is the one front and center: his face. Tattooed as a skull, it's an intentionally hard aesthetic meant to instill fear and act as warning: A man who's already a skeleton of himself isn't afraid to die . . . or to kill.

For Deadshot, Coutts did a nice simple tat that reads, "I am the light, the way." Though the audience sees this tattoo only a few times, Coutts says, it gives another texture, another level to the character. "It doesn't matter where on a character you look," he says, "there's always something to see, something to find."

When the film wrapped, several actors got matching tattoos that read "Skwad," illustrating a bond rendered in ink and sealed in blood.

For Enchantress, Coutts's worked closely with hair and makeup to create the character's overall aesthetic. Some of Enchantress's tattoos are primitive while others are vaguely futuristic. The team also drew shapes in mud all over her body.

Where Diablo's tattoos are highly personal, Harley Quinn's are a bit more slapdash. Coutts says, "When it comes to David's aesthetic for her, he wanted her to have a little bit of obsession with a little bit of lunacy." To that end, many of her tats are imperfectly hand-drawn, their application and placement impulsive. Coutts's drawings weren't isolated to Harley Quinn's body—they also found a home in the Costume Department.

"Let's bend it, let's twist it, let's make it something fresh."

—Rob Coutts, *tattoo artist*

When Harley is imprisoned in Belle Reve, she takes to drawing on her own clothes, sometimes using her blood as ink. Costume Designer Kate Hawley asked Coutts to render the bloodied words in his handwriting so everything—from Harley's tattoos to her insane doodles and hand-wrought love letters she composes to Mr. J—complement each other. The creative cross-pollination didn't end there. A drawing that didn't make the cut as a back tattoo wound up being a T-shirt design. Similarly, when Coutts drew a jester's head as a graphic for one of Harley's shirts, it ended up as the adornment on Mr. J's pinky ring. Look closely: many of Coutts's drawings are laser-etched onto the Joker's leather shoes or screen-printed onto Harley's jacket. Coutts even helped rework the design and look of the Joker's signature deck of cards.

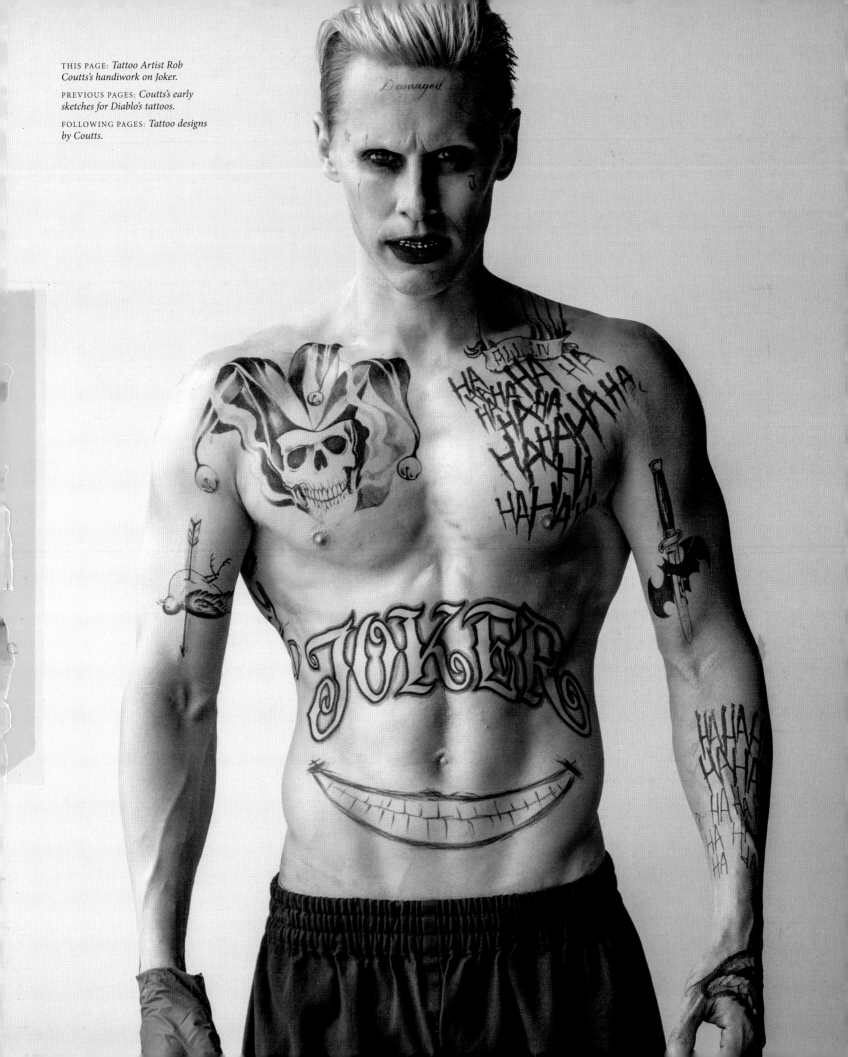

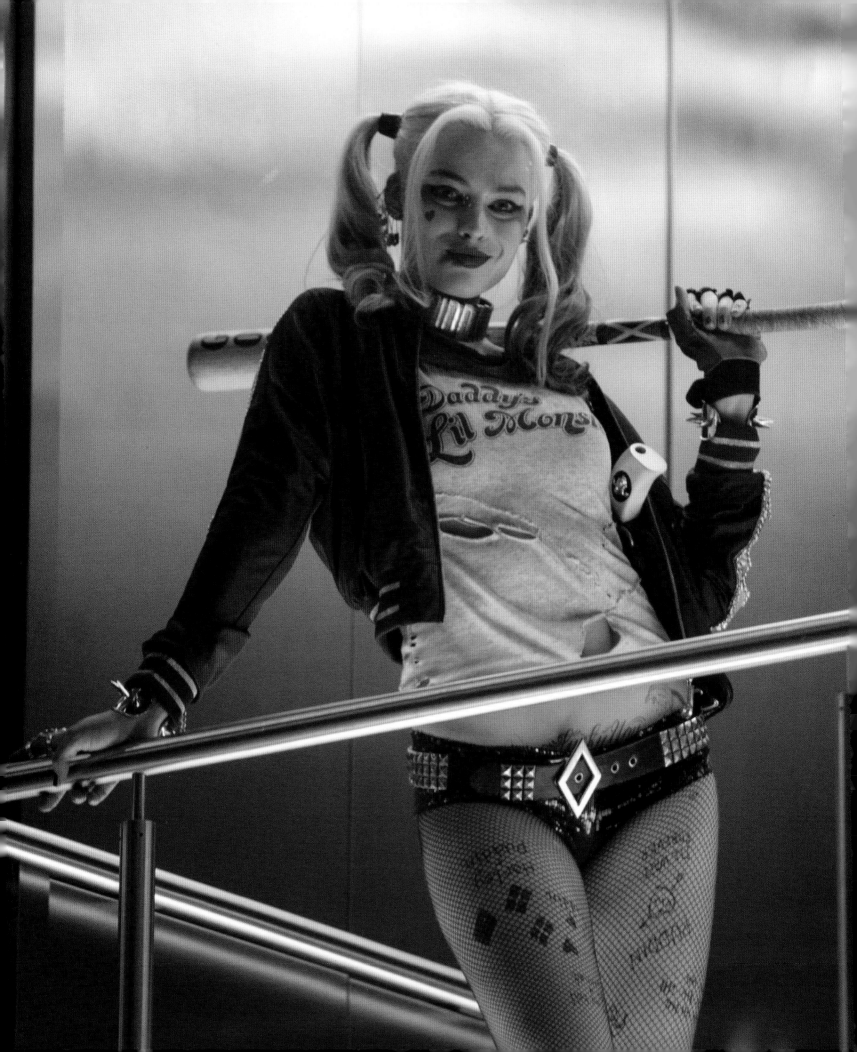

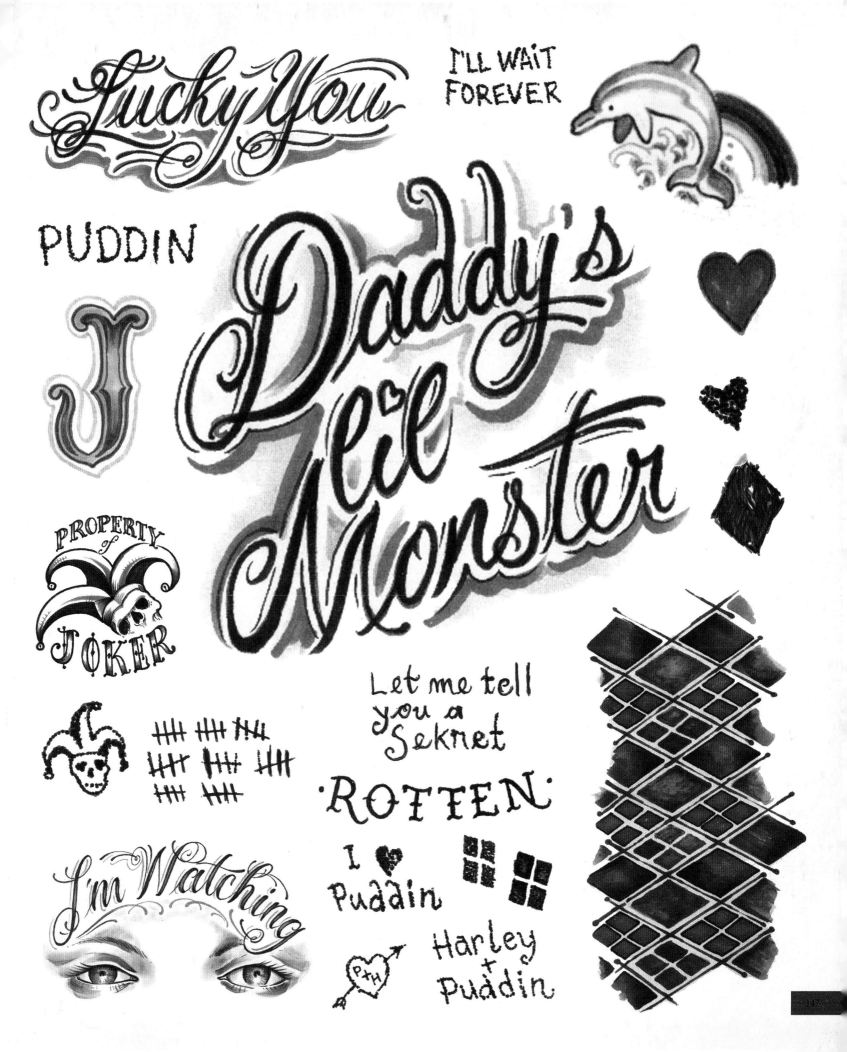

Lucky You

I'LL WAIT FOREVER

PUDDIN

Daddy's Lil Monster

PROPERTY of JOKER

Let me tell you a Seknet

· ROTTEN ·

I ♥ Puddin

I'm Watching

Harley + Puddin

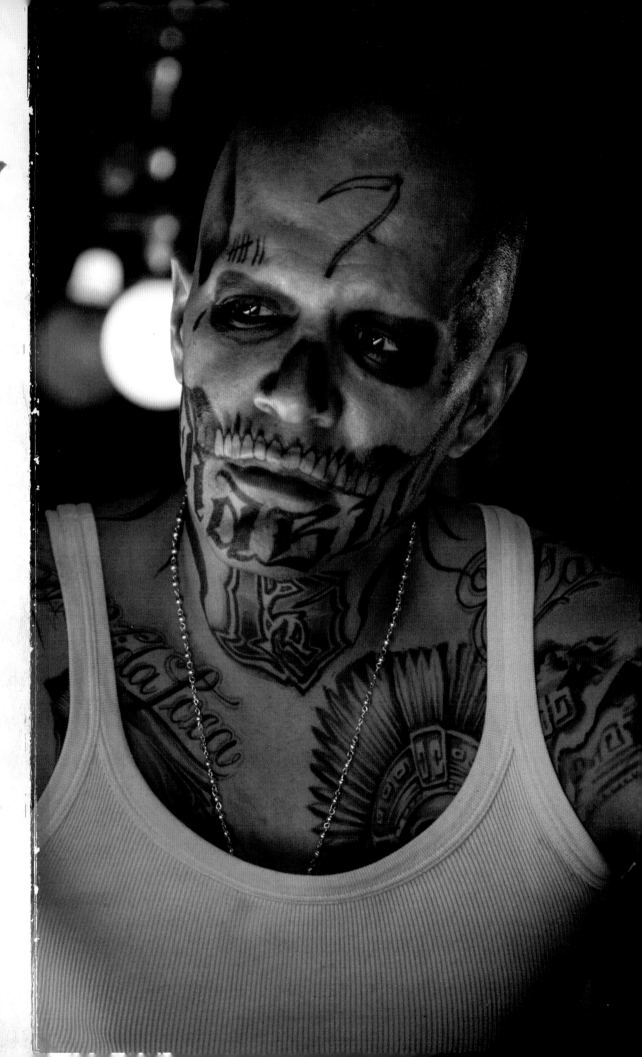

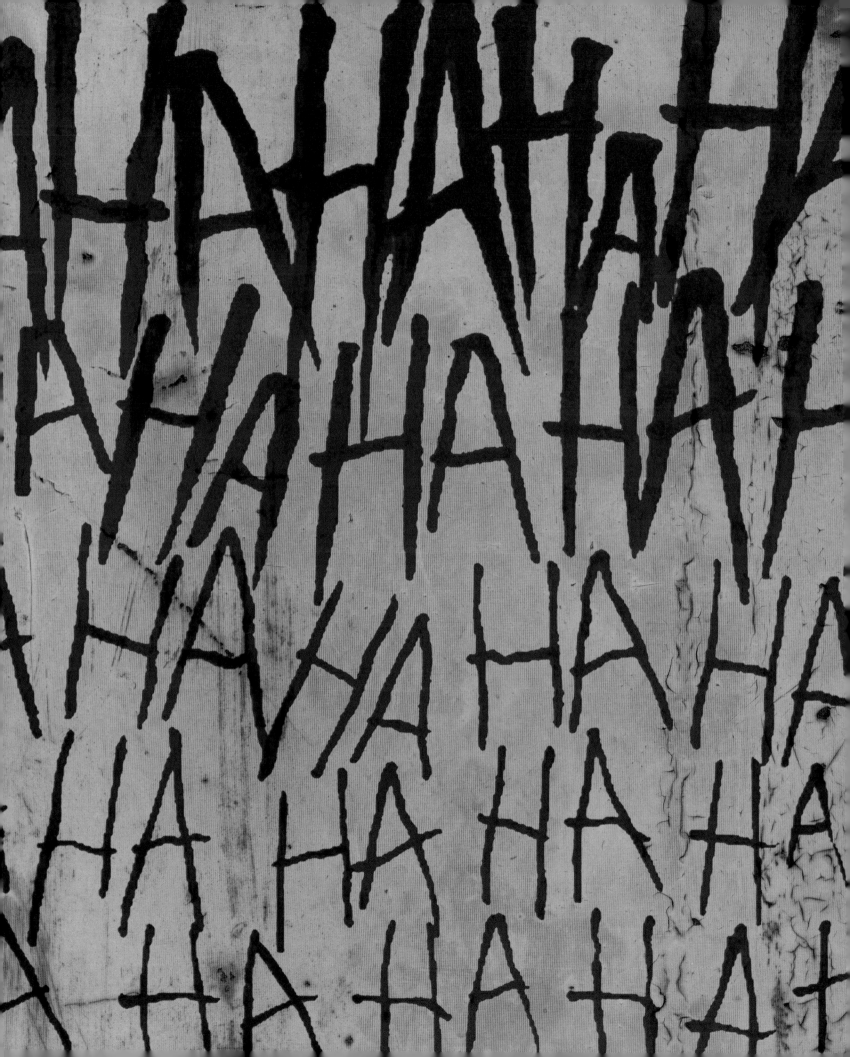

JOKE'S ON YOU

BECOMING THE JOKER

Jared Leto

JOKER

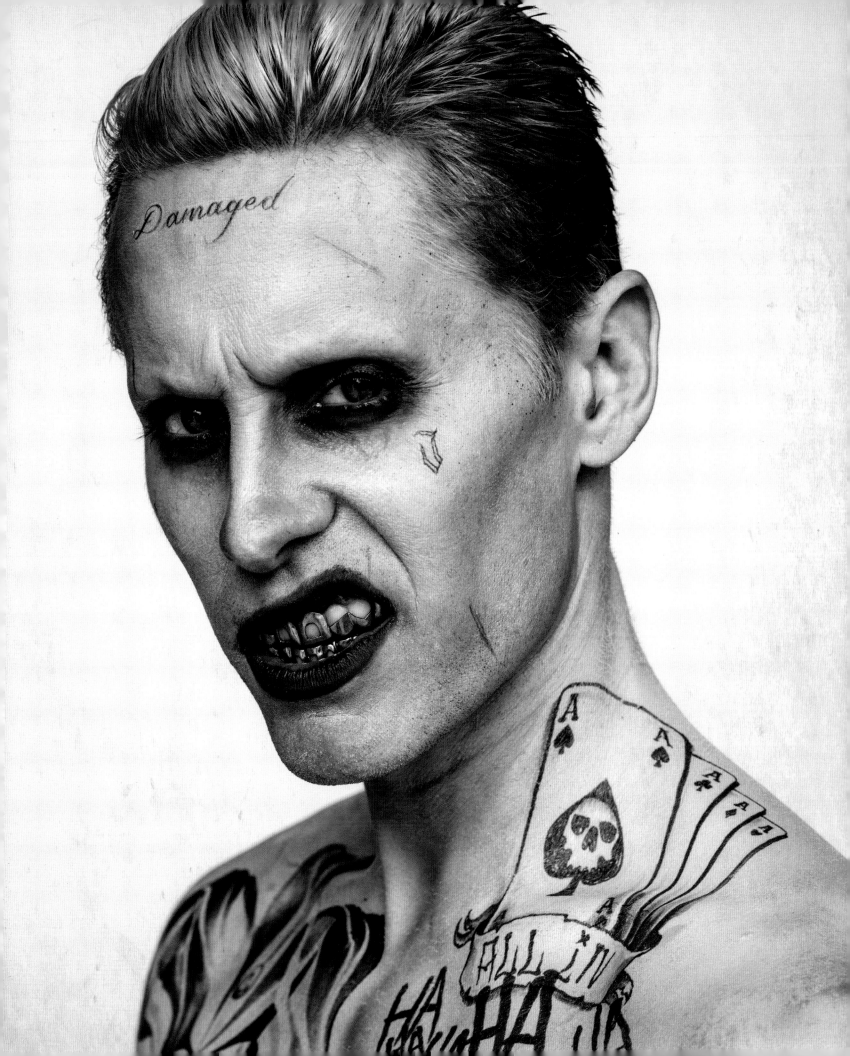

LETO STAYED IN CHARACTER as the Joker for the duration of filming. Producer Richard Suckle says, "I've never worked with an actor who would be in character when I was talking to him when the camera's not rolling. But I would go into his trailer to have a conversation with him, and the first time that happened, I was pausing because I realized I was actually having a conversation with Mr. J and not necessarily Jared. I had to figure out how to navigate those waters.

The film's producers never met Jared Leto. Instead, they met the Joker. For the duration of filming, no one addressed Leto by his first name. Even the cast and crew referred to him as Mr. J or Smiley. It was only after the film wrapped that Leto walked up to specific people in the crew—individuals who had worked with the Joker for the past six months—and

introduced himself as Jared Leto for the first time. Leto wasn't afraid to plumb the depths of his character: a good challenge often brings out the best in people. He explains, saying, "David Ayer is great because he understands a really important and simple concept: greatness usually comes as a result of working your ass off. You can't cheat your way through it, you've got to get down, you've got to grind, you've got to push, you've got to grovel, you've got to beg and plead and make sure that you bleed for it."

"The Joker changed me forever."

—Jared Leto

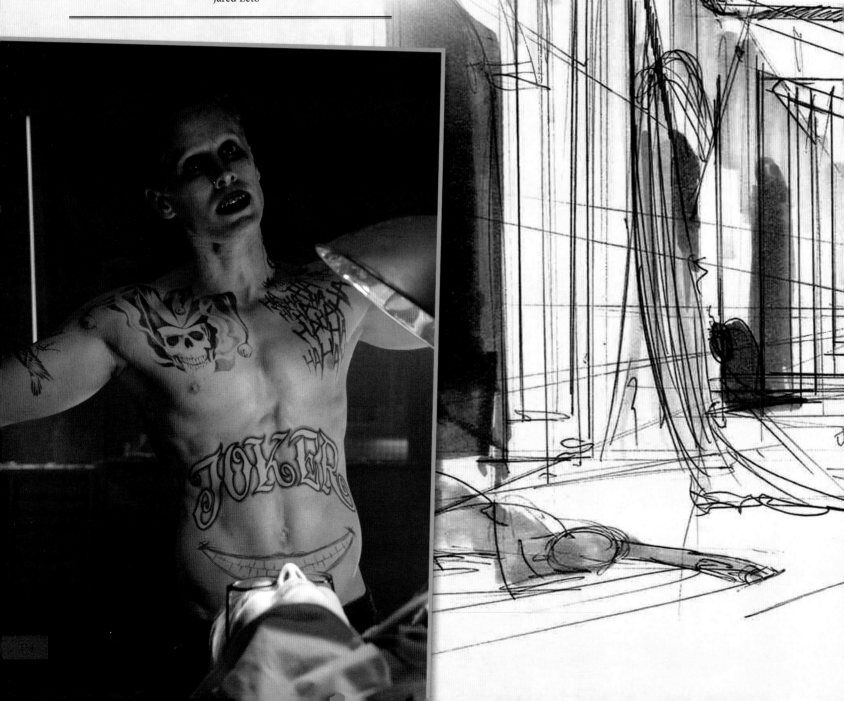

WE'RE ALL MAD HERE!

"I can make you smile."

– the Joker

DR. HARLEEN QUINZEL was the Joker's psychiatrist at Arkham Asylum before she became his main squeeze. The Joker quickly—and literally—turned the tables on Dr. Quinzel, forcing her to withstand some heavy doses of her own electroshock therapy treatment. It isn't until she takes a tumble into a vat of acid that Dr. Quinzel completely transforms into Harley Quinn.

Together, the Joker and Harley are like two live wires with no socket. Their dysfunctional relationship feeds each other's addictive personalities: the worse the Joker treats Harley the harder she falls for him. Leto says, "No one else really matters much. Why would they, right? When you got her [Harley], what's the rest of the world? It's just a game."

While the Suicide Squad is busy saving the good of mankind, the Joker is running an altogether separate mission: to get Harley back. At any cost. Seeking to restore Harley to her rightful position as the unofficial queen of Gotham City's underground, the Joker, like Enchantress, will stop at nothing to get what he wants.

FAR AND NEAR LEFT:
*Film still and early
sketch of the scene in
Arkham Asylum when
the Joker makes Dr.
Harleen Quinzel lose
her mind.*

THIS PAGE (TOP):
*Early concept art of
the Joker carrying
Harley Quinn after her
transformation at the
Ace Chemical Lab.*

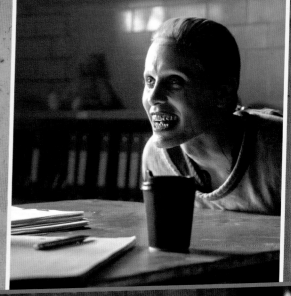

THE JOKER HAS BEEN A THORN in Batman's side—and a pop culture archetype—for more than seventy-five years. Jared Leto says, "As soon as I heard the word 'Joker,' I knew that I was going to have to dive really deep and go to a place I had never gone before." Leto's interpretation of the Joker has some basis in the canon of DC Comics, though he's also a man of our time. As David Ayer says, "This is Joker with an iPhone." Sadistically charismatic, the Joker also possesses a sick sense of humor along with a lethal entourage of psychokillers and henchmen.

Ayer admits that one of the biggest challenges of the film is to re-invent the Joker. He says, "To see Jared step up to the job so fearlessly, really become the character and become a version that's both new and incredibly faithful to the source material, is amazing. . . . And when he came on set to shoot for the first time, you could feel it. Everybody knew they were seeing something special. Everybody knew they were witnessing an important birth." For Leto, the Joker is Hamlet. He's Mount Everest: an impossible idea. He explains, saying, "It was an incredible experiment, an incredible exercise. So disappearing, going into that rabbit hole was . . . something I never expected. I never thought in a million years that I would have the chance to play a role like this . . . that side of me that likes exploration, that likes adventure, that likes to push the envelope, that part of me was set on fire immediately. You're walking along the precipice, you're on the ridge, you look to the right, it's a five-thousand-foot drop. And to the left the same." To become the Joker, Leto separated himself from the rest of the cast and crew, interacting with them only in character and in scene.

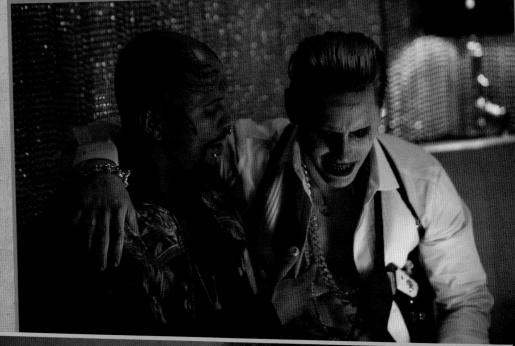

The character is larger than life. "I think the Joker will live forever," Leto says. "There will always be a Joker. You may not think so, but he's there . . . waiting to chew your bloody face off."

OPPOSITE: *The moment of transformation: Dr. Harleen Quinzel stands at the edge of the precipice, her life about to change forever.*

"It's daunting and terrifying, exciting, and a complete and total honor to take on that role."

—Jared Leto on playing the Joker

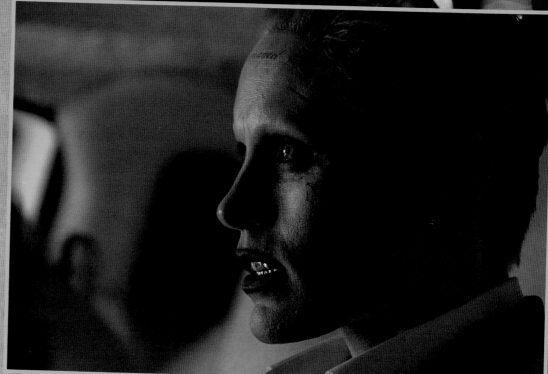

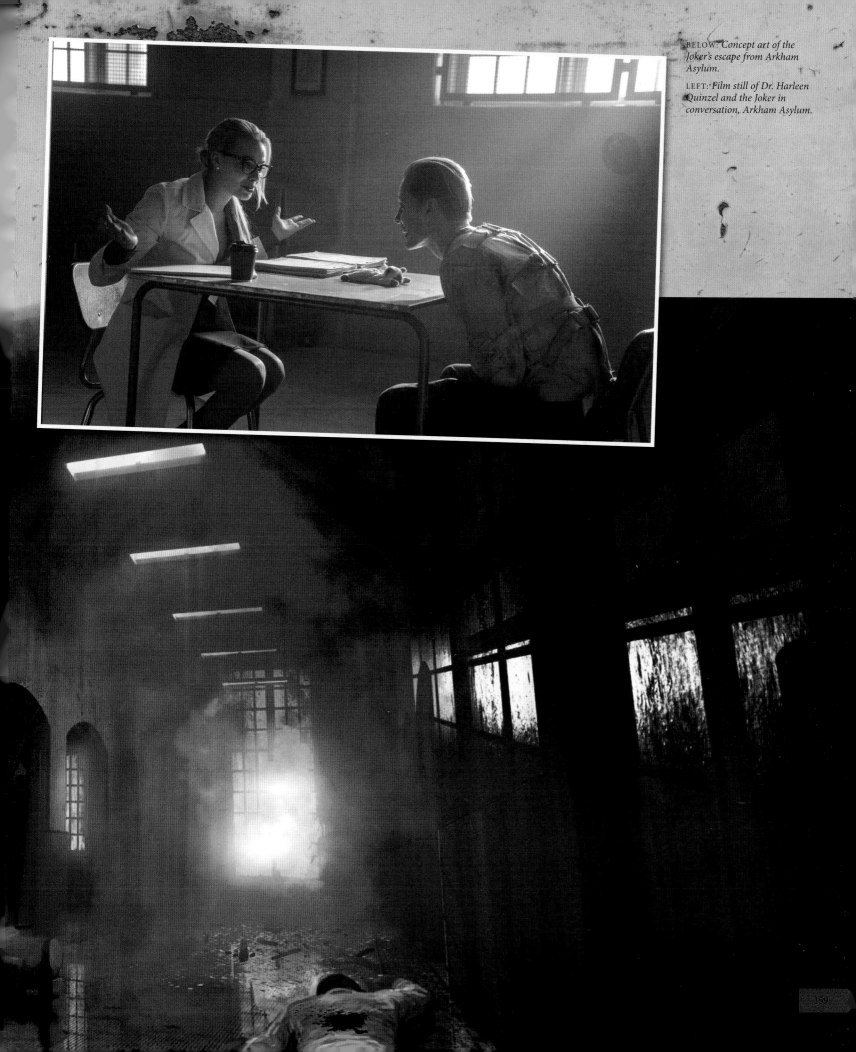

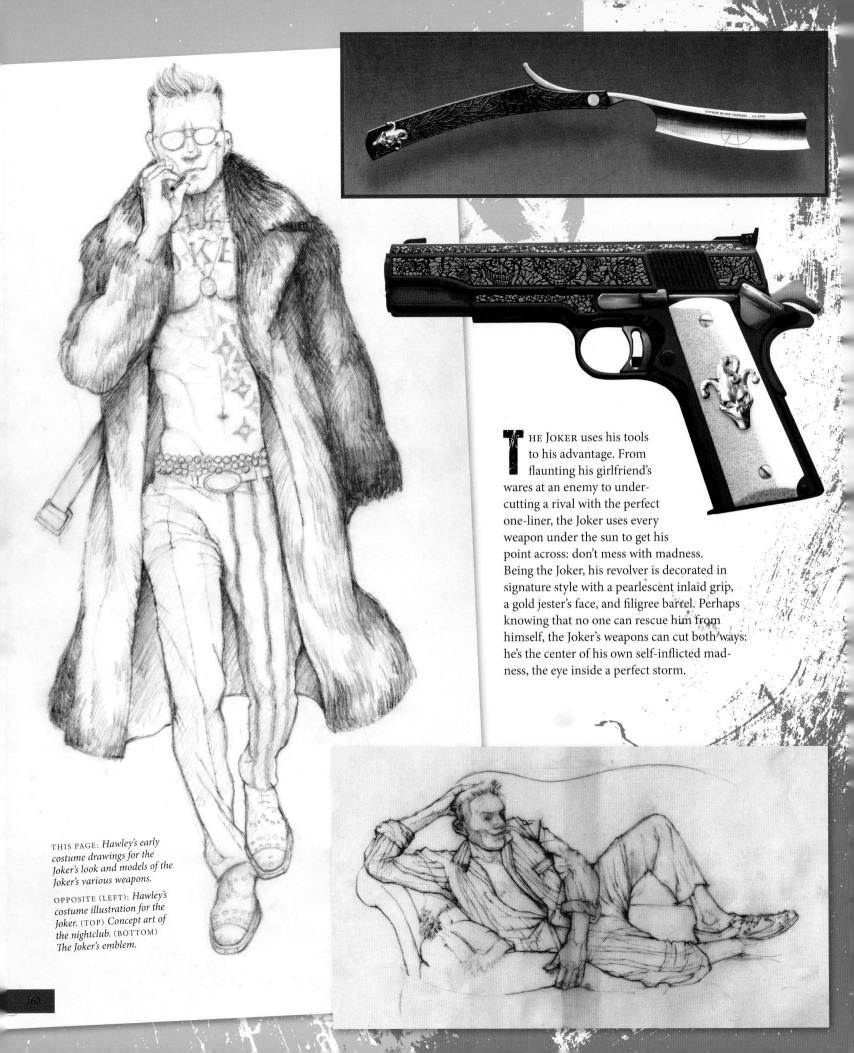

THE JOKER uses his tools to his advantage. From flaunting his girlfriend's wares at an enemy to under-cutting a rival with the perfect one-liner, the Joker uses every weapon under the sun to get his point across: don't mess with madness. Being the Joker, his revolver is decorated in signature style with a pearlescent inlaid grip, a gold jester's face, and filigree barrel. Perhaps knowing that no one can rescue him from himself, the Joker's weapons can cut both ways: he's the center of his own self-inflicted mad-ness, the eye inside a perfect storm.

THIS PAGE: *Hawley's early costume drawings for the Joker's look and models of the Joker's various weapons.*

OPPOSITE (LEFT): *Hawley's costume illustration for the Joker.* (TOP) *Concept art of the nightclub.* (BOTTOM) *The Joker's emblem.*

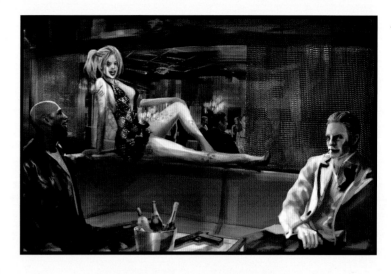

JOKER AND HARLEY QUINN are, as Costume Designer Kate Hawley says, "Two of the most seductive characters that we have in this world"—Gotham City's king and queen as it were. For their costumes, Ayer stressed the importance of something he calls "chasing the real." It was paramount to design the look of each character within the context—the reality—of their world. "And then," Hawley says, "to heighten it and distill the elements, the iconography of the comic book characters into this cinematic reality." Ayer wanted the Joker's world to be saturated in rich colors, for him to be very put together, tailored. Distilling his look down to the basics gave Leto room to explore the character and to truly inhabit Joker's mental space.

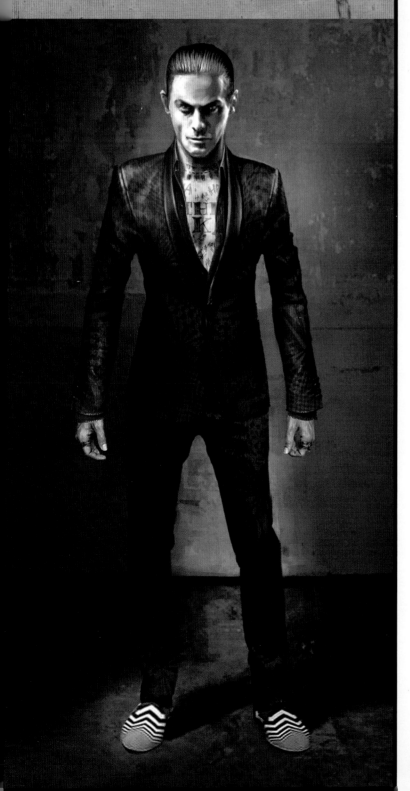

GOTHAM CITY'S POWER COUPLE

"I think everyone's dedication to this movie was pretty insane. But his was on another level."

—Cara Delevingne on Jared Leto

THE ENTIRE CAST showed up to watch the first scene filmed between Leto and Margot Robbie. It marked the first time, too, that the cast and crew saw Leto in full costume as the Joker. Leto had intentionally kept his distance from the cast, opting out of the in-depth rehearsal time that consumed pre-production. That's not to say, however, that the Joker wasn't present. Leto—in character—brought as gifts a live rat, complete with love letter, to Robbie; bullets, along with a note, to Smith; and a dead hog and a video of himself as the Joker to the rest of the gang.

The scene between Robbie and Leto happened on day two of shooting; the other actors had yet to even step into their costumes on camera. Co-producer Andy Horwitz says, "That scene allowed everyone on set to realize that this gig wasn't like other movies; there was an opportunity here to do something incredibly unique with these characters."

For Robbie, it was terrifying: she couldn't see a glimmer of Leto in the green-haired man standing before her. Because the duo hadn't done any off-camera rehearsals, their interaction was especially electric and spontaneous. "Those characters are unpredictable," Robbie says. "You don't know whether Harley's going to laugh, hug you, or shoot you in the face. And Joker's even worse than that."

TATTOO ARTIST ROB COUTTS initially wanted the words "Ha Ha Ha" to be the Joker's eyebrows. Not being able to put a transfer over eyebrows, however, he asked Ayer if Leto would shave them off. Coutts says, "Ayer walked over [to Leto] and said, 'So we're gonna shave off your eyebrows.' And Jared just said, 'Fine.' Off went the first eyebrow, and then the second, and he looked in the mirror and at that very moment, I swear, you could just see his brain go *click*. And Jared was gone. From that moment forward, I wasn't talking to Jared. Every day that I saw him, he was the Joker." The team soon abandoned the idea of tattooing his eyebrows. As the Joker, Leto understood that the key to projecting madness is all in the eyes. He didn't need anything else doing the work for him.

The words "Ha Ha Ha" did find a home on Leto's body, however. During a film test, Ayer simply grabbed one of Coutts's drafting markers and scrawled the words on Leto's chest along with a big happy face.

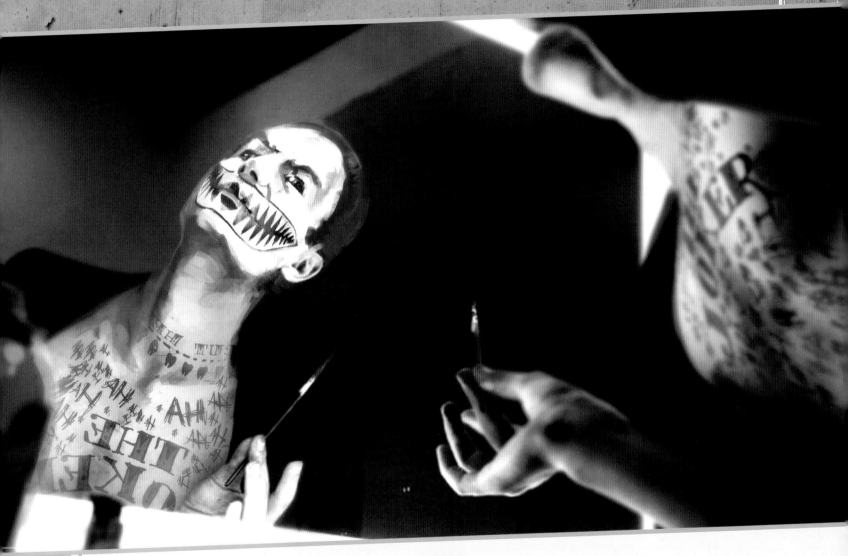

"Do you feel like the Joker now? Because if you don't feel it, I did something wrong."

—Alessandro Bertolazzi, *makeup and hair designer, on the transformative power of his craft*

THIS PAGE: *Early art of the Joker.*

FOLLOWING PAGES: *Film still of the Joker distraught over Harley Quinn in his hotel room.*

MAKEUP AND HAIR DESIGNER Alessandro Bertolazzi got rid of Jared Leto's beard and long hair almost immediately. "It was great," says Bertolazzi, "because we started at a completely opposite place, and were forced to discover the character." It took an hour and a half to apply the Joker's makeup, and during that time, Bertolazzi says, it was like watching the slow glow of a dimmer light . . . slowly, slowly Leto retreated into character and then the Joker appeared in his place.

The Joker's green hair is such an iconic visual reference for the character. Bertolazzi wanted it to be "a beautiful green" with movement to the color. To achieve this, the makeup team used three different shades of green. Using only one shade risked making Leto's hair appear wig-like; the goal was to make his hair look real and, in true Joker style, be styled and cut beautifully too. The scar on the Joker's face creates a counterpoint to his sleek hair.

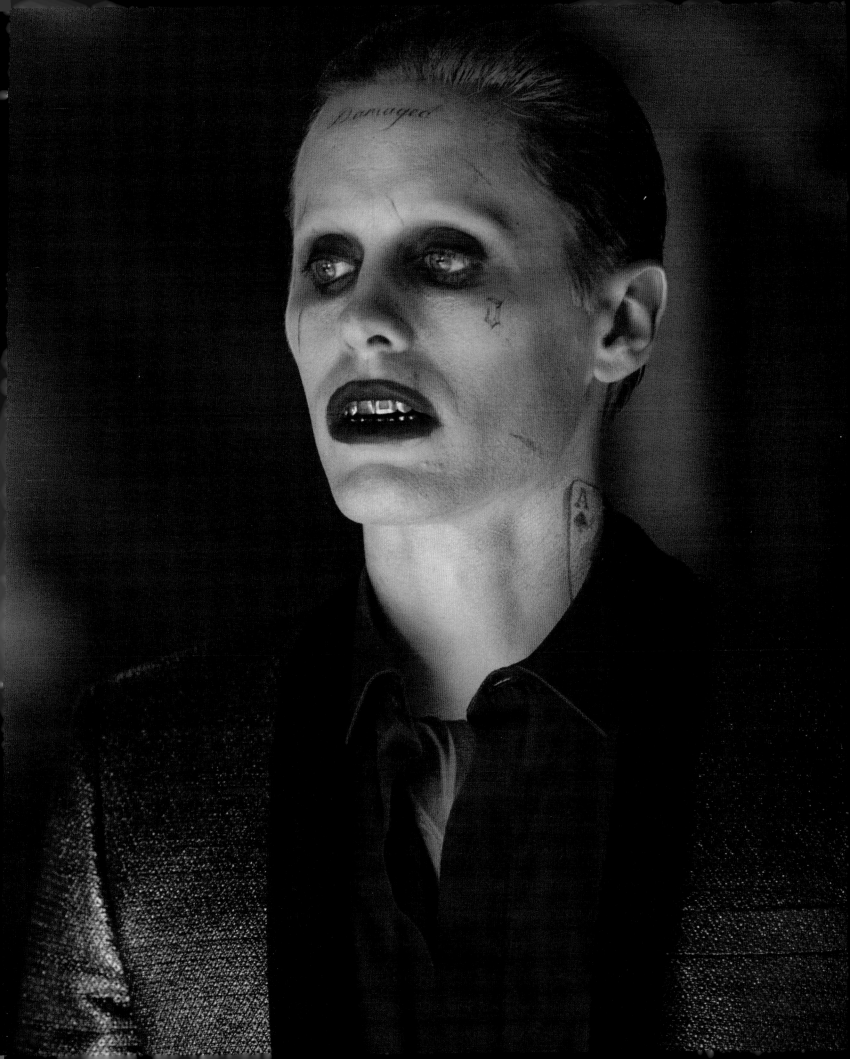

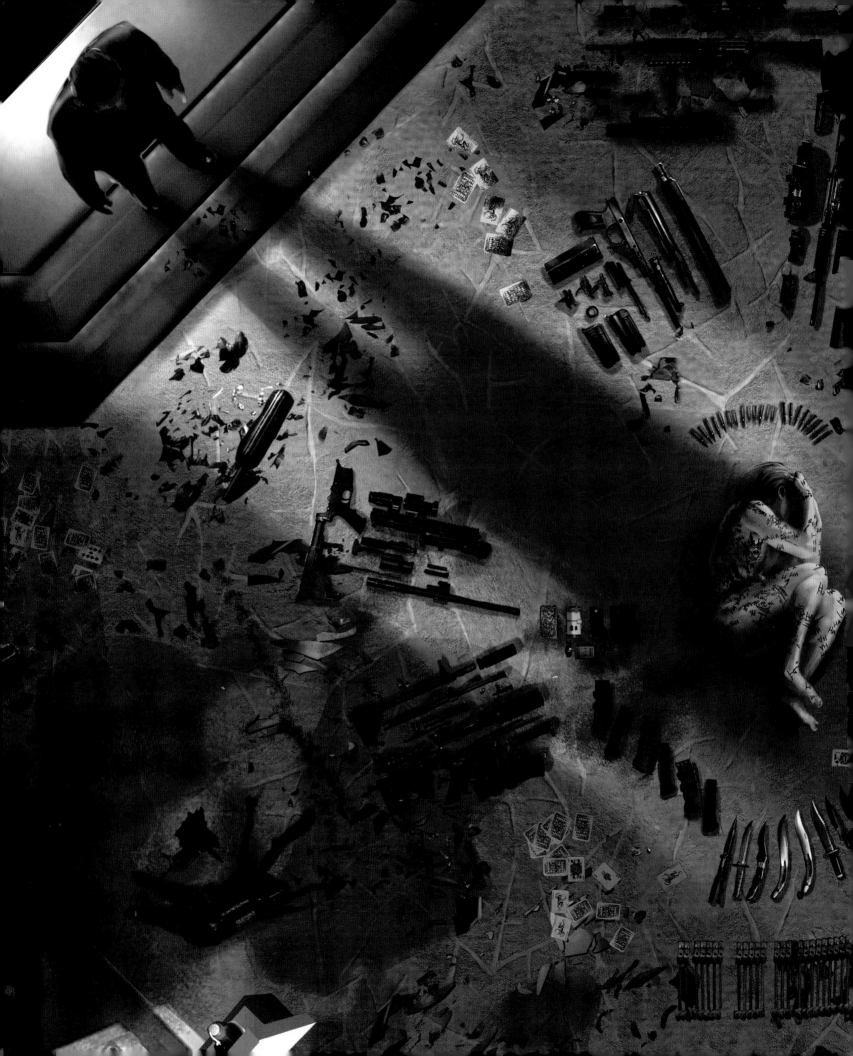

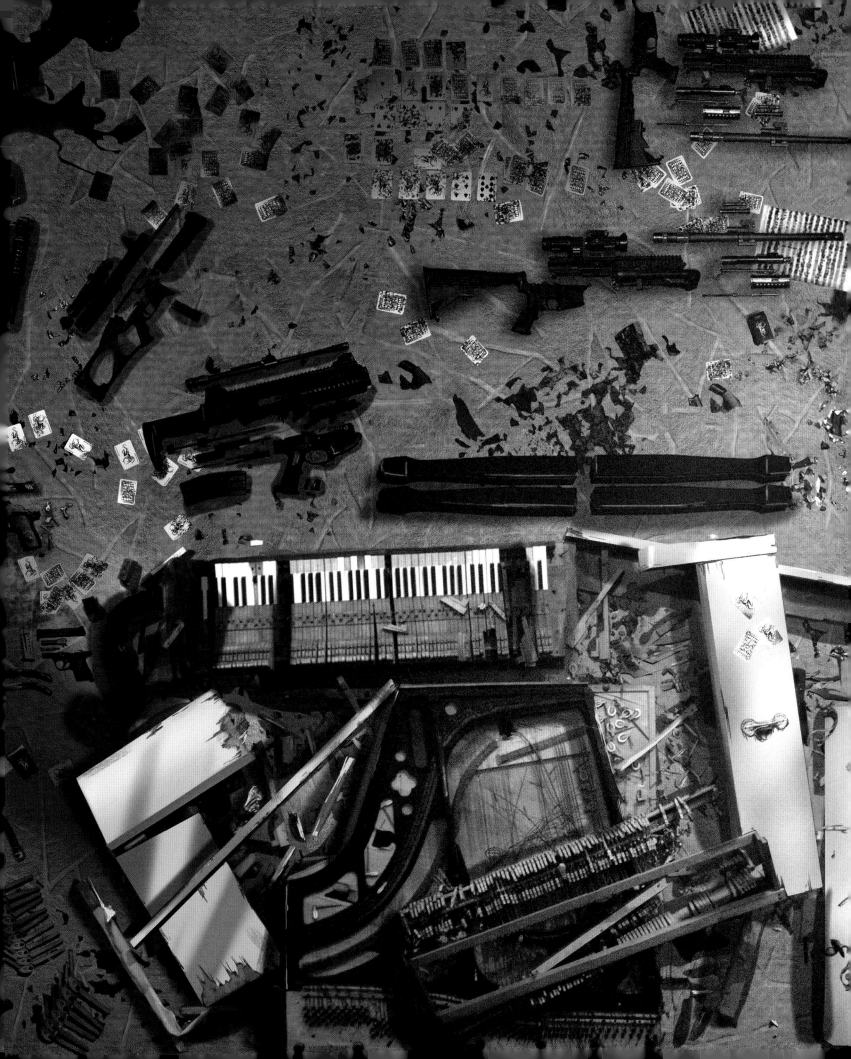

THE JOKER'S GANG

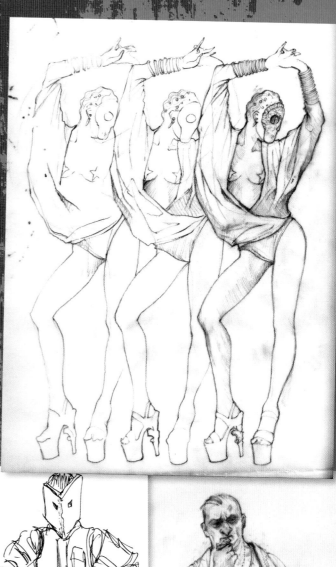

F OR THE JOKER'S GANG, the costume design team explored the idea of psychological warfare. Costume Designer Kate Hawley looked at patterning elements, like camouflage, that could be integrated into their wardrobe. "Abstract black and whites became a big theme in the movie," she says.

The larger goal, however, was to keep the audience on its toes. The Joker's thugs are intentionally costumed to make audiences do double- and triple-takes. For the scene in Arkham Asylum, Hawley applied a modern-day Hieronymus Bosch surrealism to the bad guys' masks. These masks reference the Eyes of the Adversary enemies covered in eyeballs that appear later in the film; a satanic goat makes an appearance; men run around with all manner of masks covering their faces, an arsenal of weaponry strapped to their bodies. But perhaps the most memorable of the gang thugs is Panda Man. It was Hawley who first had the idea for the outrageous panda suit, although Panda Man had many previous iterations as first a cat, then a penguin. "But," Hawley says, "David [Ayer] had this thing about it being a panda," and so the team circled back, and the rest is cinematic history.

> ## "Mr. Frost is a good man. He's a loyal man. He's like a Timex. Not too fancy but always keeps perfect time. . . . And he's fantastic at getting blood out of carpet."
>
> —Jared Leto, speaking as the Joker on his partner in crime

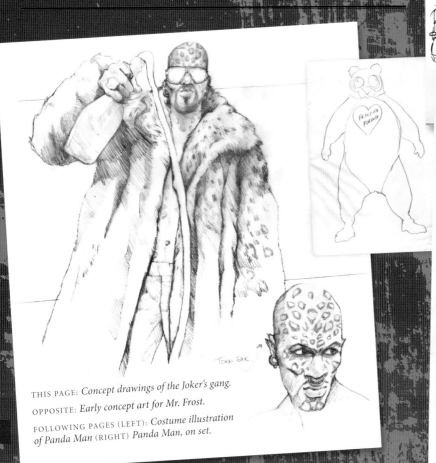

THIS PAGE: *Concept drawings of the Joker's gang.*

OPPOSITE: *Early concept art for Mr. Frost.*

FOLLOWING PAGES (LEFT): *Costume illustration of Panda Man* (RIGHT) *Panda Man, on set.*

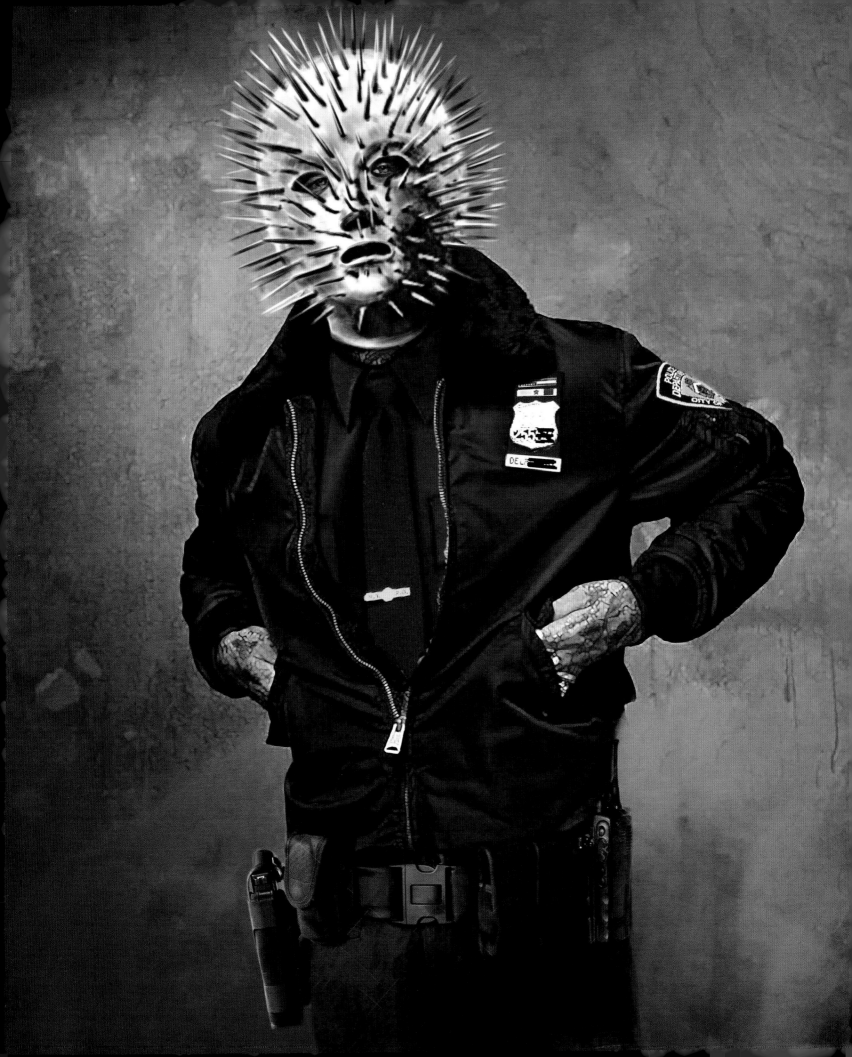

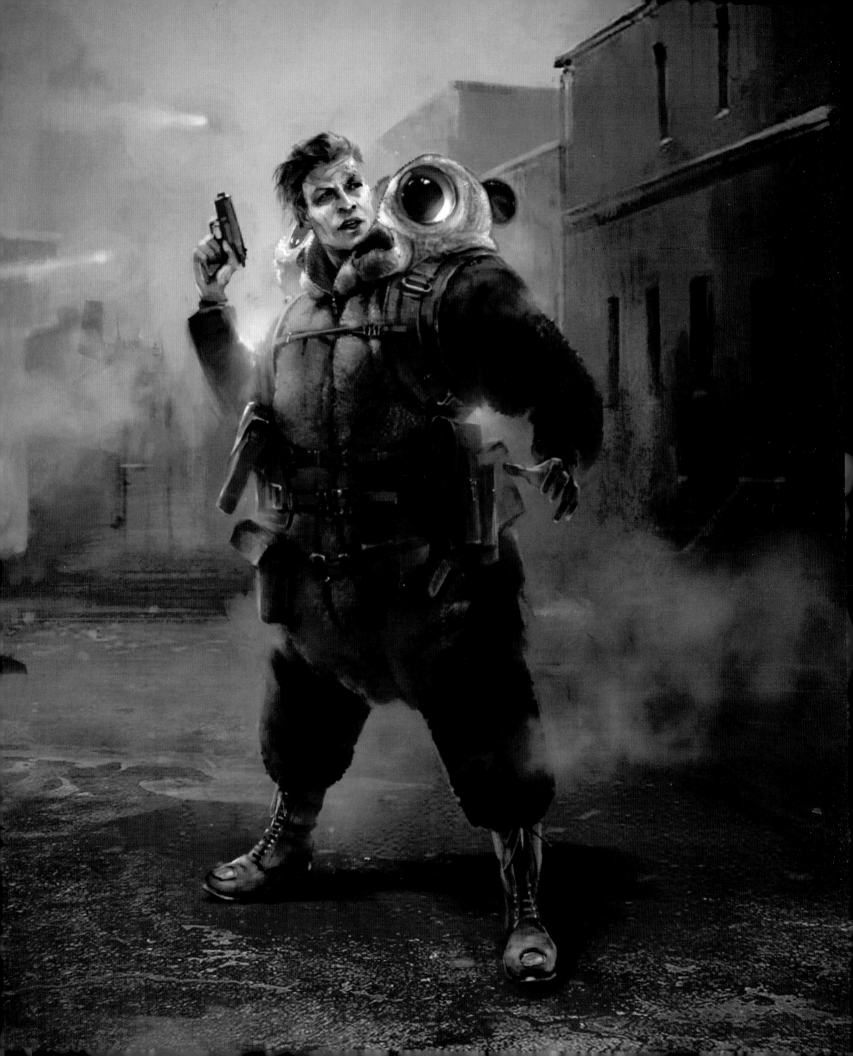

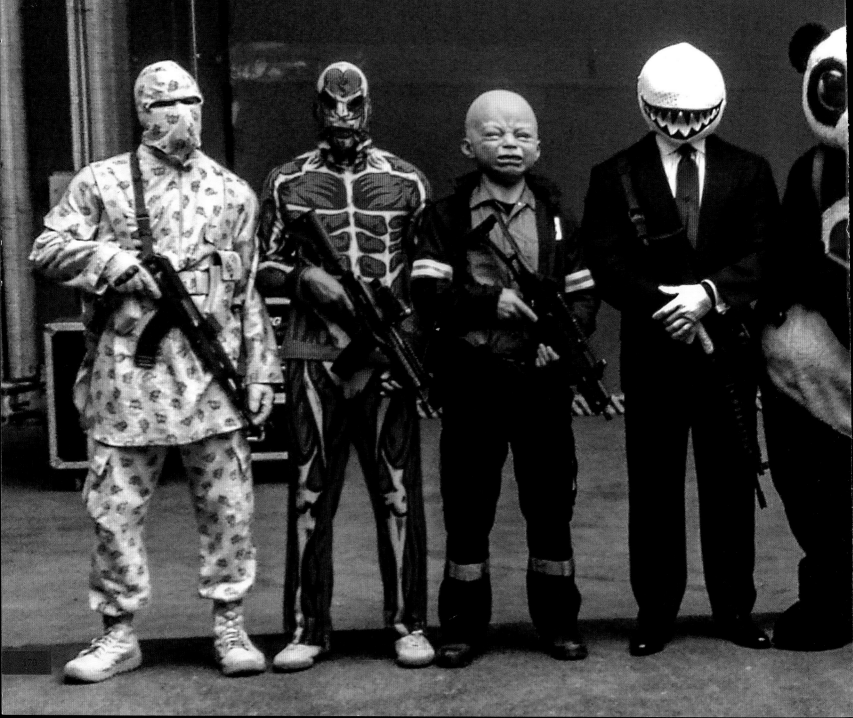

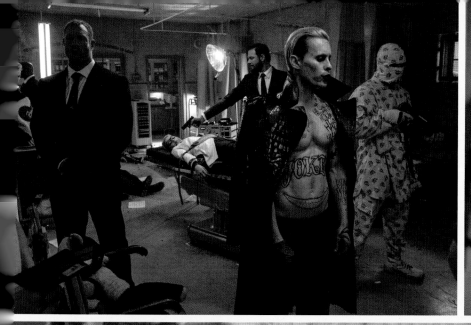

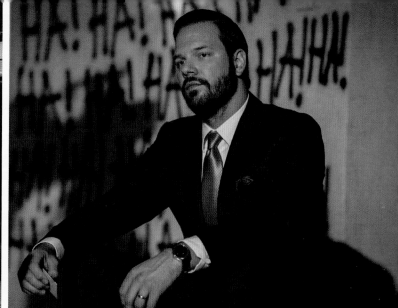

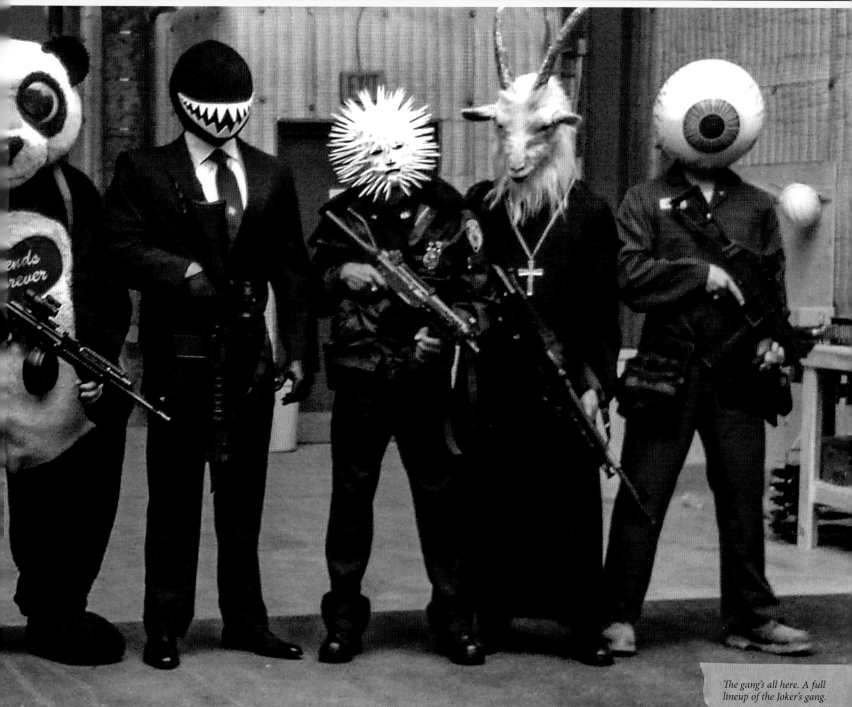

The gang's all here. A full lineup of the Joker's gang.

CAST & CREW FAREWELL

SPEAKING ABOUT her fellow Squad members, Robbie says, "Off-screen we were far more bonded than you ever see us on-screen. . . . The Squad was together all the time." This film made a lasting impression on its cast and crew. The intense rehearsal time certainly helped the actors connect with one another. The camaraderie was largely the result of David Ayer's efforts in creating a supportive, energetic, and creatively collaborative environment. Set became a kind of home away from home: cast and crew celebrated birthdays together. Will Smith presented Adewale Akinnuoye-Agbaje with a homemade cake and Robbie shared her own birthday (and cake) with fellow cast and crew members alike. And Squad members solidified their bond in ink by giving each other matching tattoos.

As production wound to an end, Robbie says, "We didn't leave the set for the last three days of shooting. We slept in our trailers every night, like we set up a little camp. No one wanted to leave." Robbie was the last person to wrap, and the entire cast and crew stayed 'til the end—a rarity in the film business. She says, "No one had slept in days. Everyone was so tired or whatever, but we all stayed.
. . . I was so touched by that."

THIS PAGE: *The last day of shooting, on set at the train station.*

OPPOSITE (TOP): *On set, Diablo waging the final battle.* (BOTTOM) *On set, Harley Quinn in the Chinook helicopter.*

FOLLOWING PAGES: *The entire* Suicide Squad *crew on the last day of shooting.*

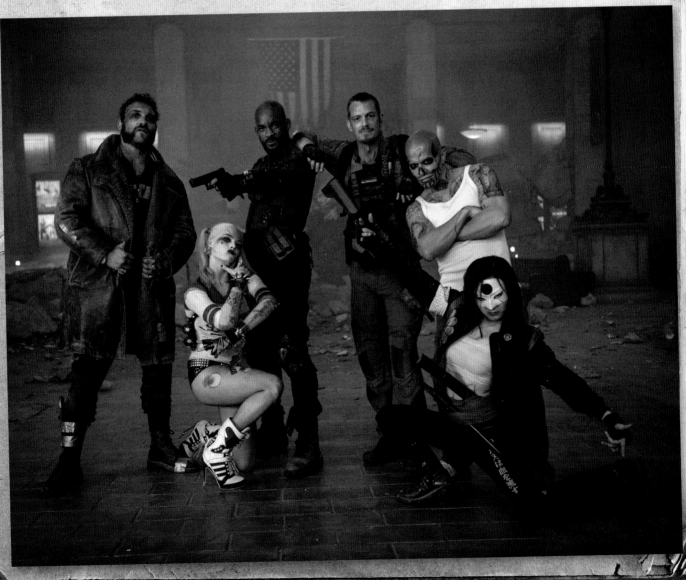

ACKNOWLEDGMENTS

Thank you to everyone who helped make this book come together: David Ayer, Charles Roven, Richard Suckle, Andy Horwitz, Shane Thompson, Josh Anderson, Spencer Douglas, Gary Barbosa, Daniele Dohring, Nik Primack, Nick Gligor, Eric Wolf, Melinda Whitaker, Rebecca Hunt, Lynne Yeamans, Marta Schooler, Iain R. Morris, Signe Bergstrom, Elaine Piechowski, concept artists Christian Scheurer, Steve Burg, Vicki Pui, Ed Natividad, James Oxford, and Henry Fong, unit photographers Clay Enos (*all photos, except page 70*) and Ron Batzdorff (*page 70, left*).

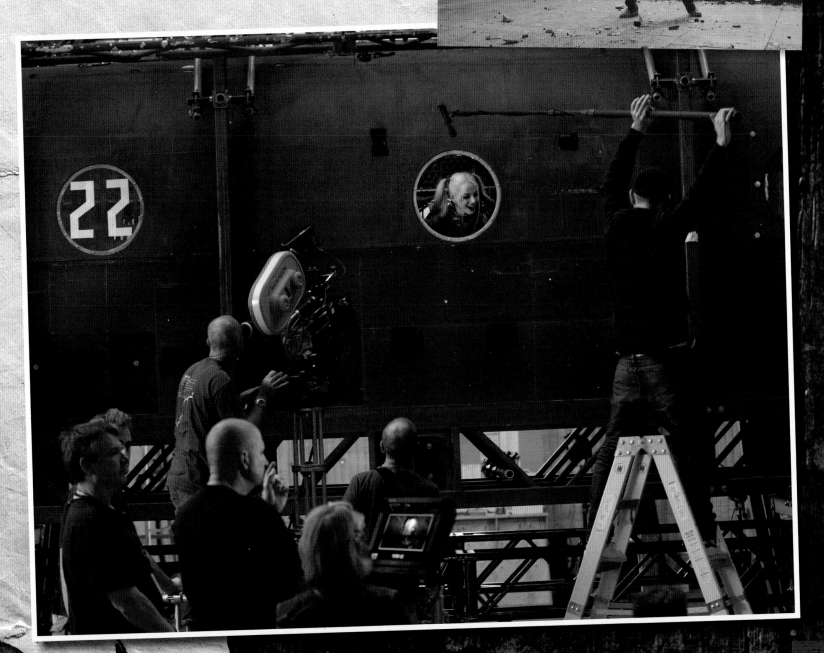

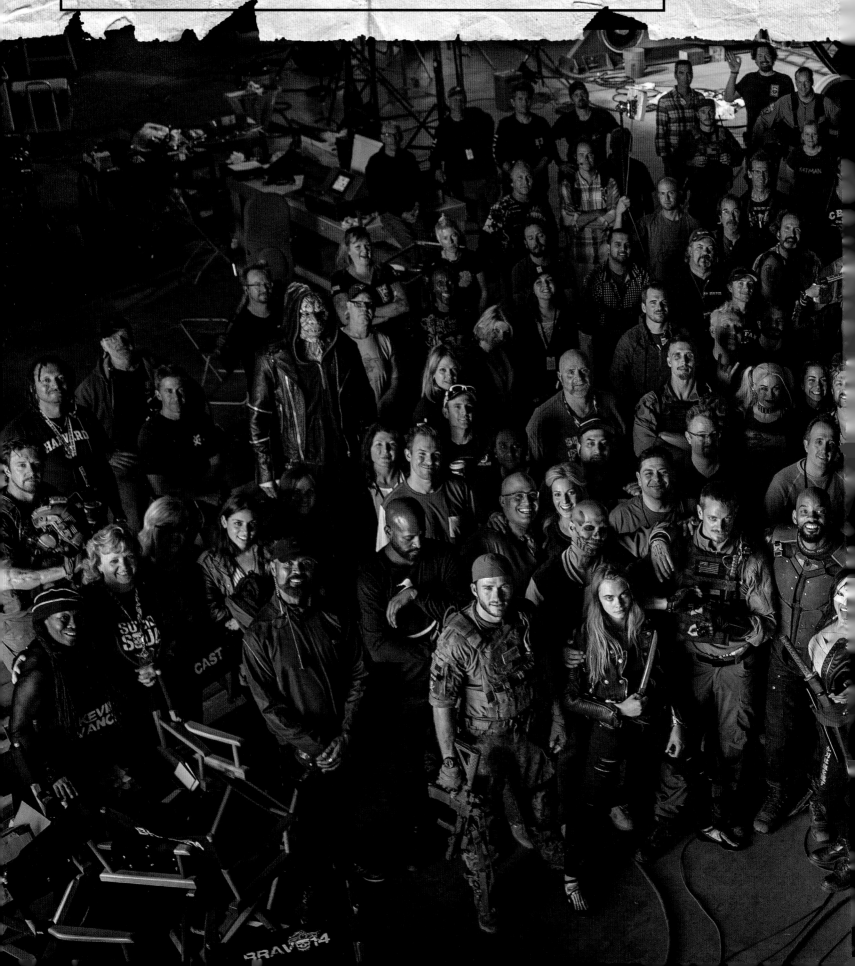

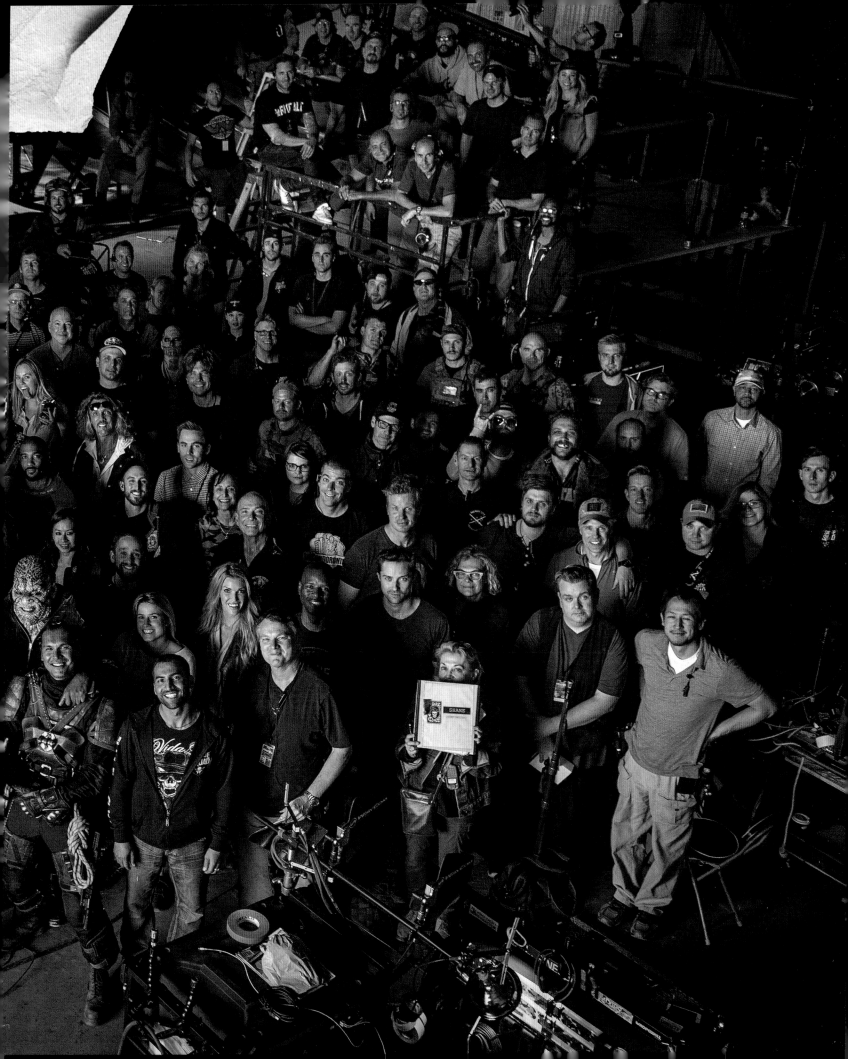

SUICIDE SQUAD
BEHIND THE SCENES WITH
THE WORST HEROES EVER

CONFIDENTIAL

Book design by Cameron Studios, The Old Mill,

Suite B-6, Petaluma Blvd. N., Petaluma, CA 94952

Published in 2016 by Harper Design
An Imprint of HarperCollins*Publishers*
195 Broadway, New York, NY 10007

Tel: (212) 207-7000 • Fax: (855) 746-6023
harperdesign@harpercollins.com • www.hc.com

Distributed throughout the world by HarperCollins *Publishers,* 195 Broadway, New York, NY 10007

ISBN 978-0-06-247166-6 • Library of Congress Control Number 2016939345

Printed in China • First Printing, 2016

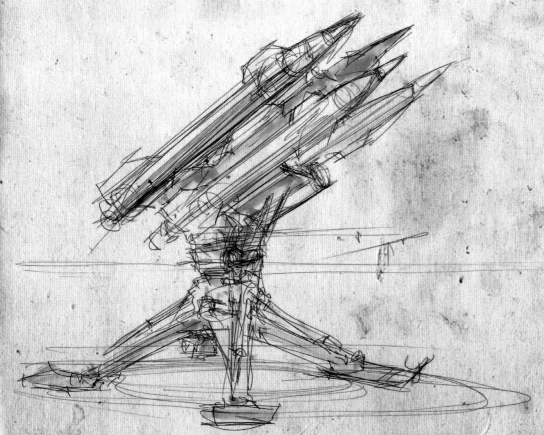

DC
COMICS™

LEFT: Sketch by Oliver Scholl (Production Designer).